*surrealism
the
road
to
the
absolute*

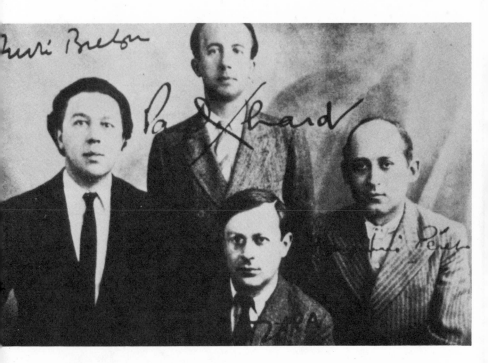

André Breton, Paul Eluard, Tristan Tzara, and Benjamin Péret (LEFT
TO RIGHT) at the time of *Littérature*, edited by Breton, Eluard, and
Philippe Soupault, 1922.

Anna Balakian

SURREALISM

*the
road
to the
absolute*

with a new introduction

 The University of Chicago Press
Chicago and London

Anna Balakian is professor of French and
comparative literature at New York University.
She has been writing on surrealism ever since, as
a graduate student at Columbia University, she
met André Breton during World War II. She later
met Pierre Reverdy in Paris and came in contact
with many of the younger members of the
surrealist coterie. Her books include *Literary
Origins of Surrealism, Symbolist Movement in
Literature: A Critical Appraisal,* and *André
Breton, Magus of Surrealism.*

The University of Chicago Press, Chicago 60637
The University of Chicago Press, Ltd., London

University of Chicago Press edition 1986
Printed in the United States of America

95 94 93 92 91 90 89 88 87 86 5 4 3 2 1

Library of Congress Cataloging in Publication Data

Balakian, Anna Elizabeth, 1915–
 Surrealism : the road to the absolute.

 Originally published: New York : Dutton, 1970.
 Includes index.
 1. French poetry—20th century—History and
criticism. 2. Surrealism (Literature)—France.
I. Title.
PQ443.B3 1986 841'.91'091 86–19147
ISBN 0–226–03560–3 (pbk.)

to Stepan
and
to Nona

contents

illustrations

introduction
to the
third
edition

The age of surrealism has bridged the age of existentialism and of
the "nouveau roman." However, as this edition goes to print, sur-
realism is being subjected to more formidable challenges than the
stoicism of the Sisyphus archetype of the '50s or the nonanthropo-
centric vision of novelists of the '60s. A new age of acute rational-
ism is upon us, with a resurgence of positivistic methods of viewing
all the branches of knowledge. These empirical methodologies are
applied to the understanding of literature and raise issues of value
deconstruction, reader reception, and idiosyncratic approaches un-
der the guise of hermeneutics. To these preoccupations are added
an intense interest in the previously overlooked power of women in
society.

Curiously enough, at first glance these are issues that were at the
core of the surrealist dogma and should, therefore, put surrealist

studies at the forefront of what is relevant, and worthy of the attention of a generation of new readers. Viewed in terms of current preoccupations in critical writings, surrealism appears to provide extraordinary fields of reference.

To destroy the language stereotype, to emancipate the Word so that it could unleash a greater measure of its potential energies, was the basic motivation for the exercise of automatic writing, but the purpose of this liberation was more positive than negative. The purpose was not so much to discredit connotations congealed in certain social philosophies of the time as to let a live language leap ahead in unpredictable directions. Hermeneutic procedures were explored not primarily to retrieve from a seemingly static text its capacity for polyvalence—which is so often the case today—but to learn from hermeneutic processes how to uncover the germinating source of language, the discovery of the ultimate unity of overtly disparate meanings. Whereas today hermeneutic criticism moves from seeming clarity to obscurity of signification, the surrealists have always aimed toward illumination: toward "what would lead to clarify symbols which have heretofore remained tenebrous."[1]

Regarding reader-reception, a crucial issue of current literary criticism, surrealists were very aware of the fact that without readership, the act of writing would lose its moral justification. The bond between the instigator and the recipient of the writing was reinforced as, with the example of Guillaume Apollinaire, poets of the surrealist band closed the ivory towers of the symbolist writers and descended into the streets, there to cull experience, reshape it and return it to humans in whatever stations of life, or of whatever race or color, who needed to have their faculties sharpened not by subtle abstractions but by the concrete forms of existence they encountered daily and took too much for granted.

As for the significance of Woman in the surrealist perspective, Breton and his followers supported their hope for the survival of humanity on her power to reintroduce passion into every activity from the sexual to the quotidian. Not through polarization and competition but through union with the female principle could man,

[1] Andre Breton, "Du surrealisme dans ses oeuvres vives," in the Pauvert edition of *Manifestes du surrealism* (Montreuil, 1962), p. 358.

and society as a whole, overcome the scandal of the human condi-
tion. This integration of forces was a prerequisite to the human
unity with nature and what the hermeticists had called the *coni-
unctio oppositorium.* Through unity with woman, man had a pre-
monition of the ultimate fulfillment in the union with nature. This is
another way of saying that the inward vision is a void if it does not
illuminate the journey toward the *other* and the plenitude immanent
therein. This is the meaning of "the primordial Androgyne" whom
Breton evokes in 1953 in retrospect.[2]

Reiterated in more philosophic terms by Herbert Marcuse: "The
imaginary is an instrument of knowledge insofar as it contains the
truth of the Great Refusal, or envisaged in a more positive manner,
insofar as it protects, against total reasonableness, human aspi-
rations toward the integral complementing of man and nature, aspi-
rations which are inhibited by the function of reasoning."[3]

Subjects that preoccupy thinkers throughout the ages can be
invoked by succeeding generations for different reasons. At present
these recurring issues have taken on different meanings, high-
lighting pure rationalism rather than the encouragement of the
powers of the imagination. But if the revival of interest in precepts
integral to surrealism does not necessarily recharge interest *in*
surrealism, there are other propitious factors present to promote
broader understanding of surrealism today than at the time of the
second edition of this work in 1970.

More surrealist writings are available today in new and affordable
editions: no serious critic need any longer leaf through yellowed
editions to get to these writings, or to do the kind of informative
criticism that marked my own pioneering historical approach to
scholarship in the field. After the students' revolution in France in
1967, the French University system accepted, among its curricular
innovations, the legitimacy of surrealist studies, and a center for
the study of surrealism was established under the general research
conclave of the *Centre National de Recherche Scientifique.* Within
this structure, assiduous university scholars such as Henri Béhar,
José Pierre, Marie-Claire Dumas, Jacqueline Chénieux, José Vo-

2 *Ibid.*, p. 360.
3 *Eros and Civilization* (Boston: Beacon Press, 1955), pp. 142–43.

velle and their associates, grouped as the team of *Champs des activités surréalistes* in conjunction with surviving surrealists such as Jacques Baron and Philippe Soupault, have not only restored to print the wayward writings of surrealists but collected tracts in book form, and valuable journals from 1919 to the 1930s, important platforms of surrealist thought which had become rare and tattered have been reprinted.

New journals, *Mélusine* in Paris, *Dada/Surrealism* in the United States, now bring us the latest scholarship in the field both in French and English, updated regularly. They provide outlets for the many university researchers on both sides of the Atlantic who have centered their attention on surrealism although unfortunately these scholars often fail to refer to each other's work in the same field. Within the last decade, the bibliography of surrealism has become enormous. Most of the production is illuminating, if fragmental, with emphasis on linguistic structure or specific paradigms rather than on the philosophical depth of surrealism. There have been, however, some works of synthesis among which are Dumas' work on Desnos, Chenieux' on the surrealist novel, J. H. Matthews's on surrealist theater, José Vovelle's interdisciplinary work on surrealist painting and writing, Matthews's and Mary Ann Caws's writings on surrealist poetry, my own critical biography of André Breton, and Marguerite Bonnet's subsequent study of his early years. Noteworthy among reconstitutions are the collected works of Tzara by Béhar, the Pauvert edition of René Crevel's complete writings—which for a long time had been completely out of circulation—and the first publication of the poetry of Jehan Mayoux.

Surrealist writings offer many opportunities for psychoanalytic study, but sometimes those engaged in such activity overlook the distinction between a mental case history and the creative process whereby a poet is born.

On the whole, as one of the initiators of surrealist scholarship, I should be rejoicing at the momentum with which critical attention is bolstering surrealism as a living literary issue at the end of the twentieth century. There is no doubt that the scholarly, archival, and even controversial care surrealism is getting is evidence of its power to survive successive and changing modes of writing and critical tastes.

But there is here a mixed blessing. Among the problematics of current interest are several dangers. Instead of a clarification of the distinctions between Dada and surrealism, I note more and more assumption of their common identity, and studies included under the joint rubric tend increasingly to favor Dada over surrealism. Dada demolitionists are cool players with language and, therefore, closer to the spirit of deconstruction prevalent among today's critics. Surrealism was not cool; it was a hot, ebullient struggle with the ascending sign. Dada advocated the abolition of all literary schools and traditions, whereas, from the first and most intense moment of his revolt, Breton felt that he belonged to the lineage of the great rebels of the past: the hermeticists, the religious heretics, and certain literary moralists.[4]

Another disturbing trend, hostile to the spirit of surrealism, is the increasing belief in relativistic philosophies as they apply to the arts in keeping with revised interpretations of the universe. It becomes a dreary prospect for one to stand behind a notion such as "The Road to the Absolute" in an age which applies the concept of relativism to spiritual and aesthetic values. Indeed, Dada believed in the theory that any utterance was as valid as any other in accordance with its expressed intention to demolish the notion of literariness. But significantly, when Dada pamphleteers such as Tzara and Hugo Ball turned to poetry, they made magnificent use of the kind of literary elements that have received universal recognition over the ages.

Even more apparent is the discrepancy between experimental or bravura writing on the part of the surrealists, and concessions to literature manifested in their formal works. Automatic writing was *exercise*, eventually used as a resource or pool for the writing of poetry. Speaking of automatic writing in retrospect, Breton observed that it involved "no dismemberment of syntax nor disintegration of vocabulary." He went on to say that its purpose was to lay a hand on the *primary substance* of language. "After that we knew where to stop and it goes without saying that there was no point in reproducing it to a point of satiation; these remarks are

[4] See Balakian, "Dada-surrealism: Fundamental differences," *Surrealism to the Absurd* (Lubbock: Texas Tech Press, Proceedings of Symposium, 1970).

intended for those who are astonished that among us the practice of automatic writing was so quickly abandoned."[5]

The distinction between surrealist text and surrealist poetry was made obvious in the surrealist magazines by the marginal place given to the former in the layouts of the page. There is a danger of associating the current defense of "trivial" literature with the acceptability of Dada and surrealist fragments. If such texts have a documentary value, the quality of *lasting* works belies both Dada and surrealist theories as well as those of modern relativist supporters of popular literature. And current philosophers may well note extensive resignation to man's relative unimportance in the universe, which makes the notion of "absolute" vision appear derisive and anachronistic; in that context the surrealist quest may seem naive in its revised perception of the sacred and the sublime, which is basic to the surrealist aspiration and the definition of the poet. But it must be remembered that Breton and his colleagues, most of them scientifically trained, and virtually all agnostics vis-à-vis established religions, had an acute sense of the mountain peak, i.e. the progressive and ultimate grasp of the total experience of existence: "the exceptional intensity of man before the spectacle of life" as Breton expressed it. Poetic truth was conceived as a gradation with a supreme point, unattainable but conceivable nonetheless. The apparatus of sensory coordination toward that absolute goal was the catalytic power of poetry.

Finally, there is a fundamental danger in the application of modern critical methodologies in surrealist studies: if the psychic apparatus gets overlooked, surrealist works can become mere pastures for the analytic grazing of language; indeed, the words may be observed as the fulfillment of the potential of language rather than as the servant and medium of poetic illumination. Such accumulation of interest in surrealism for reasons outside of the surrealist poetics could presage the deconstruction of the surrealist movement. In that case, surrealist writing would attract attention in proportion to the opportunity it provided for such manipulations. The strong interest in Raymond Roussel who, without ever having been a surrealist, is constantly being brought under the label by an

5 Breton, op. cit., p. 357

ever increasing number of admirers of his linguistic exploits, is a
perfect example of the *linguistic* measure of literary merit.

In contrast, the primary objective of surrealist studies should
inevitably lie in the direction of the sorting out of works on a
judgemental basis. If as an early scholar in the field I often had to
assume the tone of apologia of what I had discovered, it was be-
cause I was among the first to speak of certain poets at a time when
no one was writing about Lautréamont on this side of the ocean and
no one cared about Saint-Pol-Roux or Pierre Reverdy on either side
of the ocean. I had read *Igitur* in folio and commented on it when no
one else was referring to that cryptic and avant-garde work of
Mallarmé in the context of its relevance to the surrealists, and I had
to read Apollinaire in the Rare Book Room of the Columbia Univer-
sity Library and write about him with trepidation. I felt like the
preserver of a universal rather than simply a French heritage which
was being passed over in the face of more pedestrian literary fads.
At such a time one had to be on the defensive and opt for surrealism
and its sources as if it were a package deal.

Now that there is too much rather than too little tolerance of
"avant-garde," it is no longer a question of either/or. There are
enough—perhaps too many—people convinced that surrealist liter-
ature and art are important phenomena, significant sign posts in the
cultural heritage of the Western world. The need, then, is to dis-
criminate between good and bad surrealism, and to separate the
chaff from the wheat, in the manner in which literary historians and
critics have regularly dealt with artistic movements of the past.
There is some very bad writing that is passing for "surrealist" work,
just as there are some obnoxious paintings usurping space on mu-
seum walls under the guise of surrealist art.

Happily, other forces counteract the pitfalls I have mentioned.
Since writing my previous introduction I have discovered the fertile
field of surrealist poetic growth in the countries of Latin America
where the philosophy of surrealism, particularly its arachnean tra-
dition, is crystallized in poetic imagery rather that in technical
devices of simple wordplay and collage. The rising star of Octavio
Paz owes much to the fact that surrealism has found in him perhaps
its sturdiest heir; "Liberty of the Word that gives you its liberty,"
says Paz, and in works such as *Piedra de sol* images of fire, earth,

air, and water convey the same inviolate sense of the totality of life and solidarity of all natural phenomena as in Breton's work. Like his predecessor, Paz forges ahead in the labyrinth in search of phosphorescence. He looks for the sacred in signs and numbers. He shares Breton's need to create exaltation and to provoke vision and vertigo. In time others in this galaxy will be recognized as they emerge from behind the burlap curtain of translation. Enrique Gomez-Correa, Enrique Molina, Ludwig Zeller, Aldo Pellegrini, Rosamel del Valle, Humberto Diaz Casanueva, and a number of others are part of the universal spectrum of surrealism. They have been particularly drawn to Breton's monistic embrace of the metamorphic circuit of creation, the sacred and the mysterious, captured in beings and things having no meaning unless given one by the poet or artist.

In my previous introduction, I deplored surrealism's lack of serious impact on American poetry. The era was more conducive to Dada than to surrealism. Is there room for surrealism in the reign of rationalism? The overwhelming routines of contemporary life and the homogeneity of culture that is developing rapidly may be sufficient ground to proscribe surrealism. Need and demand do not necessarily coincide in the history of ideas. If signs can predict phenomena, however, the direction taken recently by a leading writer associated with protest and direct discourse should be scrutinized. Allen Ginsberg's dream sequence, called *White Shroud* (1985), demonstrates a transformation of style proceeding from the level of dream description to one which conveys the dream state. His dream of his mother, as it vacillates between verifiable detail and dream mutation is reminiscent of the experiments of the surrealists. It follows a nontransitional structure that draws the reader into the kind of psychic empathy achieved in the best of surrealist poetry of decades ago. It is synchronous perception, multilevel construction that conjures an apparition of the physiological as well as the spiritual identification of the mother. Like Apollinaire before him, Ginsberg demonstrates a mnemonic process generated by an ambulatory perusal of place associations and their power to reshuffle images and events. So, the poem, descriptive and seemingly direct in discourse, conveys familiar experiences which are trans-

formed by stealing from each other their meanings, and creating strangeness in the commonplace by the forces of juxtaposition and contamination. The curb from "the Dead to living Poesy" connects points of subconscious longing for what is irretrievable with overtones of affirmations about life; the pattern demonstrates the basic conciliation of opposites at the core of the surrealist poetics. This is a curious change in Ginsberg. Whereas many of the French surrealists went from early cryptic, involuted discourse toward a more standard form of direct expression in the course of their development—as in the notable cases of Aragon and Eluard—Ginsberg seems to have taken the opposite direction, proceeding from his earlier, direct poetry of protest to the interweaving of dream and reality, and to more subtle devices whereby to express regret, nostalgia, longing for the ephemeral qualities both of presence and absence in this new phase of his poetry.

New American poets are unabashedly calling themselves "surrealist" and take—and sometimes mistake—the cult of incongruous imagery as proof of their rejection of obvious forms of reality. Russell Edson's prose poems are characterized as "genuine surrealism that seems to have no limits," according to the blurb on the book jacket of *The Intuitive Journey*.[6] He carries the humor of unexpected collisions of images to a level reminiscent of Benjamin Péret. He specializes in the shock technique of the displacement of words, of the obliteration of time. He also has a sense of his identification with nature: "I should love to photosynthesize in one leaf lost at the top of a tree . . . I do not call this dying, but metamorphosis."[7]

Most significantly, Edward B. Germain published in 1978 an anthology called *English and American Surrealist Poetry*, in which many of the poems are tanslations or manipulations of French- and Spanish-language surrealists by the distinguished American and English poets, Robert Bly and David Gascoyne respectively. Ted Berrigan's paraphrase of a section of Rimbaud's "Bateau ivre" demonstrates superb empathy between the French poet and his transformer, while George Melly's "Homage to René Magritte"

[6] *The Intuitive Journey and Other Works* (New York: Harper & Row, 1976).
[7] *Ibid.*, p. 69.

makes one realize that American poets have been closer to surrealist art than surrealist poetry. In James Tate's "The Blue Booby" we note that the passage from one image to the other is provocative of astonishment but does not contain the cryptic syntax necessary to evoke multiple tiers of meaning. Mark Strand's "The Man in the Tree" takes as its model the graphic quality of surrealist figurative art rather than of the poetic techinique of "one in the other" images, and John Digby's poems are stunning word collages corresponding to his quizzical art renditions marked by the rebus technique we miss in the Americans included in the anthology, and which we have come to recognize more and more as the primary signet of surrealist poetry.

As in most modern American poetry, the neo-surrealist poems are self-referential, devoid of the mythological reference-system that lends so often that quality of polyvalence to French poetry. The alchemic inner lining of surrealism that gives it a credo beyond the literary is not yet part of the poetics of those who represent the American or English versions. Actually, Edward B. Germain's definition and sense of surrealism is closer to pristine surrealist writing than many of the poems he has collected under that label. When he concludes that "the spirit of surrealism has become the spirit of modern poetry," it could perhaps be said that the statement portends rather than confirms such a trend.

Current American Poetry seems to be to surrealism what imagism was to symbolism: the emphasis on the achieved image rather than on the process of its achievement. Nor are the consequences of the juxtaposition of random encounters of words questioned and piloted toward the high voltage of illumination which was the goal of the surrealist adventure, a goal constantly gauged, rarely attained.

The American spirit still considers the capture of prizes more significant than the intricacies of the quest. That is in the nature of a new, vigorous country whose priority is to shape its traditions rather than to reinterpret or reassert them. The shadow of the great builder, Walt Whitman, is still the strongest force behind the American poet. I say this not in criticism but as an observation of fact. The case is somewhat different for the Latin Americans whose class structure directed the writers from literate backgrounds back to the European culture of their derivation, and with the manage-

able translations between cognate languages there was no time or distance lag to poetic integration with the source of inspiration.

But if in spite of cultural barriers, American poets have turned toward surrealism in the past decades, it must be remembered that there was a catalyzing force here analogous to the impact of World War I on the original group of surrealists gathered in Paris. The Viëtnam war provided much of the provocation of the shock imagery in recent American poetry labeled "surrealist." Bill Knott's "(End) of Summer (1966)" is a case in point:

> *I'm tired of murdering children.*
> *Once, long ago today, they wanted to live;*
> *now I feel Vietnam is the place*
> *where rigor mortis is beginning to set in upon me.*
>
> *I force silence down the throats of mutes,*
> *down the throats of mating-cries of animals who*
> *know they are extinct.*
>
> *The chameleon's death-soliloquy is your voice's pulse;*
> *your scorched forehead a constellation's suicide-note . . .*

Whether such poets will find a way to express the protest in less circumstantial ways but with the same impact is yet to be seen.

Multimedia artists are also moving toward surrealism. Such is the case of the late Nahum Tschacbasov who surprised his art followers by collecting at age eighty-two his poetry, in which some of the basic resources of surrealism are ingrained: its power through the word or painterly line to conciliate opposites, to grope toward a sense of unity between human form and movement and those of what we call "nature" from the bowels of the earth to the constellations. He senses a striking analogy between the earth's layers, bottoms of oceans, vortex and geysers, underground fossils and the substrata of the human mind. Thereby, the notion of the subconscious becomes a matter of shading rather than an antipodal alternative to the conscious state. Most of all Tschacbasov retained from his early surrealist experience in Paris the resourcefulness latent in the layered mind: "the sea shallow in comparison with the mind."[8]

[8] "The Sea now Dying," from *Machinery of Fright* (Southampton College Press, 1982).

In an age of acute technology, when automatic writing means something entirely new under the jurisdiction of the computer, there is yet an evident thirst for the poetic. Sophisticated intellectuals may appraise this book as "introductory" in its simple, direct style of communication of cryptic messages concerned with desire, rebellion, verbal dynamics—powers which were rallied in the young stages of the twentieth century to combat negation, apathy, and the mechanical enrolling of the spool of life. But I shall hope that it may catalyze undercurrents of longing in young readers, so many of whom aspire to be poets if not overtly at least secretly and under cover. If Apollinaire in his "The New Spirit and the Poet" proclaimed in 1918 that one can be a poet in any field of endeavour, we have a verification of that statement in the resurgence of poetry as the ultimate fulfillment of the human condition whether it manifests itself before a word processor or in space, in a laboratory, with a chisel, a scalpel, or a ball point pen. The surrealist phenomenon had no precedence in literary history but it is having unrelenting repercussions all over the world on the level where all the inequities of fortune cease to matter under the aegis of the imagination.

<div align="right">ANNA BALAKIAN</div>

Old Westbury, N.Y., 1986

introduction

In the ten years that have elapsed between the first printing of this book and the current, enlarged edition, the notion of "The Road to the Absolute" has taken on an increased and more immediate meaning. It becomes relevant to a field of speculation which is henceforth bound to become more and more important: the philosophy of science. Ernest Renan, who in the nineteenth century was one of the first to suggest the structuring of philosophical thought on scientific knowledge, had spoken of the "infini réel" as opposed to a religious infinite, and Aragon had said in the 1920's, in his surrealist period, that the only inconceivable notion was that of physical limit. At the same moment, André Breton, the founder of the surrealist movement, had stated in his *Discours sur le Peu de Réalité* that "the imaginary is what

tends to become real." The objective of surrealism was the infinite expansion of reality as a substitute for the previously accepted dichotomy between the real and the imaginary. Acknowledging the human need for metaphysical release, the surrealists believed that through the exploration of the psyche, through the cultivation of the miracles of objective chance, through the *mystique* of eroticism, through the diverting of objects from their familiar functions or surroundings, through a more cosmic perspective of life on this earth, and finally through the alchemy of language that would learn to express this more dynamic reality, man might be able to satisfy his thirst for the absolute within the confines of his counted number of heartbeats.

Before the surrealists, Guillaume Apollinaire had exhorted the artist to keep up with the scientist, if he could no longer be ahead of him in transforming reality, in enlarging its scope. The surrealists took up the challenge of Apollinaire as they identified with the earlier aspirations of Rimbaud: to "change life" and to put the emphasis in art not on the expression or representation of set norms of reality but on invention and creativity, deeming art not an end toward the attainment of which the life of the artist plays a functional role, but a means to a fuller fulfillment of that life itself. The surrealists, unlike the futurists and in that respect unlike Apollinaire himself, were not entranced by the products of modern technology,—what Breton deemed an empty notion of *progress* and disdainfully called "modern comfort,"—but by the process of creative thought that produced these objects and could liberate man from his limited environment, to which a limited logic confined him. For the surrealists the notion of "poet" encompassed all creative activity within the scope of human endeavor; and the advances of science were, particularly for a number of surrealists whose academic training had had a large scientific base, a rich source of material for the arts.

There is perhaps nothing as emblematic of the surrealist aspiration to change man's perspective of reality as the title of André Breton's first collection of poems, *Clair de Terre*. As we see

today the reality of this imagined "earthshine" displayed in the four corners of the world, we must remember that after almost half a century science has caught up with Breton's verbal vision of the earth in cosmic perspective.

When I wrote this book about the makers of surrealism in the 1950's, I stated that the surrealist influence in American literature had been negligible until then. On the eve of World War II the original group of surrealists in Paris had disbanded, for many of them, artists as well as writers, hostile to the fascist invaders of France, had sought voluntary exile in other countries, primarily in America; a number of them were to remain here permanently. When André Breton returned to Paris in 1946, the literary climate was entirely different, permeated with the somber and stoical philosophy of existentialism, whose influence was felt much more quickly, borne overseas at the same time as our returning armies. In the 1940's and 1950's surrealist writings were almost all out of print and most remained untranslated until the last years of the 1960's. André Breton's activities after World War II were generally confined to the direction of art exhibits and to social protest, in which he had the collaboration, through a series of pamphlets and little magazines, of a new group of surrealists sprung from a younger generation.

When in the first edition of this book I suggested that surrealism had not made an impact on American literature, several American contemporaries of the surrealists of the 1930's expressed dismay. Had there not been *Transition* and *View* magazines, the writings of Charles Henri Ford, Kenneth Rexroth, Philip Lamantilia, Edouard Roditi, Arthur Cravan, the art of Man Ray, and of many others who had empathy with the surrealists in Paris? Matthew Josephson has indeed documented the relationship of American writers and artists with the surrealist group in his book of memoirs, *Life among the Surrealists*. But this initial contact can be compared, in an earlier period, with the relationship that English writers like Arthur Symons, George Moore, and Edmund Gosse had had with the symbolist *cénacle* of

Mallarmé. Some of these surrealist-oriented Americans had breathed the same air and rubbed elbows with the surrealist group in Paris, but *as observers,* conveying to a small circle in their own country the broad lines of activity of the new "avant-garde." Others, like Man Ray, had become surrealist as expatriates, just as the Alsatian Hans Arp became Jean Arp, and the German Max Ernst joined his French friends in Paris, and thus contributed to the Paris group in the same way that Stuart Merrill and Vielé-Griffin had become French symbolists in a previous literary period.

In a recent conversation Charles Henri Ford admitted to me that although he was in spirit close to the surrealists, he never intended to make of his magazine *View* a totally surrealist periodical such as were *La Révolution Surréaliste* or *Le Surréalisme au Service de la Révolution.* That the general poetry-reading and art-conscious public in America never embraced surrealism can be seen by checking the book reviews of surrealist writing or the critiques of art exhibitions in the 1930's and 1940's, which possess a tone either of paternalistic indulgence or benign mockery; the Americans were struck above all by the exhibitionist elements of surrealism, particularly as these were more and more displayed in the paintings and personal demeanor of Salvador Dali.

A second edition of a work gives one a gratifying opportunity to clarify what might have been expressed too succinctly. When I said that the surrealist impact was not apparent in America, I was thinking of that type of influence—not imitation—which, in the case of the symbolist movement, one can discern in the poetry of Yeats, Stevens, Rilke, Jiménez, etc., i.e., a transplantation and metamorphosis, a germination of the seminal concept on another soil, in another climate. Such had been the miracle by which Symbolism (with a capital S) was evolved into a symbolist technique and *mystique* that spread all over the literary world of the early years of the twentieth century. Even in the late 1950's I could not discern a similar trend for surrealism in America.

I am not alone in this judgment. In an article in *Poetry* magazine in March, 1960, entitled "Surrealism in 1960," Wallace Fowlie stated: "After a lapse of twenty years, the direct influence of surrealism in most countries appears slight. In England for example, it has been almost negligible. In America there are more traces of its effects. But, all in all, when the accounting is made, surrealism is essentially French." (p. 365) In a much more recent statement in *The Novel of the Future*, Anaïs Nin confirms my impression and Fowlie's: "When I lectured in the fifties I had the feeling that the students had no reflexes." (p. 73) And going back to the period of the 1940's, which should have been the appropriate moment of dissemination, chronologically speaking, she found that surrealism was "an unpopular term" and a misunderstood one. She concludes that "there is no purely surrealist writer, but there are writers who use surrealism to convey a flight from naturalism." (p. 35) As a reactionary manifestation rather than in the spirit of a new aesthetics or way of life, Anaïs Nin sees this antinaturalism primarily in the novels of American writers like Nathanael West, John Hawkes, Henry Miller, and Djuna Barnes, and she is silent about the American poets. The explanation that she gives for the lack of surrealist impact in America is that "the climate of the forties was insular, provincial, antipoetic, and anti-European." (p. 1) She expresses further disappointment that when the young did rebel against the repression of imagination and against the prevalence of "standardization achieved by commercial interests, the regimentation which had reached a point of absolute monotony" (p. 12) they "turned to the magic of electric effects. It comes from a machine, not from within, but expresses a need for magic and freedom from steel and concrete." (p. 33) In other words, what latter-day surrealist tendencies had been proclaimed in America, in terms of the psychedelic, Anaïs Nin considers symptomatic of an attrition rather than creatively significant.

Let us examine the conditions behind the facts on which Fowlie's and Anaïs Nin's opinions concur. Revolutions occur

where constrictions are severe. By the beginning of the twentieth century the character of English had greatly developed from its usage in the eighteenth century, whereas French conceptual writing still more or less used the idiom of Voltaire. A sentence from one of André Breton's surrealist manifestoes could easily be equated with one of Diderot's. But because of the very nature of this rigidity and immutability of fixed verbal associations, indissoluble in their hopelessly sterile marriages, the poet in Breton had protested and unleashed a revolution in language just as Mallarmé did years earlier. A linguistic crisis, prepared by a century of subversive activity in this field by the poets of France, such as had exploded with the conclave of the surrealists, had not occurred in English, and if James Joyce and Gertrude Stein had staged individual protests, they had not had many adherents; there certainly had not been any group activity in that direction.

More flexible than French at the start of the twentieth century, English had faltered in its linguistic liberalism, whereas French had been transformed from a narrow, inflexible, poetic medium of impoverished rhyme schemes into a kaleidoscopic, analogically oriented language, capable of conveying multidimensional meaning and a new spectrum of sensual experience. The "horrible workers" in this field, envisaged by Rimbaud, had indeed done their work. Thus, ironically, the English language, originally better predisposed for surrealist communication, was, in the era of French surrealism, not prepared for surrealist writing.

Nor was the time spiritually ripe. In a country like France where Catholicism had channeled most of the forces of spirituality, where heresies such as that of the Cathares had been radically destroyed, agnosticism had come early and brutally, and its impact on the spirit of the artist had been of long enough duration to prove Pascal's wager that total nihilism perpetrates its own vengeance on the mind. The spiritual pendulum had had time to swing fully back and persuade the artist that an awareness of the abyss and of the mortality of man was as frustrating as a

vain aspiration to immaterial paradises. So there evolved a new type of mysticism, whose seeds were sown long before the advent of surrealism, but which came to crystallization with the metaphysics of surrealism: that the transformation of life, the expansion of vision, could be experienced and expressed in terms of the *here and now*, in the confines of our material existence and in relation to the physical reality of which we are a part. What makes surrealism unique in the history of literature is that there is in its credo a convergence of the crisis of language with a revision of the notion of spirituality itself. In Anglo-Saxon countries, where religion had gradually become more permissive in its practice and had put its emphasis on the social and moral manifestations of the Christian dogma rather than on metaphysical transcendence, the quarrel with religion came much later and the devastating effects of a radical agnosticism, particularly as it concerns the artist, had not been as openly manifest, or the need, as a consequence, of a rechanneling rather than an annihilation of mysticism.

Perhaps the most direct point of contact between surrealism and American literature after World War II has been the character of social protest inherent and explicit in surrealist manifestoes from the very beginning. Early in their life as a collective group of artists, the surrealists had a controversy concerning the character of social protest, and those most closely allied with Breton rejected those for whom social protest could become an end in itself and for whom communism could accomplish the liberation of humanity without an assist from the surrealists. Breton's adherence to the Communist Party had been very short-lived and it had been his conviction, often expressed in his prose writings, that man's lot on earth cannot be transformed merely by social legislation if the habits of mental regimentation were not broken as well. The "nonslavery to life" which he proclaimed in *L'Amour Fou* was only partly economic and mostly spiritual in character. More serious still, as a misunderstanding of surrealist

objectives, was the writing of circumstantial works containing direct communication of social protest, relevant to precise abuses and particular conditions. Protest was to create a climate for vigorous, convulsive writing and intense living, but was not synonymous with literary militancy. A surrealist had empathy with the victims of all kinds of enslavement but committed himself wholly to no particular program for the political or social liberation of slaves. Above all, Breton unwittingly agreed with T. S. Eliot (with whose writing his had not the least connection), that the emissions of philosophical or social concepts did not constitute poetry in themselves, no matter how expertly versified, if they were not modified by the poetic metaphor: i.e., through the image in Eliot's case, through the process of alchemic analogy in Breton's.

In this context, the "beat generation" of the immediate postwar period in its protest against the mores and social conditions of bourgeois society, communicated by a rather direct and logically explicit idiom, has the sense of surrealist protest and even of adventure. Kerouac's *On the Road* surely is reminiscent of Breton's *Partez sur les Routes,* but lacks its broader *mystique* of rebellion and its analogical language. Ideas are at the core of the poetry of Allen Ginsberg, and the avalanche of images that clothe them are vivid, concrete, often superbly ingenious, crowding each other out, but these images are not ambivalent, not multidimensional. The problems are specific and the communication hits its target right on the nose but is not elliptically provocative. Much of the poetry of the 1940's and of the 1950's in America, even if it has rid itself of the narcissistic, ascetic rarefactions of symbolist imagery, and even if it has abandoned the monotonous coupling of the abstract and the concrete, as inspired by T. S. Eliot and the American Imagists, has not thereby become surrealist. American poets of the last two generations have been, on the whole, following rather in the footsteps of Walt Whitman, using starkly concrete imagery, descriptive rather than evocative in the manner of surrealist poetry. Strangely enough, Whitman's

form is preserved even when the tone is so alien to Whitman, as when Claire Livingston cries: "I hear America burning."

On the other hand, a number of distinguished poets such as Robert Lowell and John Ashbery have become humanists in free verse; the very rationality of their communication suggests that they could have given their thoughts just as vividly in essay-meditation. For instance, one brief example is Ashbery's "The Picture of Little J. A. in a Prospect of Flower":

> *For as change is horror*
> *Virtue is really stubbornness*
> *and only in the light of lost worlds*
> *can we imagine our rewards*

Even when it is not abstract, much of the writing of these poets is descriptive or narrative, and its vistas, if large and varied, have the ubiquity of modern tourism.

The alchemic incorporation or embodiment of concepts into images simply does not occur. On the other hand, where there is no ideological message imparted or no cumulative image constructed, we often find the fragmental type of word-image units, such as Hayden Carruth's "Journey to a Known Place," reminiscent of the pre-Surrealism of Pierre Reverdy; or there are the calligrammatic effects, or poem-conversations, reminiscent of Guillaume Apollinaire, displaying graphic freedom rather than verbal bewitchment.

What is most often absent from American poetry, even of very recent vintage, is true automatic writing; although there is a lot of collage there is no evidence of that free association of words that produces sudden and psychically revealing images. Nor have I seen, in examining volumes of *New Directions, Ambit, Monk's Pond, Extension,* and other collections, the exploration of the *mystique* of chance encounter, of the poet's tingling sense of being terribly alive, with an open-ended disposition of the nerves. Eroticism, as it illuminates the nature of desire—which the sur-

realists explored with scientific relentlessness and meticulous observations as an avenue of physiomystical experience and revelation—is, in American poetry, more apt to fall into obvious precision and a posteriori description of sexual experience, not with the "one and only" love as was the case with the surrealists, but much more often with multiple loves in promiscuous or libertine fashion, until in Martin Bax's "The Turned-in, Broken-up and Gone World" you have a four-to-one relationship.

Finally, the mood of recent American poetry appears too often to be chillingly despondent in sharp contrast to the joyful sense of being that was at the core of surrealist poetry. W. D. Snodgrass tells us in "Heart's Needle":

> *The window's turning white*
> *The world moves like a diseased heart*
> *packed with ice and snow*

The heightened excitement with which one awaits a human moon landing was inherent in much that the surrealist in his aleatory movements through the streets of Paris experienced or that he predicated in his manifestoes. But Snodgrass, who has power over words, chooses in "Heart's Needle" to walk among cancerous growths and malignancies.

Apollinaire had said in his preface to *Les Mamelles de Tirésias* that henceforth the artist, instead of facing the problems of any particular society, must confront the universe itself. This cosmic or, as Mallarmé had called it, "orphic" concern does not yet seem manifest in the poetry of our time. An instance is James Dickey's poem "Falling," based on an actual tragic accident where a stewardess was hurled from a plane into the void. Here the poet had a magnificent opportunity to convey the convulsed, terrified psyche of this victim of irrational chance; instead, her thoughts are rationally set forth, her images are those of an acrobat.

In general, I find little of the dream-phantasmagoria of surreal-

ist writing. Dreams are designated and stated, not simulated or given that sense of immediacy one sometimes finds in Eluard, Breton, or Michaux. These comments should not be construed as a criticism of modern American poetry, vivid and powerful at its best in other than metaphysical dimensions, and often even possessing some of the cold and brilliant intellect of a Marcel Duchamp. But my observations and references support the impression that the American poet of the last two or three decades has neither imitated surrealist writing nor appropriated its spirit of cosmic adventure, whose most significant crystallization Breton had projected into the future.

If the pulse of American poetry has changed at all, it has done so since Vietnam. What World War I meant to the surrealists in terms of spiritual upheaval and rebellion was not felt, except in isolated instances, in America either in World War I or World War II, not even in the Korean War. The virulent reaction to the total futility of violence and the rejection of the society that allowed war produced in Europe the spirit of Dada during World War I. This spirit is much more evident in America now than that of surrealism. It is after destruction that renovation generally comes, and it is destruction that the young are cultivating as they repudiate all that their elders stand for. Will they also repudiate the language of that society based on logic? Will they create a new language?

The new forms of communication seem to derive more from the cinema and the theatre than from poetry. According to Michael Kirby, the author of *Happenings*, the translation of Artaud's *The Theater and Its Double* had much to do with its breakdown of theatrical concepts and the orientation toward a new theatre; in the Happening, he thinks, the collective concept of art-communication goes beyond the Dada-type collage to surrealist juxtaposition, the blending of animate and inanimate in a more total comprehension of the unity of the universe, and in the interplay of psychic automatism, manifest in a spontaneity of action and in

dream simulation. For this he gives much of the credit to Claes Oldenburg. It is indeed obvious that the Happening is a very lively illustration of the cult of objective chance, which the surrealists called "the divine hazard." Perhaps, as Guillaume Apollinaire prophesied in *L'Esprit Nouveau et les Poètes,* the realm of the future poet will indeed be in the cinema (and in the theatre playing a mobile role like that of the cinema), as the screen (and any viewed space) replaces the white page and becomes a more propitious meeting ground of inscape and landscape, of physical action and psychic energy, of associations of distant realities, as a more believable transformer of time and place, as, for example, was evident in the renewed emblem of the philosopher's stone in the film *2001: A Space Odyssey.*

But are there surrealistic tremors in the most recent poetry as well? Dada and surrealism have often been thought to be in a mother-and-child relationship. But they are better viewed as cousins—once removed—both deriving from a common matrix of discontent in a declining culture. The surrealists in France passed through a dadaistic phase, which was as short-lived as it was flamboyant. Is the young poet in America ready to pass from Dada to surrealism? Poets like Michael Benedikt, Ronald Gross, and Marvin Cohen are looking for new fluidity of language. Gross's so-called *Found Poetry,* although sometimes too obvious, often brings us into the full impact of the daily miracle of the street. The cult of the concrete, evident for some past years, is perhaps, at last being oriented toward a transformation of the function of the object rather than remaining confined to static representation.

In Marvin Cohen one senses the metaphysical thirst, as he questions the notion of reality, as he distorts the accepted relationship of time and death, as he approaches dark subjects with the good-natured humor reminiscent of Benjamin Péret, and particularly as he demonstrates his extraordinary power over words and word associations that break down the expected ones.

It implies a running over from print to life. What the book contains isn't narrowly confined within the book, but overlaps into the stock and vigor of our brawling, sprawling atmosphere here. . . .

Ought I to read a book that restlessly slides out of print into massive life?
"HOUNDED BY AN AUTHOR INTO A SECOND SECURITY"

Me, I'm the measure of the world, by passing it through my dreams.
"THE WORLD IS ALL CLUTTERED WITH OBJECTS"

One should note that he no longer feels the need for even a semblance of verse to express his sense of poetry.

As one samples the most surrealistically oriented writings, gathered by Michael Benedikt in *Chelsea 22/23,* and in other little magazines such as *Extension,* and a number of recent anthologies of new verse, one can spot what might be called poem-heralds, such as was Apollinaire's "Les Collines": i.e., which do not contain in themselves surrealist vistas, but suggest surrealist motivation and sources. Such are Robert Bly's "How Beautiful the Shiny Turtle," with its suggestion of the discovery of new eyes, his intimation in "Awakening" of the rising not of the dead but of the living:

The living awakened at last like the dead

the sense of sensual joy replacing more prevalent poetic postures of weariness and despondency, as in "Poem in Three Parts":

I am wrapped in my joyful flesh
As the grass is wrapped in its clouds of green

This kind of invitation to surrealism is evident also in the situation of the impossible visions suggested but left verbally undeveloped by Charles Simic in "Thrush":

> *This morning*
> *I heard the sound*
> *Of all my unborn children*
> *Joined into one*

or in "Poem":

> *The flies go to bless the spiders.*
> *The bats are preparing for the Mass.*
> *With its necklace of moths*
> *The northern star rides the sky.*
>
> *This is the hour in which I want to*
> *Travel through bodies of sleeping children*
> *Extracting something infinitely small,*
> *Like that single grain of sand*
> *The sea has lost to the land,*
> *And for which, now, at night,*
> *The waves are searching*
> *To carry it back into the sea*

How one could wish that he would go on at the pitch he has set in
"Dream-tree":

> *I have dreamed of a strange tree*
> *Where poppies and apples grow together*

Or when he slides for a moment inside of a stone in "Stone"!
And, Joyce Carol Oates's "Foetal Song" shares briefly the sur-
realist concept of prenatal memories.

Michael Benedikt's eye is flexible and sometimes approaches
the range Breton had in mind when he said "L'oeil existe à l'état
sauvage." Benedikt echoes: "The eye of the realist is inflatable"
in "Motions after Man Ray," using the word "realist" in a brand
new context. He gives examples of this in "A Beloved Head," and
in "Events by Moonlight."

A recent and provocative book by Ross Parmenter, entitled
The Awakened Eye, reminds one of Paul Nougé's *Images Defén-
dues*. Parmenter demonstrates modern man's inability to contem-

plate with total attention the objects of his environment and illustrates in how many ways the average man engulfs himself in self-determined blindness. It is to be noted, in contrast, that the new American poets have learned in the wake of Whitman, and under the influence of Neruda, Lorca, and Francis Ponge, to be more aware of their environment, and they state in their poetry this awareness of the power of sight; but the next step, the surrealist one, is to *give* sight or provoke it. "Donner à voir," said Eluard, "faire voir" said Breton. In a recent letter to me Benedikt senses this and observes that the new poets, in effect, seem to be "more influenced by Spanish than French surrealism," and he remembers back in 1963 a dispute with some of his colleagues over the relative merits of Lorca and Apollinaire and "everyone but me approved of Lorca over poor Apollinaire." Actually, if the tendency is toward Neruda and Lorca, it may be that they use the kind of language, direct and simple in reference, that is more readily conveyed into English. One feels that modern American poetry suffers not so much from a lack of imagination as from a language insufficiency. A poet like Adrienne Rich possesses a surrealist sensuality but not the analogical vocabulary. What is most absent from poetry that might have been surrealist is the "one in the other" technique that Breton discovered in the emblematic representations of ancient magic and that he renovated for modern poetry. Breton recognized in the "one in the other" process the creative principle of all aspects of human activity.

In an article in *Art International* for January, 1969, entitled "Art Intervenes, Anti-Art Interrupts" Nicolas Calas demonstrates that a basic character of art is what he calls "delay." He says: "A work of art is more than structure, for it is the outcome of speculation on what was seen or heard." In the best of surrealist poetry this delay in comprehension, caused by the multiplicity of references and their labyrinthine relationship, was the process that triggered in the reader a power of discovery rather than immediate transmission of thought or image.

Ironically, the most linguistically surrealist writing of the new poetry is found in translations from the French made by American poets, such as Daisy Aldan's from Breton, Derk Wynand's from Jean Chatard, and Michael Benedikt's from Reverdy, or when Ruth Krauss emulates Breton's *L'Union Libre*, both in structure and in its wide scope of analogy, in an admirable poem called "Dream":

> *My dream with its solar-pulsed gallop*
> *With its hooves as of counterpoint to the shaking of leaves*

As she enumerates the parts of the body, conveying the dream-sense of each part in a variety of frames of reference, and in the juxtaposition of the unusual, her poem sparkles and illuminates the *sense* not the *fact* of the dream, just as Breton's poem conveyed the magnetism of love rather than the portrait of the beloved. I found Krauss's poem to be the most surrealist of all those included in *Chelsea 22/23*.

The intensified cult of vision, advocated by Breton, and substantiated by the plastic resourcefulness of the artists who became oriented toward surrealism through his influence, is taking still another form in the current American context: the provocative character of things viewed by the artist in conjunction with the technician. In an article on "Art and Technology" by Nilo Lindgren in *IEEE Spectrum* for May, 1969, which describes the efforts by artists and engineers to collaborate, there is a very significant statement by John Cage that reveals the primacy of objects over words today, and of objects giving words new meanings: "Tried conversation (engineers and artists). Found it didn't work. At the last minute, our profound differences (different attitudes toward time?) threatened performance. What changed matters, made conversation possible, produced cooperation, reinstated one's desire for continuity, etc., were *things*, dumb inanimate things (once in our hands they generated thought, speech, action)." (P. 50; the italics are Cage's.)

From interest in things the next step is the direction of things to personally determined objectives. Today, the objectives of scientists seem more cosmic than those of our writers or artists, for the scientist and the technician are giving a metaphysical destiny even to steel. A TV reporter in Paris, commenting at the moment the LM alighted on the moon, recognized this as he cried out in French: "These are indeed the children of Rimbaud!" With the ever-increasing power to create objects and to direct them beyond the very limits of our globe the technologist is challenging the writer to give verbal meaning to the new, tangible realities that are emerging. Such a collaboration may well open the surrealist age in America.

ANNA BALAKIAN

Paris, July 23, 1969

preface
to
first
edition

Since the time of Baudelaire, poetry in France has been gradually severing its connections with the rest of literature. It linked its fate with art, and the two together began to encroach on the domain of philosophy. The poetic image, completely revolutionized, ceased to be considered as merely a source of aesthetic pleasure and became a new instrument of metaphysical knowledge for the poet. The persistent searchings into self and the universe broadened the scope of human imagination. Poetic vision came to be linked with the credo of existence in modern society's dilemma between surrender to the existing limits of the human condition and man's stubborn longing for spiritual release from them. For four generations of poets, writing became the barometer for the delicate changes they discerned in the moral

and philosophical atmosphere in which they lived. This study will attempt to trace the road upon which they marked their progress.

The present study is a continuation of my earlier book, *Literary Origins of Surrealism*, which I wrote in my twenties. In the years that have elapsed since then, I never ceased to explore the rich vein of modern French poetry, and I am not hesitant today to consider the surrealists and their antecedents as a liberating force against the neo-nineteenth-century aspects of much of the literature of our time. Some parts of this study have appeared in abbreviated form in scholarly journals in the course of the past ten years, namely the chapter on Apollinaire and part of the chapter on Aragon and Eluard in *Yale French Studies*, while a shorter version of "The Surrealist Image" was published in *The Romantic Review*. I wish to thank these periodicals for permission to reprint.

In the course of my investigations I have been to France, and I have met some of the poets and artists about whom I have been writing, but the reading and writing took place in the U.S., away from the physical surroundings of literary France; I have tried to judge by the testimony of the written word and have made an effort to disregard biographical events or the psychological and political conflicts of the moment. I should like to believe that geographical distance may have helped me to avoid some of the pitfalls connected with literary criticism when the time perspective is missing.

The prose and poetry translations from the French writers whom I have quoted are all mine. If they should cast a burlap screen over the original, may they spur those of my readers who do not understand French to make an effort to liberate themselves from the necessity of "secondhand" reading of the exciting and dynamic literature that France unceasingly produces in our day!

I shall never forget the kindness and sympathy that Pierre Reverdy and André Breton demonstrated in the enlightening, revealing conversations which I had with each of them. I am deeply thankful to my understanding husband for the encourage-

ment which he has given me in my work. I am ever grateful for the sound judgment, wise counsel, and sharp editorial eye of my critic-sister, Nona. Finally, I feel very fortunate to have as my editor, Cecil Hemley, a poet himself, who believes that the discussion of poetry is a timely thing and that the mysticism of the poet, modified to the needs of our day, is a significant aspect of the literary scene.

New York, June 1959

The poetic embrace like the carnal
While it endures
Forbids all lapse into the miseries of the world

—ANDRÉ BRETON

THE SIGNAL LIGHTS

1

out of
the
forest
of
symbols

The multifarious ramifications of the literary expression called "symbolism" have served as a *trompe l'oeil* for almost a century. In France it was the name of the literary coterie which between 1885 and 1895 rallied the poetic incertitudes into a concerted theory of indecision, and in England, Germany, and America, it has been identified for a much more prolonged time with the extreme subjectivity of writers who cultivated mystification with the elusiveness of indirect discourse, and who in the process of refining their senses lost them in a whirlpool of synaesthesia. The sustained introspection led to a desolate subtraction of self from the integrated universe. Symbolism, originally intended as a countermovement to naturalism, actually turned out to be a variation of it rather than its antithesis. If the Naturalist pre-

37

sumed the human will to be enslaved to the physical forces of nature, the symbolist of those end-of-the-century years was not far behind in acquiescing in somewhat equivocal statements to the fatality of nonsubjective forces. If in the Naturalist's eye man is a product of chemistry, the symbolist's world of ineffable forces is just as totally, though somewhat more somberly, controlled. For the symbolists, the forest of symbols, casually mentioned by Baudelaire in a little sonnet to which he himself attributed very little importance, is an inescapable labyrinth from which man cannot liberate his imagination; this is much the same situation in which the Naturalists place the human personality when they judge it powerless to overcome its physical and social limitations. Both points of view reveal man's destiny as controlled by forces other than his will, and the most formidable of these elements is death, whether it be considered as something determined and tangible, or as an incomprehensible intruder intertwining itself between the light and the wind. Both concur in accepting the helplessness of man's condition on earth, and it is this basic similarity which made it logical for a J. K. Huysmans or a Gerhart Hauptmann to proceed from one movement to the other.

The flight from consciousness into the dream-mystique, as practiced by most of the French Symbolists, was in a sense a default. So was Rimbaud's farewell to literature consisting as it did of a flight from writing into a life of action divorced from the contemplative self. Indeed, what becomes more and more evident as we progress into the second half of the twentieth century is that there was no concerted effort, contemporaneous to naturalism, to hold the dikes against an increasing fatalism and the depressive atmosphere it cast over the arts. Only individual instances, sometimes simply moments in an individual's writings, gave intimations of a latent rebellion against the festering tendencies of both naturalism and its would-be antithesis, symbolism.

Indubitably the influence of these two literary movements has been tremendous in the twentieth century. The tone of pessimism they encouraged in Western literature bore the mark of nine-

teenth-century literary and philosophical concepts, regardless of
the modifications made by succeeding generations.

Although in their early years the surrealists revered the sym-
bolists as their spiritual elders, their approach to art and the
human condition was radically different. They noted that al-
though the literary techniques of symbolism were being main-
tained by a majority of their contemporaries, the fame of the
nineteenth-century French Symbolists was proving very precari-
ous. André Breton observed in 1936 how the members of the
Mallarmé school sank one after the other into the sands of
oblivion.[1] The surrealists did not seek their heritage in literary
movements of the past but in certain individual writers associated
with that past: isolated intuitions which served as signal flares to
clarify their own fresh vision of the arts.

William Blake was one of the earliest of these spiritual fore-
bears, but not the Blake who expressed himself through Christian
symbols. Rather, the surrealists have seen Blake as a visionary in
Rimbaud's sense of the term and have extolled him for rejecting
exterior reality as a subject of artistic expression and for trans-
forming the physical world in his effort to alter its dimensions.
Blake's eye, they thought, absorbed but did not determine: as an
intermediary instrument, a recorder of physical sensation, it left
the matter of interpreting to the imaginative faculty. By refusing
to make of nature the object of aesthetic creation, Blake had
removed painting and verbal imagery from the controlling factors
of phenomenal reality. Blake has been admired by the surrealists
because like them he made of poetry a way of life:[2] his pictorial
and poetic imagery was the overflow of a spiritual crisis and his
art asserted man's creative capacities.

In France, the poets with whom the surrealists and their

[1] In André Breton's article, "Le Merveilleux contre le Mystère," which can
be found in his collection of essays called, *La Clé des Champs* (Paris: Les
Editions du Sagittaire, 1953).

[2] See for a development of the subject of the relationship of Blake to modern
French poetry in my article, "The Literary Fortune of William Blake in France,"
Modern Language Quarterly (September, 1956), pp. 261–272.,

sympathizers found most empathy were three who are very often associated with the word "symbolist," particularly in Anglo-Saxon literary criticism: Baudelaire, Lautréamont, and Rimbaud. In the case of Baudelaire, it was not the poem, "Correspondances" which attracted their interest, but the haunting presence of "the abyss" in certain of his works, its stimulation of the poetic imagination. Whereas the Romanticists, contemporary with Baudelaire, had been stretching their visions outward and upward, Baudelaire had projected his vistas downward and inward, not in exaltation but with hesitancy and apprehension. His cosmos is not far, but just beyond his window and in the vertiginous fringe between sleep and the dream, the pit of the subconscious where desire and deed are undistinguishable, where time and space have relationships other than those of the outer world. This sensation of prodigious physical and spiritual depth, which obsessed Baudelaire at times, became the basis of a mysticism discovered in Baudelaire, and developed as a credo and technique in much of contemporary French poetry. But what has elevated Baudelaire so far above the symbolists in the esteem of modern poets is the tension of his life experience which matched the pitch of the poetry. Whereas his fellow-symbolists were to efface their lives before their art and satisfy their mysticism with a lulling of the senses, for Baudelaire writing was intensified living. He never lost the sense of life and even his exploration of artificial paradises was a desire for keener perceptivity: "It is in effect, at this period of the rapture that a new keenness, a superior acuity of all the senses is manifested. The sense of smell, sight, hearing, touch participate equally in this progression. The eyes aim at the infinite. The ear perceives undiscernible sounds in the midst of the vast tumult. This is when the hallucinations begin. Exterior objects assume slowly, successively, singular appearances. They are deformed and transformed."[3]

Baudelaire had many more reasons than Villiers' *Axel* to join

[3] Charles Baudelaire, *Les Paradis Artificiels* (Paris: Poulet-Mallasis, 1860), p. 54.

his ancestors, but he chose life and the uncompromised will of the artist. He did not move through a forest of symbols but on the contrary constantly sought the concrete as the substance of his poetic alchemy. Axel expected nothing from life; Baudelaire expected much, too much to be ever requited, but also he sought for it too persistently ever to concede defeat.

Lautréamont, who died before he actually lived a normal life span, is another example of an energetic coming to grips with life; and it is hard to see how by any stretch of terminology he can be grouped among the symbolists.[4] He was an utter realist who in his most extreme cries of bitter combat against human destiny did not lose sight of the object of his strife: the world. Escape into death or into the dream is for him a puerile approach to the human condition. Lautréamont acknowledges the tragic character of life but the vigor of his struggle belies any real pessimism. It is this very distinction between recognizing the tragic and surrendering to it that proves to be the crux of the philosophical difference between symbolism and surrealism.

In claiming adherence to Rimbaud, the surrealists did not mean the Rimbaud who talked of himself but the one who said "*I* is another," not the one who burned in his private hell or who dropped the struggle with imagination to yield to the superficial escape of voyage. It is rather the poet who at moments had the most optimistic literary outlook of the last half of the nineteenth century, saying that man can reach seerlike knowledge: the poet who called himself an inventor, who sang of new flowers, new love, and who intimated the upsurging of unheard-of harmonies and visions, insisting that the whole world was in need of transformation. What misled many into associating Rimbaud with the symbolists was his personal relationship with one symbolist, Verlaine. But, whereas Verlaine sought pale, melted blues, misty

[4] In this study Symbolism with the capital S will refer to the French literary school of the period 1885–1895, while it will be written with the small "s" when designating the general characteristics of the form found in works which lie chronologically and geographically outside of the specific literary school.

skies, indistinct snows as landscapes for his "gray song," and in his *Art Poétique* made a slogan of: "no color, nothing but the nuance," his fellow traveler, Rimbaud, was proving a companion only in the actual voyage and not in the spiritual journey of literary experience.

Rimbaud saw not monotonous wastelands, but green hills and slopes, invigorating streams, indigos, and wished to possess all possible landscapes in his constant apostrophes to the "world." He strove to match the "fecundity of the mind" with the "immensity of the universe" by endeavoring to free the mind from its long bondage as prisoner of reason. Rimbaud's use of language is not at all linked with the Symbolists' cult of indirect or veiled meaning. If Rimbaud's visions are sometimes incomprehensible, it is because they are too specific rather than too vague. He differs sharply from the Symbolists in the substantial, concrete character of his imagery which twentieth-century French poets found worthier of imitation than the rare, pure vocabulary of the Symbolists.[5]

In an early moment of his career, Mallarmé, not yet lost in a search for pure abstractions, produced a work unlike anything he wrote later, called *Igitur*, in which he conveyed his preoccupations with the occult forces of physical life and his attempt to discover the inherent mystical qualities of material existence. This was a far cry from his friend Villiers' imitation of the same process in *Axel*. Whereas Axel's journey to the tomb was a desire to escape from life and its imperfections in a sort of nihilistic comprehension of freedom, Igitur's exploration of the process of death is an affirmation of the strength of the mind to experience

[5] A work by Charles Chassé, *Les Clefs de Mallarmé* (Paris: Aubier, 1954), would also remove Mallarmé in matters of language from the strictly Symbolist fold. The author claims that Mallarmé wrote with the Littré dictionary as his constant guide in his search for unusual connotations for the simplest words. Mr. Chassé suggests that herein lies a basic difference in style between Mallarmé and the Symbolists for unlike the Symbolists who in general are enticed by rare vocabulary, it is through the plainer words of the language that with the aid of Littré, so says M. Chassé, Mallarmé was able to create his extraordinary effects.

here and now the infinite or nothingness. Here, the concept of
eternity is not envisaged as something beyond the grasp of the
senses, or to be comprehended only through symbols or abstrac-
tions. Instead of speculating about immortality after death like
Hamlet, he seeks the absolute which *denies* immortality. But this
absolute which is subservient neither to life nor death, is not a
spiritualization of reality, as much of symbolist poetry was to
become;[6] nor is it a denuding of the earthly scene: the void or
vacuum of symbolist landscapes. Nor does it constitute a verbali-
zation of the abstract, as in Victor Hugo's metaphysical verse, or
in the more recent, more familiar T. S. Eliot end of the world,
such as:

> *Between the desire*
> *And the spasm*
> *Between the potency*
> *And the existence*
> *Between the essence*
> *And the descent*
> *Falls the Shadow*

"THE HOLLOW MEN"

Unlike most symbolist imagery, the death vision in Mallarmé's
Igitur is represented in terms of known and very concrete entities
of the world, though they be somewhat divested of external
trappings. But if the absolute is not understood as the subjective
perpetuation of perfected human experience after death, how will
the poet convey "the substance of nothingness"? The very con-
tradiction in terms gives the key to the answer. The existence of
the absolute can be established only through the acceptance of the
absurd, illustrated with an image such as of "panels opened and
closed at the same time." For the difference between the finite
world and the infinite is that in the former we recognize the

[6] Cf. A. Balakian, *The Symbolist Movement: A Critical Appraisal* (New
York: Random House, 1967).

juxtaposition of opposites as "absurd," while the power of "chance" which nullifies this contradiction in things can be said, from our point of view, "to contain the absurd." But the very fact that contradictions are reconciled by the forces of "chance" makes Igitur believe that the absurd no longer exists. The infinite, therefore, is the plane of reality in which combinations that we might call absurd in the normal order of things or logically impossible are accepted as possible. And this "chance," which turns what we call "absurd" into reality, permits, by that same token, the infinite to exist: he sees inanimate objects losing their natural attributes without being dissolved into abstractions. Sound is reduced to the beat, rhythm divested of sound, breaking down the barrier between the visual and the auditory.

"Briefly, in an act in which hazard is involved, it is always hazard which accomplishes its own Idea by self-affirmation or self-denial. Before its existence negation and affirmation come to failure. It contains the Absurd—implies it, but in a latent state and prevents it from existing: this permits the Infinite to exist." Igitur is a person "who feels in himself, thanks to the absurd, the existence of the Absolute." After him the surrealists will enlarge and maintain the domain of the absolute through this very same type of cult of the absurd which will tend to become the basis of artistic creation and a means of liberating art from the finite or natural aspects of things and beings.[7]

Except for isolated cases such as mentioned above, there was no concerted spiritual combat against the nihilism dominating the minds and activities of the artists of the end of the century. There was a weary acceptance of decadence, of a hothouse atmosphere in which the vague and the lifeless were synonymous with mystery, and the mysterious was confused with the profound. In the best of Symbolist works this sadness created a kind of exquisite, ephemeral beauty, as perhaps best embodied in Maeterlinck's

[7] A fuller analysis of *Igitur* can be found in my earlier book, *Literary Origins of Surrealism* (New York: New York University Press, 1966).

character of fragile Mélisande, who does not know what she is, where she comes from, or where she is going; she accepts this unreal existence, only to be swallowed up by death at the end. But eventually the repetitious use of the same type of weightless, shadowy imagery, populating a shut-in world, created an inverted kind of poetry, exhausted the already limited word-range of pure, abstract expression and made French literature ready not only for a new outlook but for an actual revolution in literary vocabulary and imagery.

The reaction is first sensed in the much neglected, so-called symbolist poet, Saint-Pol-Roux; it is much more evident in the vigorous poetry of Apollinaire who envisioned the poet not submerged in the vaporous hinterlands of the symbolists, but in a state of ascent above his brethren. Apollinaire came to grips with the object instead of considering it an obstacle to self-edification. As he viewed the things man has invented, he felt optimism and predicted the space age along with its challenge to the human imagination. He rejected the passiveness and torpor of his elders, extricating himself from the forest of symbols so that he might survey the wide expanses from the summit of his hill, and specu-late on "what life really is." Then man would wake to new knowledge. His whole poem is a reaffirmation of faith in the human potential to master the universe. Even the war, in which he participated actively and in which he received a wound which eventually proved fatal, did not discourage him. In one of his final poems, "The Pretty Red-Head," he stated that "without worrying about this war," he foresaw a much greater struggle between the traditionalist and the intellectual adventurer; in ardent terms he bids the reader to allow the pioneers of new fires, new colors, and new phantasms, to work on the "frontiers of the limitless," and produce a new reality.

It is true that although the dying Apollinaire's last poems were of courage, power, and victory, the initial manifestations of the younger men who formed the first postwar literary movement, Dada, consisted of outbursts of nihilism. But it became so quickly

evident to some of the members of the movement that negation was noncreative, that with the impulsion of André Breton they buried Dada with much pomp and ceremony. And with the birth of surrealism, creativity became indeed the slogan. The historical link between Dada and surrealism has been magnified because of the constant linking of these two movements in reference to the art medium through which they have become known. But it is well to keep in mind that in terms of inherent philosophies they are poles apart.

The surrealists set out to revitalize matter, to resituate the object in relation to themselves so that they would no longer be absorbed in their own subjectivity. In fact, instead of abstracting the object, instead of emptying it of its physical attributes, they decided to add to its qualities through their ability to *see*. A strange identification took place between the see-er and the seer. Seeing was no longer considered a receiving process but an interchange between subject and object. With conscious training, the senses were to reach a point of acuity whereby their function would not be limited to accepting and storing sensations. It would be aimed at enriching the objects of their perception. The essential modernism of the surrealists is their concept of art as a building process, not as an expression or statement of existence as it is, but as a modification or an addition to it. They caught the tone of victory in the last poems of Apollinaire and tried to perpetuate it. René Crevel in his provocative surrealist essay, *L'Esprit Contre la Raison* (The Mind Against Reason) said: "Is it not for the mind a truly magnificent and almost unhoped-for victory, to possess this new liberty, this leaping of imagination, triumphant over reality, over relative values, smashing the bars of Reason's cage, and bird that it is, obedient to the voice of the wind, detach itself from earth to soar higher, farther . . . O, wonderful responsibility of poets. In the canvas wall they have pierced the window of Mallarmé's dream. With one thrust of the fist they pushed back the horizon and there in the midst of space have just discovered an Island. We touch this Island with our

finger." Their tone of determined optimism is not duplicated by any other contemporary philosophy or art. In this guise, the force and vitality inherent in surrealism make of it the art-concept most in keeping with the productivity of the scientific age in which it has flourished.

The surrealists refused the lonely world of the agnostic, as well as the religious comfort of earlier ages. They also rejected the lulling of the senses produced in the self-imposed vacuum of the latter-day symbolists with their dead mountains, dry sterile thunder, decays, and arid plains. René Crevel rejoiced that "Poetry which delivers us of the symbol sows liberty itself."[8]

In one of his most brilliant articles, called "The Marvelous Against the Mysterious," André Breton attributes symbolism's weakness to its confusion of the mysterious with the marvelous. For him, it was a sign of default to create through verbal ambiguities an ersatz air of mystery. For him this is a pseudo-mysticism which lacks the power of survival, whereas communion with the marvelous opens to the writer the source of eternal communication with men. As time passes, this gap between symbolist and surrealist inspiration appears to become more and more evident. In a later article, "The Ascending Sign" (1947), appearing in the collection of essays, *La Clé du Champ*, André Breton separated the new poet in no uncertain terms from his nineteenth-century counterpart. He vigorously rejected "the end of the world" attitude of his elders. "I do not feel in the least embarrassed to say that today we want no more of this end of the world. We have seen along what lines it has taken shape, and unexpected as it may be, we are struck by its absurdity. We feel only repugnance for this universal swooning." He condemns the artist's adherence to such an attitude as an inexcusable error. In the face of personal as well as national and universal calamities, Breton's unflinching faith in the potential of mankind was the more eloquent and can be explained by his overwhelming belief in the mystery and miracle of life.

[8] René Crevel, *L'Esprit Contre la Raison* (Marseille: Cahiers du Sud, 1927).

True to Mallarmé's premonitions, the surrealists have seen the marvelous in the contradictions of reality. According to Louis Aragon in *Le Paysan de Paris* (1926), the only inconceivable idea is that of absolute limit. The metaphysical point of view should be a daily and essential preoccupation of the artist who must not surrender his conquests to a "supernatural" world. According to him, the true metaphysician does not attempt to hide or transcend the object but seeks to reveal it more fully. The metaphysical preoccupation of the artist must be directed toward knowledge of the concrete entities situated within his sensory orbit. "An object was being transfigured before my eyes, it was not assuming an allegoric shape, or a symbolic character; it was actually becoming that idea. Thus it infiltrated deep into the earthy mass. I felt the keen hope of touching one of the locks of the universe: suppose the bolt was suddenly to give." He sees a mass of wax in a beauty parlor display and to him it appears to be quivering with all kinds of possibilities, a mannikin with arms crossed on its breast and its disheveled hair seeking undulations in a crystal cup full of water, a fur store, an electroscope with golden leaves, opera hats, sometimes nothing more than a speck of dust strategically placed; each such object bewitched his imagination and persuaded him that he must shape the infinite from among these finite manifestations of the *universe*. In so doing he would be attuned to the modern spirit. But to do this he had to rise above logic and conscious reasoning, and in the intuitive search for the infinite he would approximate the mystical state of mind of the creators of myths. He came to the conclusion that "man is full of gods, like a sponge immersed in deep heaven."

In the surrealist concept of art, the human condition demands this high dose of mysticism. As one looks back upon the past fifty* years of philosophical and literary expression the mystical potential inherent in the writings of the surrealists and their spiritual kin appears to be their most striking distinction. It is indeed their basic motivation. They demonstrate by the miracle of their

* As of 1958. The statement relates to the span between the beginning of the century and the 1950s.

visions to what degree of intensity modern man can be imbued with mysticism even when in apparent combat against "ancient myths." It is a mysticism which not only accepts the concept of infinity, but has enriched it with the full exercise of the imagination, which the surrealists spent their entire lifetime cultivating and expanding. If their mystique of the image and the object remains elusive as yet to the English-speaking world it is because unfortunately English poetic language is still clotted with symbolist verbalisms. Except for a number of translations successfully handled by a few poets, surrealist poems, transfigured into symbolist poems in their English versions, have had to wait for the English language to undergo that same revolution which under the surrealist influence transformed French as a poetic language.

But the surrealists, rising as they do above artistic considerations, transcend in a sense the language barrier. Surrealism is more than art, it is a way of life. It has, as André Breton reaffirmed in his last writings, a "triple objective" far surpassing literary aspirations: "to transform the world, change life, remake from scratch human understanding." It becomes more and more evident to him that "it is high time man be given a greater awareness of his destiny." So he concludes in an article, written in Antibes in February 1948,[9] in which he reasserted the surrealist faith in man and in life despite the world disasters of the recent past and the precariousness of the future. As science opens the gates to outer space, the effort of the surrealists to push back the frontiers of creative thinking becomes more meaningful to the modern mind. The scientists' thrust outward toward new physical combinations is in the same spirit as the endeavors of the group of surrealist poets and artists and their forerunners who probed the depths of the human spirit seeking to create a more dynamic and dazzling concreteness.

[9] André Breton, "La Lampe dans l'Horloge," *La Clé des Champs*, pp. 116–130.

2

lautréamont's battle with god

—the most genial work of modern times

—ANDRÉ BRETON

When in 1938–39 a poll was taken of contemporary French poets and critics by the periodical *Cahiers G.L.M.* to determine the twenty "indispensable" poems of all time, the name which ranked third among the poets before 1900 and was surpassed only by Rimbaud and Baudelaire, was that of Isidore Ducasse, self-styled Comte de Lautréamont. But what is even more impressive than this is the fact that those who singled him out generally rated him first. Four major surrealists, Eluard, Breton, Soupault, and Péret, so designated him, and chose him, not for a single passage or excerpt, but for his whole work considered as a unit and as a milestone in literary history. The surrealists have not been the only champions of this poetic youth who died at the age of twenty-four; but it was they who first considered him a major French

50

poet, although he was technically neither French nor a "poet." He was born in Montevideo of French parents. Arriving in France to study at the Ecole Polytechnique, he wrote in prose, only to prove more convincingly than ever before that the essence of poetry resides not in rhyme but in rhythm, whereby the word pattern expresses a pace of thinking different from that of other forms of writing.

In his preface to Lautréamont's works, Philippe Soupault, one of the original members of the surrealist coterie, wrote in overwhelming adoration: "One does not judge M. de Lautréamont. One recognizes him, and in saluting him one bows to the ground."[1] Soupault was the first of the surrealists to become interested in Lautréamont. But the edition for which he wrote the preface in 1920 was soon circulating among the rest of the writers and painters of the cénacle. Actually it was the first accessible edition; the ones at the end of the nineteenth century had quickly gone out of print. But once available, Isidore Ducasse became the patron saint of the rebels. For a time second to Rimbaud as a motivating force for modern poetry and art, Lautréamont gradually moved up to first rank, if one is to judge by the sustained and uninterrupted allusions to him since 1910 in the critical comments of poets and artists related at some time or other with surrealism. Editions of his works have multiplied and have been illustrated by famous surrealist painters, including Victor Brauner, Max Ernst, Matta, René Magritte, Man Ray, Yves Tanguy, and Salvador Dali. In his Second Manifesto, when André Breton detached himself and surrealism from most of the antecedents he had mentioned in the First Manifesto, and even expressed reservations about Rimbaud, he clung as staunchly as ever to Lautréamont. In his last critical works he had Lautréamont's name constantly on his lips referring to him as a major

[1] See for contemporary judgments in detail on Lautréamont in *Oeuvres Complètes* (José Corti, 1953). It includes the successive prefaces by Breton, Soupault, J. Gracq, R. Caillois, and M. Blanchot, which appeared in earlier editions of the work. See also Aragon, "Contribution à l'Avortement des Études Maldororiennes," *Le Surréalisme au Service de la Révolution*, Vol. II, p. 22.

influence, and in an article, "Sucre Jaune," where he reprimanded Camus for not having understood the magnitude of the Lautréamont rebellion, he called the tormented youth's work "the most genial of modern times."[2] In *Entretiens* (1952) he interestingly raised the importance of both Rimbaud and Lautréamont above literary classifications. It is, he said, their primary concern for the human condition, their spiritual torment, that lifts them above literary classifications. It is, he said, their primary concern with later writers. In his preface to the excerpt from Lautréamont's writings which he included in his *Anthologie de l'Humour Noir*, Breton signals Lautréamont as a trail blazer: "The most audacious things that for centuries will be thought and undertaken have been formulated here in advance in his magic law."

Lautréamont's imagery, its hallucinatory force, the subconscious train of thought which it reveals, its occasional basis in the absurd create a point of contact with the surrealists. But these obvious characteristics have been rather easily explained away by critics all the way from Remy de Gourmont to as recent a researcher as Jean-Pierre Soulier (*Lautréamont: Génie ou Maladie Mentale*, Droz, 1964) as manifestations of neurosis and eventual psychosis. Clinical explanations minimize however the very qualities that have endeared Ducasse to the surrealists and enflamed their imagination. It is this conscious moral and spiritual perspective more than literary manifestations of an unbalanced mind that indicated a major departure from his contemporaries and brought him closer in line with twentieth-century aesthetic and philosophic thought.

The surrealists preferred to see in the *Chants de Maldoror* either new figurations of the old Greek myths of man's tormented passage through the enigma of life, or an acute metaphysical rebellion in a world losing its anthropocentric focus. Surrealists

[2] The only significant antagonism to Lautréamont in the twentieth century has been Camus' critical article, "Lautréamont et la Banalité," which appeared in 1951 in *Cahiers du Sud*. An indignant Breton takes offense at the article and chides Camus for considering Lautréamont "a guilty adolescent." See "Sucre Jaune," pp. 250–253 of *La Clé des Champs*.

Marcel Jean and Arpad Mezei (*Maldoror*, Editions du Pavois, Paris, 1947) were inclined to explain Lautréamont as a tortured victim of his own inherited traits, "Theseus and Minotaur all at once," and thus identified the author with his diabolical character, Maldoror. On the other hand, Breton and Léon Pierre-Quint have seen Ducasse as a very lucid, proud rebel, who can objectivize his plight in *the other*, Maldoror, and create the catharsis of the protest of the damned. In his magnificent book on Lautréamont (*Le Comte de Lautréamont et Dieu*, 1928), which is at the same time a profound study of the very nature of revolt, Léon Pierre-Quint calls *Les Chants* "the great contemporary work of revolt,"[3] and "the overwhelming expression of supreme revolt."[4] It is indeed in the light of a conscious and direct protest that Lautréamont's work is most poignant and most relevant to the development of the surrealist climate. The isolation of the young man in Paris and his severance from family ties were more likely to have produced benign melancholia than subversive attack on man and God.

There was a greater factor to cause disturbance in the sensitive adolescent's development than geographical or affective disorientation. The historical dates provide more decisive data sometimes than sundry personal letters. He came of age in the era of the advent of Darwinism. Lautréamont's work is closely involved with the spiritual upheaval caused by the theory of evolution in the second half of the nineteenth century. This scientific event proved as disturbing to that epoch as non-Euclidian geometry and the explorations of un-human space have been to a later era.

The theory of evolution was welcomed in France by biologists; the philosophers saw in it a dislocation in moral values. The notion of the soul seemed to be put in jeopardy. This moral shock and its inevitable effect upon religious orientation supplied the major impetus for Lautréamont's writings, for his venom, his

[3] Léon Pierre-Quint, *Le Comte de Lautréamont et Dieu* (new edition; Fasquelle, 1967), p. 41.
[4] *Ibid.*, p. 99.

rejections, his diffidence, and eventually served as a provocation for his wry, dark humor in facing up to the universe and its Creator.

Ducasse was fourteen years old when *The Origin of Species* was published and was still living in Uruguay with his French parents. (His father, a subscriber to various periodicals including *La Revue des Deux Mondes*, kept himself informed of the intellectual news of Europe and particularly of France.) We know very little about the life and intellectual development of this mystifying stranger, the outsider of nineteenth-century French literature; unfortunately he kept no adolescent's diary and died before the age an author takes to his journal. He left no bibliography of his readings, and he disdained memoirs as a literary genre. But judging from the abundant literary allusions of his final fragments called *Poésies*, he was extremely well read for his years and as familiar with English literature as with French. We also know that he showed definite scientific aptitude as a youngster, and after five years of preparatory work in French lycées, went to Paris in 1865 to register in the Ecole Polytechnique. Many a scientific allusion in *Les Chants de Maldoror* points to an interest in technical instruments, in advances in physiology. Moreover he reveals an amazing knowledge of zoology and its terminology, which for the first time becomes a predominant part of the poetic vocabulary. Gaston Bachelard discovered 435 references to animals in *Les Chants de Maldoror.*[5]

Since 1845, when Auguste Comte had disturbed men's minds by placing humanity within the order of physiochemical phenomena, France had been in the throes of a philosophical crisis. The publication of *The Origin of Species* in 1859 intensified the dispute over the biological as opposed to the metaphysical concept of human existence. The French periodicals of the time are filled with polemics on the subject. Langel, a well-known writer of scientific articles for *La Revue des Deux Mondes* wrote in the

[5] Cf. Bachelard, *Lautréamont* (new edition; Corti, 1939).

April 1, 1860 number about the curiosity, criticism, and admiration which Darwin's book had aroused in France.[6] He realized the bitter reaction the book would create. Those who saw in it primarily an attempt to prove man's relation to the ape would reject it with anger without examining it any further. Another writer for the same periodical, A. de Quatrefoges, referred to Darwin in a series of articles entitled "Histoire Naturelle de l'Homme" (December 15, 1860–February 15, 1861) and called *The Origin of Species* a "remarkable book." In his opinion it disclosed the impartiality of nature's check and balance system which allowed no one species to overrun the world.

From the point of view of its influence on literature, the most significant aspect of the French reception to Darwin's work was that there appeared less concern with the scientific accuracy of the theory *ipso facto* than with its philosophical implications. According to Ernest Renan, Darwin had taken the first steps toward unraveling the basic philosophical enigma of creation. Referring to Darwin in his article, "Avenir des Sciences Naturelles," one of a series he did for *La Revue des Deux Mondes*, entitled "Les Sciences de la Nature et les Sciences Naturelles," he envisaged the changes that would have to occur in the study of zoology and asserted that the nonstatic character of existing forms, which Darwin supposes, places his "hypothèses" "incontestably on the path of the great explanation of the world."[7] Henceforth the only true philosophy would be one which accepts this new zoological reality.

It is in this same philosophical vein that the French translator of the book had interpreted the magnitude of Darwinism. Authorized by Darwin himself in 1861, the translation had been undertaken by Clémence Royer, whom Darwin described in one of his letters as "one of the cleverest and oddest women in Europe; is an ardent Deist and hates Christianity, and declares that natural

[6] "Nouvelle Théorie d'Histoire Naturelle: L'Origine des Espèces," *Revue des Deux Mondes*, XXVI, p. 647.

[7] E. Renan, *Revue des Deux Mondes*, XLVII (October 15, 1863), p. 765.

selection and the struggle for life will explain all morality, nature of man, politics."[8] He also pointed out—and this is the most significant part of his comment—that the translator had added footnotes and "in many places where the author expresses great doubt, she explains the difficulty, or points out that no real difficulty exists." In other words through her translation the French public was presented with *a more absolute doctrine* than those who read the original. Mlle Royer added not only footnotes but a long and militant introduction which championed Darwinism and advertised the book as "a work which will assume the importance of a revolution,"[9] in the history of science. She lent further authority to her statements by asserting that Mr. Darwin had written to her saying that she had "understood the general spirit of his doctrine better than his other critics or translators." In her lengthy introduction she emphasized the Darwinian concept of gradual change from beast to man and in the expression "slowly and progressively by a long series of varieties, more and more human,"[10] used the word "human" in a manner that rings of a dramatic rather than a scientific verity. Stressing the indication of the slow progress of human development, she claimed that this theory encompassed a philosophy of nature and a philosophy of humanity. She opened for re-examination an ominous question—the theological and philosophical problem of sin in the light of Darwin's concept of *ascent* as opposed to the Christian doctrine of *the fall* of man. Thus, reading her introduction, her readers would feel themselves confronted not only with what she calls the most far-reaching thing done in the natural sciences, but with what she termed a very synthesis of the laws of economics, social sciences, and the fundamental code of ethics of all time and all places. In the preface to the second edition, which appeared in France in 1866, she assumed credit for having predicted the

8 Charles Darwin, *Letters*, p. 179.

9 Clémence Royer, *De l'Origine des Espèces, Traduit en Français avec l'Autorisation de l'Auteur* (2d edition; 1866, Paris: Guillaumin et Cie, Victor Masson et Fils), p. vi.

10 *Ibid.*

success of Darwinian doctrine in the world of science. She claimed that in France no one dared any longer to oppose it, that many of its earlier critics had reversed their stand and that it had received the support of the younger writers, particularly those who "have deserted the opposition to take up the defense."[11]

There is no direct mention of Darwin or evolution in Lautréamont's work, but in view of the intense interest in Darwinism between 1860 and 1869, and considering the youth's general intellectual awareness, his tremendous capacity for reading, and particularly his scientific tendencies, it takes no stretch of the imagination to assume that Isidore had learned of Darwinism at least as much as—if not more than—an alert youth of today knows about nuclear physics. In *Les Chants de Maldoror* the primary concern of the author is the reorganization of the living world, biologically integrated and by the same token bereft of the moral supremacy of man. It is even likely that he was thinking of Darwin when he said: "As I write this, new tremors are traversing the intellectual atmosphere: all we need is the courage to face them."[12] This sentence taken out of context has often been quoted as evidence of Lautréamont's awareness of new literary trends. But it is much more likely that he was thinking of the sciences rather than literature for the sentence comes as a conclusion to a passage in which he makes a purely biological analogy between the graftings done on animals and the physiological possibilities of identification between the reader and the author.

Darwinism and the positivist atmosphere in which it flowered affected the work of Lautréamont in the same way that the theory of the Great Chain of Being influenced the Romanticists. From plant to animal, from animal to man, from man to the angel, from the angel to God had been the graded path to perfection as visualized by pantheist writers such as Victor Hugo. In his metaphysical poem, *Dieu*, Hugo made animal, man, and the angel

[11] *Ibid.*, pp. iv–v.

[12] Ducasse (Lautréamont), *Les Chants de Maldoror* (Viau), p. 173, the translations from the French here as elsewhere are mine.

plod on their way toward the discovery of the infinite, each according to his relative spiritual capacity. Although a general relationship was sensed by the Romanticists between the other species and man, the proportion between nothingness and perfection was considered entirely different for the inferior forms of life as compared with that in man, and therefore man's belief in his superiority was not shaken. But with Darwinism the scale of gradual perfectibility was disturbed, for each species was considered perfect in its own fashion. But if we then move from the biological concept of perfection to its philosophical implications, man's aspiration toward the absolute is blocked by the very reshuffle of the biological role which promises him only the dark mystery of disappearing as easily and irrevocably from the face of the earth as a fly or a butterfly. Finding himself a descendant of the ape and a brother to the leech, man can no longer believe himself created in the image of God.

Lautréamont did not come to this notion serenely. Endowed with a propensity for mysticism, he should have lived in a world which accepted miracles and spiritual revelations equal to the scope of his vast imagination. It was a bitter disappointment for him to discover the extent of man's limitations. Maldoror, the half-man, half-beast hero of his work, wanders day and night without rest or respite, troubled by horrible nightmares and by phantoms that hover about his bed and trouble his sleep. He is tormented by his dual combat with God and with man. Lautréamont and his shadowy protagonist, who serves to exteriorize occasionally his own anguish, are indignant at being chained to "the hardened crust of a planet," and of being "imprisoned within the walls of their intelligence." Yet, Lautréamont cannot quench his passion for the infinite. And if it is true that he shares the destiny of the animal, then his own unanswered but unabated longing for the infinite must exist in the lowliest creatures. Indeed, the dogs that bark must be thirsty for the infinite, "like you, like me, like all the rest of humans. I, even as the dogs, feel the need for the infinite. I cannot, I cannot satisfy this need. I am the son of man and of

woman, so I have heard. I am surprised . . . I thought I was more."[13] He is angry with God for not having made him *more*. He chides Him for having committed such a blunder: "The Creator should not have engendered such a vermin."[14] He is equally angry with man for having been fool enough to harbor the illusion of his dignity for so long. When he refers to man as "this sublime ape" there is disdain, sarcasm, and regret in the use of the terminology.

A less virile and vigilant young man in the throes of such a spiritual crisis might have sought release from his tension by escape, either in terms of physical or intellectual evasion. The examples of such culminations to revolt are numerous in literature. The originality of Lautréamont, and the very thing which endeared him to a future generation of artists, is his refusal to be diverted from his intellectual dilemma. Art did not mean to him a form of consolation or a palliative, but on the contrary a confrontation of the problem, a search, perhaps a revelation however painful it might be.

Les Chants de Maldoror attests to Lautréamont's facing up to the tremendous rearrangement of a world in which man is to be considered a material organism and therefore conditioned by the same nonmoral impulses as the beasts. This is not really an attitude of revolt, for revolt implies refusal to accept. Young Isidore accepts a totally earthbound condition: "The stone would long to escape from the laws of gravity. Impossible!" But he accepts it with repugnance as he sets out to portray man through the eyes of his disillusionment: "Let my war against man be eternal since each recognizes in another his own degradation."[15] No longer are vestiges of the sublime qualities of man to be seen in the animal, as the Romanticists had believed; but on the contrary the undesirable or ugly aspects of animals are mirrored in human beings. Lautréamont begins with a hideously unflatter-

[13] *Ibid.*, p. 18.
[14] *Ibid.*
[15] *Ibid.*, p. 139.

ing picture of the *dear reader*, calling him a monster, referring to his mouth as a snout and comparing his movements to those of a shark. Human eyes are like a sea hog's, circular like a night bird's. When man stretches his neck it looks like a snail's; his legs remind Lautréamont of a toad's hind limbs. Man's facial expressions are those of a duck or a goat, his baldness that of a tortoise shell, his nakedness that of the worm. The cries of a dog, a child, a cat, a woman have a definite kinship in his picture of the universe.

The analogies between man and beast form the core of his imagery in *Les Chants de Maldoror*. The similarity is by no means limited to physical attributes. Human movements and attitudes are often drawn into very complicated mental associations with animal behavior: "Just like the stercoraceous, birds that are restless as if always famished, enjoy the polar seas, and venture only accidentally into more temperate zones, like them I was uneasy and dragged my legs forward very slowly."[16] Here is his concept of a human state of mind: "The mind is dried up by a condensed and continually strained reflection, it howls like frogs in a swamp, when a band of ravenous flamingos or famished herons fall upon the weeds of its shores."[17] He compares the style of a writer to "an owl serious unto eternity." By accepting a close link between man and other living organisms in his metaphors, he destroys old aesthetic values; beauty becomes for him something entirely unorthodox: "He seemed beautiful like the two long tentacle-shaped filaments of an insect," or "The beetle, beautiful as the trembling of the hands of an alcoholic."[18] It is farfetched analogies such as these which André Breton has called the surrealism of Lautréamont. The following image has become famous because of the number of times it has been cited as the perfect surrealist image: "The vulture of the lambs, beautiful as the law of arrestment of the development of the chest in adults

16 *Ibid.*, p. 175.
17 *Ibid.*, p. 182.
18 *Ibid.*, p. 180.

whose tendency to growth is not in relation to the quantity of molecules that their organism assimilates, vanished into the high reaches of the atmosphere."[19] Even death has a beauty likened to a characteristic of the animal: "Each one has the common sense to confess without difficulty that he does not perceive at first a relation, no matter how remote, which I point out between the beauty of the flight of a royal kite, and that of the face of a child, rising sweetly above an open casket, like a water lily piercing the surface of the waters."[20]

If man's physical characteristics are akin to those of the animal, his social behavior can also be seen to derive from that of the lower forms of life. Man's social incompatibility, for instance, becomes as natural a phenomenon as that of various species of fish that practice their own brand of isolationism in ocean habitats: "Aged ocean, the different species of fish that you nourish have not sworn fraternity to each other. Each species lives by itself. The temperaments and conformities which are at variance in each one of them, explain, in a satisfactory manner, what at first appears to be only an anomaly. It is thus with man, who does not have the same excuses. When a piece of land is occupied by thirty million human beings, they think themselves compelled not to bother with the existence of their neighbors, stuck like roots on the adjoining piece of land."[21]

The theory of evolution accorded Lautréamont a means of reexamining moral issues. In Mlle Royer's translation of Darwin, the universal and inevitable destructiveness in all nature was eloquently brought out: "a law of inevitable destruction decimates, either the young or the old, at each successive generation, or only at.periodic intervals."[22] In line with this basic struggle for survival described by Darwin, the translator's introduction pointed out that if destruction is a basic law of nature, then the

[19] *Ibid.*, p. 195.
[20] *Ibid.*
[21] *Ibid.*, pp. 21–22.
[22] Royer, *op. cit.*, p. 80.

fundamental rule of morality would be the efforts of each species for self-preservation. The recognition of the brutal origin and the biological universality of evil is a basic theme of *Les Chants de Maldoror*. Lautréamont accepts man's sinful inclinations as the same type of manifestation as the eagle's instinct to tear up his prey. The judges of man's cruelty to man are no other than the eagle, the crow, the pelican, the wild duck, the toad, the tiger, the whale, the shark, or the seal, for he has surpassed the cruelty of all of these.

If man is physically and spiritually no more than a sublime ape, then the angel cannot be very far from this same stage; he appears to Maldoror in the guise of a crab and laughs like a lamb. As the concept of gradual perfection is minimized, even God is divested of his sublimity.

Once the physical and moral characteristics of human beings have been reduced to the level of those of the animals, there remains only one reason for man's greater unhappiness as compared with the attitude of other living organisms on earth: it is the illusion he has of his superiority. In his own moment of disillusionment, therefore, Lautréamont seeks to reduce human pride and thereby find peace through a fraternization with the animal world and finally through actual metamorphosis. He discourses with the greatest of ease with animals (among whom are some of the principal characters of his work): the snake, the beetle, the toad. He seeks a bond with the most despicable of animals: the vampire is his friend, the scorpions his companions; he makes love to the female shark, is consoled by the serene and majestic toad. I do not agree with Bachelard that Lautréamont's obsession with animals is a manifestation of "the phenomenology of aggression."[23] If hostile, violent acts are perpetrated, as he says, to forestall his own vulnerability to suffering, the evidence seems to show that Maldoror suffers as much as the animals with which he associates. Lautréamont is making an attempt to revise

[23] Bachelard, *op. cit.*, p. 9.

the anthropocentric notion of the universe, and the process is wrought with pain and stoical humiliation. The pantheists had also felt a certain affinity with all created beings, but the bond had been considered hierarchic, and man's love of God's other creatures placed on a somewhat patriarchal plane. In Lautréamont's vision of the universe, however, the fraternization of man with beast, Maldoror's actual intercourse with animals, are based on a sordid form of democracy and a powerful atavism whereby man seeks justification for his instincts and attitudes by putting them on a par with those of the lowest forms of animal life.

Maldoror achieves complete identification with the other species. With joy he lives as a shark, or a hog, or a pretty cricket: "The metamorphosis never appeared to my eyes as anything but the high and magnanimous reverberation of perfect happiness for which I had been waiting a long time."[24] He envisions with equanimity two brothers changed into a single spider. Going one step further, he contemplates the possibility of new species: he sees himself as a hybrid, half-bird, half-man, or he imagines with scientific precision a man with the appendages of a duck in close communion with water life: "I saw swimming in the sea, with large duck's feet in place of the extremities of the legs and arms, bearing a dorsal fin proportionally as fine and as long as a dolphin's, a human being, with vigorous muscles, and which numerous schools of fish (I saw, in this procession, among other inhabitants of the waters, the torpedo, the anarnak of Greenland, and the horrible scropene) followed with the very ostensible marks of the greatest admiration . . . The porpoise, who have not, in my opinion, stolen the reputation of good swimmers, could hardly follow from afar this amphibian of a new species."[25] In still another instance, his disgust for mankind makes him assume partially the shape of a swan and live at peace with the fish. "Providence, as you can see, has given me in part the organism

24 Lautréamont, *op. cit.*, p. 159.
25 *Ibid.*, p. 162.

of a swan. I live in peace with the fish, and they procure the food
which I need."[26]

It is significant to note the difference between these metamor-
phoses and the *Metamorphosis* of Kafka. Gregor Samsa, trans-
formed into a tremendous insect, feels nothing but contempt and
fear in his new condition. He senses an eternal barrier between
himself and humanity. His metamorphosis symbolizes his exclu-
sion from the rest of society, his tremendous loneliness that
nothing can cure. On the contrary, Lautréamont feels no disgust;
to him the tentacles of an insect are beautiful. It is, rather, the
return to his former shape that he considers a misfortune. His
metamorphosis is not the terrible thing it is in Kafka's story, but
an affront to that human hypocrisy he cannot tolerate. Basically,
then, he is not such a pessimist as Kafka for he finds relief from
his dissatisfaction with humanity—unwholesome though the man-
ner may be—through his identification with other forms of life.

Nonetheless Lautréamont's attempts to take man down from
his self-appointed pedestal and to integrate him with a more
closely knit animal kingdom produce a tragic note throughout his
writings. Although on the one hand he concedes a dreary sort of
materialism that endows man with as little immortality as a
butterfly, his innate mysticism produces undertones of a protest
against a totally materialistic concept of life as pungent as his
determined intent to undermine the traditional faith in human
superiority.

The mood fluctuates between insolence and derision on the one
hand, and on the other, the despair of Adam chased from para-
dise. Although he was obsessed by the seeing of the animal in man,
he did not achieve a total portrayal of man as a beast. Even in
comparing Maldoror's crime to that of the eagle he unconsciously
pointed to the great difference by adding: "yet as much as my
victim, I suffered." For all his self-imposed materialism he could
not rid himself of the notion of immortality. The very evil he saw
in man and in beast he explained by their common rage against

[26] *Ibid.*, p. 167.

the inability to fathom the absolute. Although he humiliated God before his creatures he could not deny His omnipresence. And although man and beast are pictured as being equally ephemeral yet there exists for all a paradise, described in eloquent terms by brother toad who will share it with Maldoror.

What dazzled the surrealists and intensified their admiration for Lautréamont was his ability to confront the human condition squarely in all its abject and tragic facets yet to discover at the same time a weapon for self-preservation in his battle with God. It was what Breton called in his *Anthologie de l'Humour Noir* a "humor that reached its supreme power and that brings us physically and totally under its law." Léon Pierre-Quint had earlier seen in this two-edged instrument of attack and self-protection the basic metal of the modern comic, which has something sacred about it and is at the antipodes of the old: it is aimed at the irremediable plight of man although humor allows Lautréamont a moment of exemption from the target of his derision. Léon Pierre-Quint says that Lautréamont put an infernal machine at each junction of his thought process: "When Lautréamont responds with humor to Maldoror's cries of fury as he stands in judgment over Jehovah and as an executioner over men, he has truly attained the revolt of the mind, and it is superior to the integral nihilism of the destroyers of society."[27]

Lautréamont died too young to have reached any philosophical conclusions. The ultimate picture which *Les Chants de Maldoror* leaves is twofold. True, on the one hand there is the image of man on a plane little (if at all) above that of the beast; but at the same time Lautréamont's tableau of the animal world is endowed, through his longing for fraternity, with the human qualities he would deny: wisdom, kindness, sympathy, at times even a certain "douceur." As a result his apostrophes to the lowliest creatures, touched as they are with an undercurrent of pathos and compassion, transform many a passage of the work from a derision of mankind to a mockery of those who would deny man any powers

[27] Pierre-Quint, *op. cit.*, p. 112.

beyond those of animals. "I thought I was more than that!" is the chant that soars above the absurd fraternizations. The bold manner in which Lautréamont came to grips with "the great problem of life," whether he transferred his concern to his alter ego, the brother of the leech, or took it upon himself directly, gave his work a universal and timeless character, and set the tragic but unresigned and sometimes sardonic tone, characteristic not of his age but of a future one.

3

saint-pol-roux
and
the
apocalypse

Among the living he is the only authentic precursor of the modern movement.

—ANDRÉ BRETON, 1925

There is not a more fantastic figure in all French literature than Paul Roux, the native of Marseille, who settled on the shores of Brittany, in the fairy-tale chateau of Camaret, and there lived out his long, Druid-like life with the legends he created. There also he died in highly tragic fashion in 1940 as a consequence of an aimless, absurd Nazi pillage of his home on June 23, 1940, after he had fought off the murderers of his servant and the attackers of his only daughter, Divine, whom he worshipped as a goddess.

When Paul Roux arrived in Paris in 1882 to study law, he quickly fell into the ecstatic atmosphere of the Symbolist *cénacle*, which was just forming, and decided to sublimate himself and his mission on earth by transforming his name into Saint-Pol-Roux. However, as he did not manage to fit into any category or gene-

alogy of the Symbolists amidst whom he developed his own quality of talents, he was left out of its annals and completely overlooked by literary critics and historians until the surrealists claimed him as one of their masters. He holds the distinction of being less known abroad than any other French poet, while the writers of literary manuals are still inclined to relegate his merits to a footnote.

Saint-Pol-Roux's connection with the surrealists was brought about by André Breton, who in 1923, while on his usual summer stay in Brittany, found himself in the proximity of Camaret, the hermit-poet's retreat, and he wrote him a fan letter telling him how much he admired the purity of his character as a poet, and how much he deplored the neglect Saint-Pol-Roux had suffered in the literary world: "I have the most profound admiration for your literary attitude . . . and I consider you the man toward whom the world has been most unjust."[1] After the interview, which was granted the young Breton, he came away so exhilarated that he dedicated his first volume of verse, *Clair de Terre* (Earthshine) to Saint-Pol-Roux: "To the great poet Saint-Pol-Roux to those who like him can afford the magnificent pleasure of letting themselves be forgotten." Shortly after the organization of the surrealist movement, Breton prepared with his colleagues a tribute to Saint-Pol-Roux, which appeared in the May 9, 1925, issue of *Nouvelles Littéraires* and included besides his own article called "The Master of the Image," others by Aragon, Eluard, Péret, Leiris, Desnos, Vitrac, Morise, and Baron, all particularly impressed by Saint-Pol-Roux's independence as a man and artist, made possible by his decision to conciliate "liberty and exile" in order to remain unsoiled by a venal world. The youngest of all the surrealists of the moment, Jacques Baron, wrote in his tribute: "We who are the last to be deceived in a false and perverse century, we who are taught the sad rigidity of existence, we who struggle in this world with the cold rage of *Free Men,* we find

[1] *Saint-Pol-Roux,* Letter of André Breton, *Mercure de France,* p. 261.

ourselves at last before a free man, the veritable and magnificent prince of the pure Mind."[2]

What the surrealists derived from the heritage of Saint-Pol-Roux was on the one hand his personal stance as a poet: "O, Magnifique," said Aragon, "you have not bargained with life." Saint-Pol-Roux's had been a life totally devoted to the function of poet, and unlike his symbolist contemporaries he had tried to redefine the mission of the poet in the modern world. His personal withdrawal to the far end of the European continent, almost into the Atlantic Ocean, did not lessen his awareness of a need for radical change in the philosophy of life and of the necessity for the poet to adjust his function to the new spirit of creativity in other areas of knowledge. In this respect like Apollinaire he confronted the crisis in the arts and suggested ways in which the poet could hold a position in the front line of the seekers of knowledge: "World of the future where, by the transmutation of the elements and of spiritualities at the crossroads of universal Knowledge and in the area of a mutualized atmosphere, our spectacle and our species will change their character and their destiny."[3]

On the other hand, the surrealists were also attracted to Saint-Pol-Roux for what had been the main reason of his oblivion among his contemporaries: the fact that he eluded literary classification. In the end-of-century pseudo-antithesis between symbolism and naturalism, accompanied by leftover "art for art's sake" aestheticism, Saint-Pol-Roux was the only Frenchman who showed himself able to conciliate realism with the symbolic interpretation of art and to succeed in producing a fusion which he called "ideorealism" or "supernaturalism" which is in fact the nucleus of what was later termed "surrealism." If symbolism was the transfiguration of nature, then Saint-Pol-Roux foresaw a more evolved process, which might be called *metafiguration:* not beyond the figure but a virtual change of it within its own entity.

[2] *Ibid.*, p. 283.
[3] *Ibid.*, p. 219.

This was in fact the simultaneous acceptance and refusal of reality.

At a time when the "pure" word and the rarefied vistas, and vagueness of vision were the fashion, he reestablished contact with the world, a world not age-weary as seen through the eyes of latter-day romanticists, but one which he imagined to be constantly on the verge of the apocalypse, possessed of multitudinous objects which the poet in the fashion of a Merlin can change into wonders through the enlargement of the range of his vision, through a hallucination of his eardrum, and the use of an inner mirror: "I acquired, then, a fabulous mirror that makes you see within." Thus equipped, he reaches what before the advent of Freudian terminology he called "the isle of the inside of my being" (*L'Enfer Familial*).[4]

To explore the relationship between this inner self and the outside world became the substance of his poetic work, much of which appeared in the periodicals of the time, such as the symbolist *Vers et Prose*, and in the *Mercure de France*. These writings, mostly poems in prose, were collected in three volumes between 1885–1900, called *Les Reposoirs de la Procession* and subdivided into the beguiling titles: "La Rose et les Épines du Chemin" ("The Rose and the Thorns of the Road"), "De la Colombe au Corbeau par le Paon" ("From the Dove to the Crow by Way of the Peacock"), and "Les Féeries Intérieures" ("The Inner Fairyland"). Although a new edition of them appeared in 1946, they are among the collected works that are hardest to find even in Paris and practically nonexistent in the bookstores or major libraries of the U.S.[5]

[4] "L'Enfer Familial," *Mercure de France* (May, 1892), p. 57.

[5] *Les Reposoirs de la Procession, Mercure de France*, Paris, 1893. The only place where I have been able to find a copy of this work is at the Maison Française of Columbia University. I was unable to purchase it in Paris. (Fortunately in 1966 *Mercure de France* brought out an edition of *Les Plus Belles Pages: Saint-Pol-Roux*, with a very good introduction by Alain Jouffroy. This volume makes available at last the most significant selections of *Les Reposoirs* as well as a number of unpublished pieces.)

Yet despite the inaccessibility of his works, Saint-Pol-Roux, as a poet's poet, has received the highest tributes from poets such as André Breton and Paul Eluard, and from critics such as Rolland de Renéville. A selection of his writings, together with biographical and critical essays have appeared in the collection of *Poètes d'Aujourd'hui* and he is also included in a touching volume by Robert Ganzo called *Cinq Poètes Assassinés.*[6]

In a work inevitably marked by the imprint of symbolism, what is there that constitutes his modernism? Among the several descriptions he gave of his heterogeneous collection of pieces, one phrase stands out in particular: "magics of phenomena." It is the notion already highlighted by Rimbaud that the poet is a kind of magician who, not with the wand but with the word transforms the monotony of existing reality. Saint-Pol-Roux goes a step further. For him the only way to compensate for the loss of faith in the supernatural is to create a new type of miracle, and to replace the God without by a God within. "God will be made physical and man will become metaphysical."[7] The poet is regarded as best able to preserve the mystic essence and to give it its new direction. At a time when the poet and his outmoded sense of beauty were threatened with complete extinction, Saint-Pol-Roux proclaimed, as a self-appointed prophet, the transformation of the twilight of the poet into a new dawn, in which the poet possessing his own dose of divinity can shape his own universe.

"Ended is the time of useless dreams, oh my friend, all the lies have been lived. No, poet, there is no more room for the wandering heiress of abolished gods, except to seek her refuge prudently in the soul of poets where alone there is possibility of survival. Desist, then, from searching anywhere but within yourself, Beauty, exiled from her antiquated heavens."[8]

This God within, said Saint-Pol-Roux, is the Word. Language

6 Robert Ganzo, *Cinq Poètes Assassinés* (Paris: Editions de Minuit, 1947).
7 *Saint-Pol-Roux*, "La Répoétique," p. 221.
8 "La Suprême Hôtesse," *Vers et Prose*, II (1905), p. 89.

has been exiled by those who thought that "to fish for golden rhymes at the bottom of a black inkwell" was all that was to be expected of a poet. The poet must seek not the language that represents old ideas and known visions, but that creates new thought and designates the new vistas: "man will have learned to reconstitute the initial sound and the generating thought."[9] Like Lautréamont he believed that the advance of one man is the advance of all, in poetry as in science, and the work must rise out of the collective psyche and be identifiable with the universal: "The true poet is not a simple entity but a compound . . . the organ in the forest drowning out the traditional nightingale of the old-fashioned egotism."[10] He went even further than Lautréamont's notion of "poetry . . . made by all and not by one" and envisaged a future state in which all the arts would have a collective purpose and performance, "all the arts forming a single Art."[11] One might say that Saint-Pol-Roux is in effect the ancestor of the advocates of mixed media. The fusion of the arts was to be accompanied with an even greater conjunction in his view, that of science and magic, with the artist as the natural, predestined mediator: "chemistry will no longer laugh at alchemy."[12]

All these concepts of Saint-Pol-Roux, a man and poet way ahead of his time in terms of ideology if not altogether in terms of techniques, were to find their way as basic premises of the surrealist ideology and aesthetics.

In a piece called "La Joie," appearing in the part entitled "The Inner Fairyland," Saint-Pol-Roux accused of ignorance those who have not yet realized that "it behooves humanity to be the architect of its own paradise and that to become a happy man is equivalent to being metamorphosed into a god." The supreme duty of man is "to claim for one's own time the distant promises

9 *Saint-Pol-Roux*, p. 216.
10 *Ibid.*, p. 218.
11 *Ibid.*, p. 220.
12 *Ibid.*, p. 220.

of religions and to make of the future chimera a present reality.
Joy means force and health, that is to say, Divinity."[13]

His new spectrum with one end dipped into the inner self, the
other extremity stretching to the farthest reaches of imagined
physical frontiers, contains a palette not for an imitative art but
for pure creation: "Why say again, not say? why do again, not
do? why copy, not create?" he asks in his famous *Poesia*.[14] As
he reiterated in terms of an "ars poetica" in the *Mercure de
France* of 1913: "the art-formula asserts itself as sur-naturalist—
the total work can only be sur-creation or supercreation. The
whole future of art seems to be there. It is no longer a matter of
evolution, what matters is to convert the known substance into an
unforeseen substance, an extraordinary one, and, consequently, to
transport tradition out of its centuries of lazy habit, into the
arduous path of the infinite."[15]

The rise out of the cloistered circuit of his known world is
described in impassioned terms. His release is brought about by
the image which serves as a sieve; through its transparency, its
open hands, the poet envisages a new elasticity of time, and
though motionless, he makes voyages into realms which were
yesterday only promises.

This attitude of hope, of strength, and optimism was a far cry
from the tenor of his time, with its brooding unconcern with the
outer world, incompatible with nihilism and its egocentric vision.
Although there is here an aspiration toward the divine as in
Rimbaud, it does not echo his revolt, his spurning of world and of
society. Saint-Pol-Roux expounded tremendous faith in the pow-
ers of man, and if he asked that man mobilize his imagination it
was not for personal apotheosis and for satisfaction of a sterile
narcissism. On the contrary, he assumed the guise of a pioneer
and in colonizing the absolute he had the concern of all humanity

[13] *Les Féeries Intérieures, Les Reposoirs, Mercure de France*, Vol. III (Paris,
1907), p. 49.
[14] *Ibid.*, p. 262.
[15] "Réponse Périe en Mer," *Mercure de France* (1903), p. 656.

at heart. The dreams of the past seemed vain to him. The poet's main care should be for the future. "Believe me, humanity, which must be your only interest, will find its delights in the exteriorization of your love, and so it is that the death of the chimera will serve as a preamble to the pure truth. Write without fear and proudly for the future."[16] Such was his message as he strained to see over the crest of the turning century and set the tone of expectancy and hope that was to be taken up a few years later by Apollinaire and passed on to the surrealists: a thin, but unbroken line of faith in the capacities of man's mind, that will some day perhaps be noted as an unusual affirmation of man's distinction in a century widely marked with literary pessimism.

As a "geometrician of the absolute" he invades eternity and entrenches himself like an oasis contrived with Beauty. He is to fashion countries which he signs into existence, imbues them with his own body fluids and muscle strength. Is this transcendentalism? No, says Saint-Pol-Roux. Transcendentalism means changing the existing substance into something ethereal, whereas what he is striving for is quite the contrary: it is the crystallization of essence, the shaping of the ideal into seizable, concrete values, the miracle turned into reality.

How did he propose to bring this about? Not through mathematics, which today has in this sense produced the poetry of technology. Saint-Pol-Roux, the artist, but through his faith in the word, in its liberation from the captivity in which it was held for centuries, in its potential uses, in its multiplications of meaning, in what André Breton, in his article on Saint-Pol-Roux, was to call "the power of earthquakes." In a pertinent article called "Idéoplastie," dedicated to André Gide, Saint-Pol-Roux pondered on the destiny of words: "The words expressed since the origin of the races become eventually a single, continued evocation which in the course of the ages, gathers virtual forces until the magic power has at last its paroxysm, beings and things which were

[16] "La Suprême Hôtesse," *op. cit.*, p. 90.

evoked, cohering, germinate, assume textures, reveal themselves little or much, to populate definitely the solid empire of the senses."[17]

Describing the emancipation of the word in "Le Style C'est la Vie," he speculates on the marvels of unexpected word encounters: "The reconciliation of a negative word and an affirmative word would soon engender the miraculous sparkle."[18]

Basing his "ideorealism" on Hegel's admonition that art must no longer imitate nature, Saint-Pol-Roux went with his scepter of words on his fervent quest for images through which he would filter the evidences of his senses.

It must be here admitted that the "master of the image," as he has been called by André Breton, did not always fulfill the promises which he made in his aesthetic theories. Much of the imagery which fills the three volumes of his *Reposoirs*, as well as the substantial part of his single, unperformable, poetic play, *La Dame à la Faulx*, are in the symbolist tradition with the narrow parallelism of abstract and concrete vocabulary.

But proceeding from page to page one discovers some of those miraculous sparkles which gave the old man with the flowing beard his warm welcome among the younger generation and earned him the epithet of "magnificent." Before the popularization of psychology he sensed the hallucinatory power of the irrational and indicated that it was a source of poetical inventiveness to be tapped. Prying into the abnormalities of the simple-minded and the insane, he identified his sight with their possible vision. In his projection of such images, it must be noted that he makes illogical juxtapositions, approximation of disproportionate objects, and often accepts on the same level of reality abstract and concrete qualities; these are all characteristics that were to form the basis of the technique of surrealist painting and poetry.

In the vision of the "Simples" he perceives: "A dwarf princess marrying a giant king; an explorer in a blue cloak and under his

[17] *La Rose et les Épines du Chemin, Les Reposoirs,* Vol. I, pp. 51–52.
[18] *De la Colombe au Corbeau par le Paon, ibid.,* Vol. II, p. 175.

arm a yellow umbrella, swallowed up by a crocodile, color of
fresh grass; a red Indian fighting desperately inside of the belly-
ache of an abominable reptile with oyster shells; and other fearful
parodies. In the forefront of the stage, two insane musicians. One
beats with rapid percussion on a donkey metamorphosed into a
drum."[19]

These absurdities are the manifestations by which the "simple-
minded" translate into concrete form their intuition of the be-
yond. Saint-Pol-Roux made the most simple and the most civi-
lized join hands just as the surrealists, who were to represent the
more sophisticated phases of man's reception of the human
condition, were to seek wisdom and solace in primitive cultures
and art forms. Saint-Pol-Roux's contact with "Le Fol"[20] is a
voyage into the realm of pure metaphysics. In Saint-Pol-Roux's
fascination with the sensory and mystical orientation of "Le Fol"
there is a preview of the interest which Breton and his colleagues
were to show in the behavior of hysterics and of their simulations
of stages of insanity. Saint-Pol-Roux's "Fol" is a man who is not
losing touch with reality but on the contrary is endowed with the
power to make concrete what others consider nonexistent or
abstract. He can touch "little bits of nothingness," caress their
absent plasticity. He has created his own environment, peopled it
with life in such vivid fashion that the visitor is willingly beguiled
by him. Noting the satisfaction of the "Fol" the poet wonders if
after all the sense of concrete possession of one's dream is not the
supreme fortune to which man can aspire.

Perhaps the most constant sources of wonder for the poet were
the objects that surrounded him every day—what some years
later Aragon was to call "the daily miracle." Now, the romanticist
appropriated to his ego the beauty perceived in the object, or he
attributed his own spiritual qualities to the object. The symbolist

[19] "L'Ame Saisissable," *Mercure de France,* 34 (1900), pp. 392–395.
[20] *Les Reposoirs,* Vol. I, pp. 240–243; more accessible in *Mercure de
France,* 34 (1900), pp. 392–395.

saw a parallel existence between himself and the symbols in physical nature. Saint-Pol-Roux's approach is neither of these. Man's inanimate and human surroundings are a constant source of enrichment to his creative faculties: "The soul gapes before the symphony of things and the apotheosis of beings,"[21] he observes in "Le Poète au Vitrail." Calling himself a "physical poet" because the things about him are his chief concern, he does not however encompass them in a confining reality. The object is not a target but a volleying agent. "The spectacle of the meanest flower emancipates my eyes, and the entire world invades me in a gush of breeze, and directly I perceive divine Beauty delivered of her priests and of their lies."[22]

This power to reverse in the objects seen the hierarchy of values is what makes Alain Jouffroy call Saint-Pol-Roux "the first modern baroque." (Cf. Introduction to the Mercure Edition) With this fixation on things Saint-Pol-Roux anticipates the literature of "le regard" characteristic of the poets around Francis Ponge and in the notion of "concrete poetry" as well as in the so-called new world of the sixties. He devised, before Apollinaire, the poems of "il y a," wherein the objects shape the ideas in a veritable somersault of the metaphor. Two of his poems, "Choses" and "Ondes" create a kaleidoscope of images about them, illogical associations (which a little later on would be called automatic). These images suggest the furnishings of Saint-Pol-Roux's world, enlarged by the dose of mysticism in the poet and by the power of the "emancipated" words which serve as a bridge for him between reality and metaphysics, the winged words that shuttle "between the fairyland and the domain of things."

To what extent he cherished these "things" can be seen by one of his last poems, "To be Recited at the Funeral of Poets,"[23] in

21 *Les Féeries Intérieures*, p. 16; more accessible in *Saint-Pol-Roux*, Pierre Seghers, *Poètes d'Aujourd'hui*, p. 179.

22 *Ibid.*

23 See *ibid.*, pp. 208–210.

which he bids the gravediggers to be careful with the casket of the poet for it is filled with an infinite variety of things, including living forms and man-made objects, a smile and a rainbow, a laurel and a kiss, a nest and a diadem, trophies and an urn— nondescriptive enumerations, but in their nakedness the words sum up the poet's earthly existence, its richness, and its scope.

Portrait of Guillaume Apollinaire by Picasso shortly before Apollinaire's death in 1918.

4
apollinaire
and
l'esprit
nouveau

An unusual experience in historical self-consciousness must have belonged to those who attained the age of reason with the turn of the century and felt compelled to express awareness of a new era. Dates are arbitrary landmarks, and the world does not alter suddenly because a new number appears on the calendar. Yet, a reading of the more personal writings of those who experienced the change from the 1800's to 1900 gives indications of a psychological upheaval and of a conviction on the part of these writers that if things had not changed they should—an attitude not as readily associated with the mid-century adult. The writings of Guillaume Apollinaire, born in 1880, show that he was not only conscious of a transition but felt that he must have a hand in the heralding and shaping of a new world.

Nineteen-hundred brought to France an international exposition. One of the most important gadgets peddled there was the magical electric bulb; it was also the year of the cinema, the Paris subway, and liquid oxygen. It marked the advent of the supremacy of the scientist in the history of human progress, not the *pure scientist* who dealt with the abstract, but the man who applied the principles of science and *produced*. Whatever else twentieth-century man was going to possess in the way of distinguishing traits, he seemed assured of a generous share of concrete intelligence, an inventive spirit, which would provide unfathomable resources to the activity of his imagination.

This development of technical imagination seemed, however, to have no immediate parallel in artistic activities. Art suddenly appeared a weak sister. Since the end of the nineteenth century a rift had taken place between science and art which was growing wider and wider. Art, after a shortlived alliance with positivism, had soon protested, revolted, taken refuge in the dream, unsuspecting that soon science was to claim the dream itself as one of its legitimate domains of investigation. Science seemed to be the destroyer of the marvelous and the mysterious. The resentment was not untouched by a certain amount of jealousy on the part of the artist in regard to the strides made by the scientific inventor.

This conflict is vividly demonstrated by Apollinaire in his *Le Poète Assassiné* (1916). Much of this Rabelaisian novelette is autobiographical. We trace the fantastically confused origin and international upbringing of the poet-hero, Croniamental, which parallels closely the apocryphal data about Apollinaire's own early years. We see the poet making ties with the vanguard painters of his time, like Apollinaire's own relations with the cubists. We are exposed to Croniamental's conception of an extraordinary play containing in a one-paragraph description the seeds of playful irrationality (which was to be more notoriously demonstrated the following year in the staging of Apollinaire's play, *Les Mamelles de Tirésias*):

"Close to the sea, a man buys a newspaper. From a house on

the prompt side emerges a soldier whose hands are electric bulbs. A giant three meters high comes down from a tree. He shakes the newspaper vendor, who is of plaster. She falls and breaks. At this moment a judge arrives on the scene. He kills everyone with slashes from a razor, while a leg which comes hopping by fells the judge with a kick under the nose, and sings a pretty, popular song."

Finally Croniamental comes face to face with the archenemy of poets, not the smug unimaginative bourgeois, but the champion of the scientists, Horace Tograth, who demands the killing of all poets because they have been overrated and are contributing nothing valuable to present civilization.

"True glory has forsaken poetry for science, philosophy, acrobatics, philanthropy, sociology, etc. Today all that poets are good for is to take money that they have not earned since they seldom work and since most of them (except for cabaret singers and a few others) have no talent and consequently no excuse. . . . The prizes that are awarded to them rightfully belong to workers, inventors, research men. . . ."

Croniamental protests furiously against this persecution of the artists, and pays with his life. Yet Apollinaire leaves an undertone of criticism directed not exclusively against the philistine debaser of the poet, but also against the artist in general who has partially merited the attack. He indicates that the fault for this apparent impotence of poets is partly the public's, that public which demands boredom and unhappiness as the subject matter of literature instead of magic such as is expected of the modern scientist and even of the simple acrobat. As for Croniamental, he is Apollinaire's concept of the authentic twentieth-century artist, one who has looked God in the face: "I am Croniamental, the greatest of living poets. I have often seen God face to face. I have borne the divine refulgence which my human eyes made softer. I have lived eternity."

He is killed by the science worshipper, who does not realize that Croniamental is not a stereotype poet. His sculptor friend,

cognizant of the hard times through which poets are passing, manages to build him a statue, an extraordinary one, "a profound statue made of nothing," ironically symbolic of the emptiness of art and glory, also indicating that the true quality of the poet is indistinguishable to ordinary eyes.

Although in *Le Poète Assassiné* the conflict between science and art ends in tragedy and defeat for the artist, Apollinaire rejected in his own life and writings the secondary role attributed to the artist in the world of new values. He sought a conciliation between the work of the scientist and of the modern artist. He called himself and those like him "pilgrims of perdition" because they were risking what intellectual security they had as artists to explore the uncertain and the unproven. Although his conjectures about the potentialities of the modern mind were most precisely stated in an article, "L'Esprit Nouveau et les Poètes," which appeared in the *Mercure de France* in 1918 shortly after his death,[1] he had been crystallizing these views since his earliest associations with the artistic and literary coteries of Paris.

The need for inventiveness to preserve the prestige of the twentieth-century artist in competition with the twentieth-century technologist was first illustrated through Apollinaire's negative reaction to the existing imitative and autobiographical novel much in vogue then in France. As principal reviewer on the staff of *La Phalange* for a number of years, early in his career, he found ample opportunity to criticize the unoriginality of the novel form. Even when commending what he considered an exceptional one such as *Tzimin-Choc* by Louis-Bréon he makes of it an opportunity to chide the average contemporary novelist for his superficial realism, for his recourse to the easy autobiographical material. And yet he somehow hopes that a change of direction is at hand:

"Wonder should be the primary concern of the novelist, we should abandon for a while—long enough to realize what reality

[1] See "L'Esprit Nouveau et les Poètes," *Mercure de France,* 130 (December, 1918).

is—all this false realism which overwhelms us in most novels of today, and which is only platitude. Under the pretext of following the trend for psychological and sentimental naturalism, most authors do not even need to have recourse to their imagination any longer. Autobiography is all that is needed, and those who take the trouble to invent the most insignificant little story become famous. They have almost no competition to fear. But things appear to be changing. Imagination seems to be reclaiming its rightful place in literature."[2]

While literature had been neglecting imagination, science had learned to make maximum use of it. It had cast aside the known patterns of matter and through ingenuity had created new ones. Science's contribution, in Apollinaire's opinion, was *its ability to give reality a relative meaning* and thus to liberate it from its assumed synonymity with the *natural*. The unnatural could become a reality, as twentieth-century objects, which had no connection with nature, were proving more conclusively every day. The factory worker was all the time creating reality. The automobile had a dynamic existence which removed Apollinaire from the old world and its limited scope; candidly he states it in his poem, "La Petite Auto":

> *We said goodbye to a whole epoch . . .*
> *We understood my friend and I*
> *That the little auto had driven us into a*
> *brand new time*
> *And though we were grown men*
> *We were really born only yesterday*
> CALLIGRAMMES

Why not a parallel between the creativeness of applied science and that of the arts? In his preface to *Les Mamelles de Tirésias* he fabricated the word "surreal" to designate the human ability to create the unnatural, and he pointed out that man's first

[2] *La Phalange*, 27 (1908), p. 271.

surrealistic act was the creation of the wheel, which imitates the physical function of motion but creates a form entirely independent of forms known to exist in nature. The wheel becomes for him a product of purely creative work on the part of man, a manifestation of unconscious surrealism. Now the magic of the telephone, the automobile, the electric bulb, the airplane—creations in the same sense as the wheel—disproved even to a further degree the well-accepted adage that there is nothing new under the sun. The same independence from natural objects, which the technologist had achieved by his inventions, and through which he revolutionized the physical appearance of the world, should be sought by the artist in his own medium. To Apollinaire the acquisition of that freedom was to be the fundamental attainment of the modern mind. One could be a poet in many fields, and the technologist had proved for the moment to be a "poet" in a truer sense than the artist, admits Apollinaire in "L'Esprit Nouveau": "Poetry and creation are one and the same thing; he alone must be called poet who invents and creates, as much as it is given to man to create . . . One can be a poet in all fields: all that is needed is to be adventurous, to go after discoveries."

In retrospect it occurred to him that the poet had until recently been the precursor of the scientific inventor. Had he not conceived of the airplane centuries before the technologist was able to materialize his legend of Icarus? But Apollinaire had to admit that for once the scientist had stepped ahead of the artist in the realm of magic. Since the scientist had become not a destroyer of fantasy but a producer of marvels, his inventiveness should prove a challenge and an incentive to the artist: "The wonders impose on us the duty of not letting imagination and poetic subtleties lag behind those of the artisans who improve the machine. Already scientific terminology is in deep discord with that of the poets. This is an unbearable state of affairs."

Art's pitfalls in recent times had been its imitative approach to nature. Apollinaire waged war against photography, which to him was in all its technical perfection what smoke is to fire. He made

photography the symbol of imitation and the antithesis of art. Some years later Louis Aragon was to repeat Apollinaire's words against photography even more vehemently in defining his concept of the relation between reality and art. Since reality, according to Apollinaire's understanding of it, was dependent not on physical nature but on the mind's creativeness, all the arts were long overdue for the same basic revolution: that of creating rather than representing the object.

The symbolists had had a similar notion about the "interiority" of art but they had feared the object, feared the *concrete*, which they had mistaken for the *natural*. To point out the difference Apollinaire made up the word "surreal" as opposed to "symbolist." True to this distinction the culmination of the symbolist attitude was to be abstract art and not surrealism.

Although Apollinaire showed a certain affinity at first with Marinetti and other futurists, he soon noticed something superficial in the way the futurists extolled science. It was the object of scientific creation which interested them rather than the process of creation. Marinetti's attitude toward science is a far cry from Apollinaire's. When in an unfriendly apostrophe to the moon the futurist praises the electric bulb and belittles the light of the moon, he is led to no adventures of the imagination by the stimulus of the newly created object of science but merely expresses a journalistic appreciation of technological progress. In much the same manner, in his *The Pope's Monoplane* the airplane is admired as a means of escape and not as an impetus to broader artistic visions.

Apollinaire's relations with the cubist painters were of a much more fundamental nature. He found in the cubists the truest competitors of the imaginative technologists. As the perfect illustration of his own theories he defined cubism in *Les Peintres Cubistes* (1913) as "an art of conception which tends to rise to the level of creation." In looking back on traditional painting he found too many painters who worshipped plants, stones, water, and men. Without being iconoclastic—as some of his followers

were to become—he warned the artist not to be too much attached to the dead. He foretold before José Ortega y Gasset a dehumanization in art, contended that the true artist tends to be inhuman: "They painstakingly search for the traces of inhumanity, traces which are to be found nowhere in nature."

He discovered in the works of the cubists the fourth dimension of reality, which he deemed not only a proof of creativeness but of divinity. This new dimension was conveyed by simultaneous representations in various perspectives, giving the impression of the immensity of space which overflowed in all directions at the same time and suggested the infinite. The cubists were thereby producing, according to Apollinaire, a fusion of science and metaphysics. Through his observations of the cubists' activities he was able to make a crucial distinction between the new and the old mental formation of the artist: the traditional artist is a sieve of human experiences and, stimulated by the muse, he is a facile interpreter of life; while the new artist, like the scientist, plods from effort to effort in the process of construction, unaided by divine inspiration, but possessing himself the grains of divinity.

Apollinaire's friendship with Picasso, Braque, Picabia, and the Douanier Rousseau made him a better apologist for the new art than the painters themselves could have been, thus setting a precedent for closer association between the arts of painting and writing, a relationship which was to prove so significant and influential in the development of dadaism and surrealism.

The influence of ideas is a subtle thing and an elastic one. To what extent an individual is the originator and principal propagator of concepts can be a subjective evaluation. Certainly in the writings of several early twentieth-century thinkers there were to be found parallel definitions of the new objective in the arts. We have noted Saint-Pol-Roux's stress on the creative powers of the poet. Max Jacob, who was Apollinaire's friend and contemporary, gave a similar importance to inventiveness and to the faculty of using concrete imagery in his *Conseils à un Jeune Poète*; and the

gifted young poet, Pierre Reverdy, was seeing in cubism in 1917 much the same thing as Apollinaire and expressing it in almost the same words: "an art of creation and not of reproduction or interpretation."[3] And strangely, in an issue of *La Phalange,* at the time when Apollinaire was its book reviewer, there appeared the translation of an article by the American, Gerald Stanley Lee, explaining the modern writers' fear of the machine and deploring their melancholy attitude toward it. The artist, he said, is afraid of the machine only because he has let himself be dominated by it instead of emulating the attitude of mind which created it.[4] The examples could be multiplied. Apollinaire's importance lies not so much in being the originator of an attitude as in having stated it more provocatively and held to it more persistently than his contemporaries. His ideas on art did not remain in the realm of theories but were illustrated consciously in the major portion of his poetic work.

Apollinaire was not a suggestive artist in the manner of the symbolists. Like the magician that he wished to emulate, the poet tried to infuse his work with unexpected sparks: visions, concretely resplendent and limitless, meant to surprise and mystify the reader in the way that a rabbit is pulled out of a sleeve. The old artistic aim was to arouse the emotions of the reader or spectator; now art was to be a sort of jovial game to create not pity or empathy, but *wonder*—and sometimes irritation.

His earliest poetical work, *L'Enchanteur Pourrissant* (*The Rotting Enchanter*) 1909, depicts the imprisonment of the enchanter by those who exploit his power but also prophesies the magician's eventual resurrection.

In it he combines the concepts of death and resurrection just as André Breton was to do sometime later in *Arcane 17.* The enchanter Merlin is dead because the world has willed it so by rejecting magic and enchantment. But the anomaly of his position

[3] Pierre Reverdy, "Cubisme," *Nord-Sud,* I, p. 6.
[4] Gerald Stanley Lee (trans. Léon Bazalgette), "La Poésie de l'Âge des Machines," *La Phalange,* 33, pp. 789–795.

is replete in the fact that the enchanter, who is immortal, cannot die.

> The enchanter had entered consciously into the tomb and had lain himself down as do the cadavers. The lady of the lake had let the stone fall back on him and seeing the sepulcher close had burst out laughing. And so the enchanter died. But as he was immortal by nature and his death derived from the incarnations of the lady, he remained living in his cadaver.

He is then dead only in the eyes of the world, and he will come back to earth when humanity is again ready to reclaim him. Apollinaire sees this time as close and bases his whole optimism on the fact that man's inventive spirit has again become ignited with the advent of the new century. It must not be forgotten that the advances made by Einstein in the early part of the century were as exciting to that era as the progress into space has been to later generations. Both Saint-Pol-Roux and Apollinaire refer to Einstein, and long for the day when the artist may be able to make breakthroughs in the concept of reality in step with the mathematician's theories. For them Einstein is the supreme poet of their era.

The symbol of the immortal Merlin dead to mortal man is an obsessive image for Apollinaire and the basis for his poetic vision which he tries to shape through the fusion of the finite with the infinite, what he calls "reasonable irreality." In *L'Enchanteur Pourrissant* all the apocalyptic events that Apollinaire describes in the ambience of the enchanter are marked by a language that tries to waive the contradictions of physical reality which it expresses.

L'Enchanteur Pourrissant ends with a piece of writing called "Onirocritique," which is a natural appendix to his work. It represents Apollinaire's earliest example of inventive writing: in an apocalyptic vision of the universe he combines creatures and disintegrates them into a hundred feet, eyes, in an ever-changing panorama; sounds are transformed into beings, silence into

movement, trees consume stars; and each reader is left with his own interpretation of the imagery. Apollinaire was to adhere all his life to this faith in the poet, which he had expressed in this early piece of writing. Later in "Les Collines" he was indeed to announce that the resurrection of the old enchanter was at hand, and that he was about to arise again from his man-imposed grave: "Voici le temps de la magie."

The two basic anthologies *Alcools* and *Calligrammes,* in which he collected his poetic writings, contain two types of poems, both inspirational to the future surrealists, although in different ways: the poem-manifesto and the poem-illustration, the first giving comfort, the second being more relevant to the techniques of surrealist writing.

In *Alcools* (1913), his first collection of verse, we find instances of the same mixture of perspectives and sensations. Just as the technologist formed a new world of realities with existing matter, Apollinaire believed that words could make and unmake a universe. He attempted to use his "five senses and a few more" to string side by side images often logically disconnected, demanding of the reader leaps and bounds of the imagination to keep pace with his self-characterized "oblong" vision. His dislocations of temporal and spatial perspective defy ordinary reality but are of this earth in their tactility, colors, and scents. "Cortège" presents one of the most incoherent yet challenging visions in the theme of the inverted flight of a bird and its effects on the relativity of land, sky, and light:

> *Bird, tranquil in your inverted flight, bird*
> *Who nestles in the air*
> *At the limit of my memory's glare*
> *Shut out with your second lid*
> *Not for the sun nor for the earth*
> *The oblong fire growing in intensity*
> *Until one day all alone it shall prevail*
>
> *[Oiseau tranquille au vol inverse oiseau*
> *Qui nidifie en l'air*

A la limite où brille déjà ma mémoire
Baisse ta deuxième paupière
Ni à cause du soleil ni à cause de la terre
Mais pour ce feu oblong dont l'intensité ira s'augmentant
Au point qu'il deviendra un jour l'unique lumière]

"Le Brasier," "Le Voyageur," "Vendémiaire," could be called experimental poems: attempts to avoid ordinary descriptions of the world and to personalize and thus re-create the realities of fire, sun, sky, sea, heights, depths, and the elixirs of human thirst. Fire is endowed with the magic power attributed to it by the ancient alchemists: "The masked future blazes across the skies." . . . "Up there the theatre is built with solid fire / Like the stars that nourish the void" . . . There is a strange, hallucinatory incongruity between the convulsive motions of the universe and his own immobility as he sits in his chair and views the spectacle: "And for ever I am seated in my armchair / My head my knees my elbows useless tentacles / The flames have grown on me like leaves." In "La Maison des Morts" (The House of the Dead) he goes as far as to combine the two spheres of life and death, and he allows his living and dead creatures to intermingle and coexperience not abstract but very concrete sensations.

On the other hand a poem such as "Poème au Mariage d'André Salmon" offers nothing new in terms of illustration of a new aesthetics; it could even be considered redundant in its repetitions and in the direct form of its communication of Apollinaire's joyful celebration of his friend's consummation of love. But it is an inventory of work in progress as far as his poetic destiny is concerned. It is in this poem that Apollinaire uses the expression "pilgrims of perdition" to characterize what he and his friend had attempted to do: to catch the eye of a dying Orpheus, to seize the divine fire, to learn also to laugh, and to ignite words with new meanings, i.e., to change the world through language,—an objective that the surrealists were to make distinctly their major concern. "Let us rejoice because the director of fireworks and of poets / Love that fills thus with light / All the solid space between

the stars and the planets / Love wills it that today my friend
André Salmon be married."

Calligrammes (1918) is a more striking example of his inven-
tive approach to writing. The theme in this collection of poetry is
the newness of the world: new fires, new forms, new colors
impatient to be given reality. The wand which has brought about
the return of the "age of magic" is said to be the war. Despite the
tragedy and pathos experienced first hand by Apollinaire, his
vigorous imagination accepted in compensation the challenge of
new vistas revealed by the inventions pertaining to the war. With
prophetic eye he placed the marvels of war above its miseries.
Beyond the political conflict he discerned the more fundamental
quarrel between tradition and invention. In a poem called "War"
he bids his readers not to cry over the horrors of war but instead
to realize that, while before we only knew the surface of earth and
sea, now we could reach deeper below and higher into space.

He felt the science of war making him at once invisible and
ubiquitous. Time had acquired a new flexibility which could
make it vanish and be restored. He sensed that man was ap-
proaching the exploration of the lower depths not only of the
physical world but also of his own consciousness.

In *Calligrammes* Apollinaire used juxtaposition and discarded
symmetry and order much more than in his previous works.
These poems are circumstantial in the sense that their point of
departure is a factual event or concrete detail of the color of the
times. But the submarine cables, the planes fighting overhead, the
bombs, the flares, the telephone or the phonograph, each serves as
an impetus to new imagery surpassing its circumstantial nature
and announcing to Apollinaire the need to alert and sharpen the
senses.

When Apollinaire was criticized for the obscurity of the sym-
bols in his play, *Les Mamelles de Tirésias*, he defended himself
by stating that true symbolism, like the Sibylline Oracles, lends
itself to many meanings, "to numerous interpretations that some-
times contradict each other." *Calligrammes* fearlessly illustrates

this theory, thereby setting a new relationship between the artist and his audience: if the writer or painter is no longer to be a mere interpreter of life but a creator, then his erstwhile role of interpreter will be transferred to the reader or spectator, who loses his passive task of absorbing and feeling the message of the artist and assumes the more creative role of relating the sensations of the artist to his own experiences and his own faculties of imagination and association. Thus in their flexibility, the visions of the artist are set to a perpetual motion of interpretations, which may in themselves be a form of creative activity. This same technique, called by the uninitiated the obscurity of modern art forms, was to become the *sine qua non* of the works of the dadaist and surrealist disciples of Apollinaire.

Here again we have manifesto poems, particularly in "Les Collines" and in the last of the series, "La Jolie Rousse." Both poems written in very direct and clear discourse have in their linguistic structure none of the sibylline character, but oracular they are and their augury is of joy and wisdom as Apollinaire foresees a future where "machines may begin to think," where the "depths of conscience will be explored" and "other worlds will be discovered."

> *Man will become divine*
> *More pure more live and more learned*

The nostalgia one can detect underlying the exuberance is not for what the new world will lose but for what he himself will not live to see.

In "La Jolie Rousse" he seems to talk to those who are resisting the change prophesied in "Les Collines." He identifies with the renovators in the struggle between Order and Adventure, which as he sees it the war had brought to a head.

> *There are new fires colors never seen before*
> *A thousand imponderable phantasmagories*
> *To which reality must be given*

The important phrase is "auxquels il faut donner de la réalité" for it places the fantastic in the domain of reality, not as its antithesis but as an agent that can expand reality. For Apollinaire believed that "The domain of the imagination is reality," a concept that was to be accepted by the surrealists as the focal point of all their efforts to intensify life and enrich vision. Apollinaire's formula becomes what Paul Eluard calls "donner à voir," and Breton "le don de faire voir." Although Apollinaire experimented with images in trying to implement this concept, he was not quite successful in the execution of the desire. He seems to transfer the default on to others in "La Jolie Rousse":

> But laugh laugh at me
> Men from everywhere particularly people right here
> For there are so many things that I don't dare tell you
> So many things that you would not let me tell
> Have pity on me

Yet, paradoxically, the eyes of the young were turned to him more than to anyone else. The fact that the desire, the verve, the prophetic mechanism were stronger than the actual crystallization they produced in his work, was to disappoint to a certain extent his young admirers. They were to remember him as a source of inspiration inferior only to Rimbaud and Lautréamont, and perhaps more provocative than either of the other two because in his person, in his vitality, in his generous heart and jovial enthusiasm the role of poet seemed to be incarnated in all its glory,— perhaps for the last time. "The last poet!" said André Breton.

Perhaps, in the long run, the greatest mark left by Apollinaire on the current of ideas will be the break he dared to make with the *mal-du-siècle* attitude which had played the poetic strings of melancholy in the nineteenth century, and had then continued uninterrupted through an undetermined state called "inquiétude" or uneasiness over the modern world's ills shared by the leading writers before and after World War I. This attitude which has been deemed by many critics to be synonymous with profundity,

had led them, perhaps prematurely, to term the epoch since World War I as the age of anxiety. It may be that when there is the possibility of observing the century with more perspective, the critic will find this noncommittal, indecisive worrymindedness a carry-over from an earlier age, just as the literary forms practiced by many of the highly esteemed writers of the epoch were not a change from those of the nineteenth century but a prolongation of them. Apollinaire is one of the very first to have felt that dejected, introspective brooding could not be a characteristic of the modern mind. "This pessimism more than a century old, ancient enough for such a boring thing,"[5] should, he said in *Les Mamelles de Tirésias*, be now replaced. The fat, jovial, buoyant cosmopolite had had his share of disappointments in life, but he always maintained his hope in the future with its challenges and surprises. In the words of his friend Philippe Soupault, who recalled Apollinaire's character after his death, he was "the being most happy to be alive" and although sometimes sad, languorous and melancholy, yet never one who despaired.[6]

Apollinaire believed more fervently, perhaps, than any writer of his generation in the future of art, and he announced in one of his very last writings, *Couleur du temps*, that the resurrection of the poets was approaching. He wanted to give man confidence in himself, he wanted to counteract the age-old cliché that man has no future, that he is hopelessly ignorant and a born idiot. Having tried to cultivate in himself the power of prophecy he saw beyond the grimness of mechanization, beyond the dumbness of uncontrolled instincts, beyond the gruesomeness of war. He was not afraid to use the word "progress" although he had an inkling that a more appropriate term for what he wanted would be found perhaps in a hundred years. Beyond mechanization was to be the new world of enchanters, beyond uncontrolled instincts would be the discovery of their secret motivations and possibly the eventual

[5] *Les Mamelles de Tirésias*, p. 31.
[6] Philippe Soupault, "Guillaume Apollinaire," *La Revue Européenne*, 6 (January 1, 1926), pp. 3–8.

improvement of man, beyond the gruesomeness of war would be the letting down of physical barriers, the broadening of the domains of man in all directions—as indeed they have been broadened since World War II. And through all these things, what primarily interested him was the possibility of new subjects for the artists' imagination: thousands of new combinations which spell progress in art, as well as in life. The hymn of the future would be "paradisiac," he said in his poem "La Nuit d'avril 1915," and "victory" had for him a more basic meaning than the cessation of hostilities.

Was Apollinaire's optimism to prove an anachronism in the intellectual history of the twentieth century? Considering the prevailing pessimistic strain in the best known and most acclaimed writers in most countries in the epoch following Apollinaire's death, and even including some of the post-World War II crop, one is inclined to believe that Apollinaire misjudged the "modern mind." Yet many of his contemporaries and younger *confrères* had the conviction that he would exercise great influence on art and literature. Philippe Soupault called him a "signal flare" on the artistic horizon and pointed out that Apollinaire subjected his contemporaries to a sort of contagion: "It is . . . thanks to him that poetry was revived. . . . All he had to do was to write a poem and immediately many poems would be born, publish a book like *Alcools* and all of the poetry of his time found an orientation."[7] André Breton, who according to Soupault was one of the first to realize what a poet Apollinaire was, grants him the credit of having been the re-inventer of poetry, in his article on Apollinaire in *Les Pas Perdus;* and he points to the psychological truth revealed in the apparent disorder of his writings, this disorder which through Breton was to become a major characteristic of modern poetry in France. But awareness of Apollinaire's role as a motivator of ideas went beyond French boundaries. In

[7] *Ibid.*

his preface to Apollinaire's *Il y a*, Ramón Gómez de la Serna states that he was the poet who has suffered the least degree of death in dying.

The group which, despite its initial tone of despair, gradually took up Apollinaire's tone of optimism, was the surrealists themselves. Ironically, in the midst of the tragic social and political chaos of troubled Europe they were increasingly to adopt the note of fortified prophecy bequeathed to them by their precursor. In the war and post-war poems of Breton, Aragon, Char, and Eluard there is revealed the same type of energetic optimism and hope as in the vigorous poems of Apollinaire written during the previous war.

Between 1950–60, the dozen or so works that unraveled Apollinaire's unpublished poems, biographical data, and souvenirs of his friends, were received by the French public as a homage to a national hero. A street was renamed in Paris to bear his name. The summer of 1952 saw an issue of *La Table Ronde*, dedicated to Apollinaire, sell as popular literature on the kiosks of Paris. In a letter to me shortly after the celebration of the thirtieth anniversary of the poet's death, Madame Apollinaire wrote of "the great enthusiasm and fervent admiration of Apollinaire which animates the youth of today."

Since Mme. Apollinaire's letter, the fame of her husband has ascended in accelerated fashion. His reputation has become solidly enough established to provoke modifications and revisions on the part of those who are the first to acknowledge his tremendous impact on the arts in the twentieth century. There has been an avalanche of critical, biographical, and bibliographical writings on Apollinaire. The work of Michel Décaudin in assembling Apollinaria and in channeling research about him has been invaluable. In *Apollinaire 1964*[8] articles by Marguerite Bonnet and J. H. Matthews gauge the actual influence of Apollinaire on

[8] "Guillaume Apollinaire," *La Revue des Lettres Modernes*, nos. 104–107, 3rd series.

the surrealists. Marguerite Bonnet is very right in saying of Apollinaire that "after him, nothing is forbidden to the poet,"[9] and "he believed in the existence of a poetic material in life, independent of the poem," but when she goes on to say that Apollinaire had too simplistic an admiration for the modern machine and that "poetry was for him the expression of life, not the promise of its transformation,"[10] the statement is more disputable. If Apollinaire abandoned his enthusiasm for futurism and its author Marinetti, it was precisely because the futurists attached, as he thought, more importance to the gadget than to the creative faculty that had produced it. And Apollinaire's own nonchalant use of "form" in his poetry should persuade anyone that he did not particularly care how he *expressed* that life but rather how he could change the condition of that life: by desire, by laughter, by the obliteration of the measurements of time and space, by the recuperation of the fire of the old alchemists. These were the resources that like a benign Lucifer he wanted to make available to those who came after him.

As for the evidence that J. H. Matthews gives[11] to show that later surrealists, those who came to read Apollinaire and Breton at the same time, did not feel as strongly their derivation from Apollinaire, this is quite understandable, just as those who feel the impact of Freud are not necessarily aware of a debt to his teachers, Charcot and Janet. A second or third generation heritage becomes natural wealth, the more freely enjoyed because in its anonymity it does not remind the recipient of the struggle by which it was accumulated. This does not, however, diminish the splendor of the original benefactor.

André Breton was himself somewhat disappointed that *Les Mamelles de Tirésias* and *L'Esprit Nouveau et les Poètes* had not added anything new to what Apollinaire had previously proclaimed, and he hesitated to pronounce himself on the future

[9] "Aux Sources du Surrealisme: Place d'Apollinaire," *ibid.*, p. 70.
[10] *Ibid.*, p. 71.
[11] Cf. Matthews, "Apollinaire devant les Surréalistes," *ibid.*

position of Apollinaire in the literary hierarchy. But he discerned as Apollinaire's basic relevance to himself and his companions in the spring of their years Apollinaire's unwavering objective: "the re-invention of poetry."

The power of love, the power of laughter—a very modern laughter in the face of adversity—the mystique of fire and of language, all of it fortifying the new poet with an optimism intended to erase the pessimism of the elder symbolist poets, these were to be the itemized legacies that Apollinaire was to leave to his young friends, Breton, Aragon, and Soupault, who had radiated toward him, first through letters, then in person at the bedside of the wounded, trepanned soldier, then as satellites of the hero of the artist circle of the Café de Flore in the last days of World War I. In fact, Apollinaire had paid Breton the compliment of saying to him: "I know no one who can speak as well as you about what I have done."

It seems incontestable that Apollinaire changed the key of the poet from the minor one of the symbolists to a more vigorous and more exalting harmony. If he is right in believing in the energy of creativeness of the modern mind and in thus establishing a *mystique* of the *here and now*, he is indeed a herald of a new age of enchantment and will loom more and more prodigious in the history of ideas as well as of literature.

5

*pierre reverdy
and
the
materio-mysticism
of our age*

Pierre Reverdy has been truly one of the important metaphysical
poets of his time. A contemporary of two great nonrealists,
Claudel and Valéry, he found spiritual outlet neither in a specific
religion nor by reducing life to an abstract purity. Incapable of
public adherences, he lived his personal as well as artistic life
in the lonely margins of literary coteries. According to him, life is
the same for everyone, nothing amazing, nothing unpredictable.
His own was free of personality quirks, of mental or physical
aberrations. In fact his art so completely invaded the current of
his daily living that biographers would have few events to record
about him. This is not to say that he "lived" for his art, but
on the contrary his art was the expression of that life, comprised
its constant pulsation and passage and was integrated with it.

Upon the publication of his first major volume of poetry, *Les Épaves du Ciel* (Chips of Heaven), written for the most part between 1915 and 1918, and collected in 1924, this is all the information which he gave about himself: "Pierre Reverdy, born in Narbonne on September 13, 1889. No travel, no adventures, no story, but what stories."

A rapid reading or sampling of his poetry misleads the reader completely: one imagines an ethereal being, Nordic in melancholy, pale with dreaming, misty-eyed with vision, at ease only in the nebulous atmosphere of smoggy cities and cloudy countrysides. The delicacy of certain imagery suggests a frail, almost incorporate being, unsubstantial as some of the mirages inherent in his work.

Yet, this is only the initial step to the understanding of Reverdy and his poetic world; and this is the antithesis of his true self.

In reality, Reverdy was a stocky, robust being, not pale but fiery of look, not delicate of movement but forceful, not fluid of speech or gesture but abruptly energetic, direct of aim, vibrant of purpose, a product not of mist but of the hot sunshine of his Mediterranean birthplace. And a deeper reading of the work reveals a much more concrete world of things and beings, solidity of objects with precise though unaccepted positions, the world in metaphysics, i.e., a mutation of the material world produced by a thirst for mysticism acute and sustained for all his lifespan, his roots in heaven and his hands in clay.

The major biographical and artistic fact in Pierre Reverdy's life was, at the age of twenty, the impact of his father's death; not just the emotional shock of loss of the dearest being in his life, but the horrifying material reality of the metamorphosis between livingness and lifelessness, the abruptness of the change, and the infinite implications it suggested to him in terms of the myths connected with immortality. On that day and forever after he was obsessed by the fixed and morbid idea of nothingness. His spiritual house of cards collapsed, and it is thereafter futile and

deceptive to talk of the poet Reverdy in terms of religious mysticism or dogmatic faith. In his prose maxims (1930–36) collected under the title, *Le Livre de Mon Bord* (1948), he says touchingly and yet bluntly: "One can believe in God without loving him . . . but one can love him without believing in him—with a love, insane, rebellious and strong, loving all that he might have been if he could have been."[1] This is the only love of God that one can honestly refer to in speaking of the mysticism of Reverdy.[2]

Yet, his loss of faith is the beginning of his real spirituality, with which his whole poetic work is inextricably involved. As he abandoned the faith of his childhood he felt that for him faith had been a stopgap in his spiritual development. It seemed to him that belief was the end of a crisis and therefore incompatible with his nature and its need for relentless searching. The loss was really a gain, the beyond had lost its determined target, expanding into something larger, in fact the beyond was henceforth "everything that is outside of the skin that is tightly drawn around our body." He took the "metaphysical distress" that arose out of his personal loss of father and of God not with self-pity but as an impulse toward greatness: "it is not a weakness but on the contrary a symptom of quality and force, for every soul that is besieged by it can henceforth rely only on itself to surmount it."[3]

The loss of faith is the beginning of spiritual fortitude for

[1] *Le Livre de Mon Bord* (1930–36) (Paris: *Mercure de France*, 1948), p. 151.

[2] Efforts have been made on the part of a number of critics to present Reverdy under the guise of a great religious poet in the Catholic sense of the word. My own observations have led me to the opposite view. In 1960 shortly after his death I visited Solesmes and interviewed the priest closest to Reverdy, who had seen him almost every day of his life in Solesmes and whose offer of prayers in Reverdy's last illness had been spurned. The admission of atheism, which Reverdy had made to me eight years before on a walk through Paris which we took together and during which he confessed that the only god he believed in was Rimbaud, was confirmed by the monk with deep compassion and no resentment. The priest, an extremely intelligent person, recognized the magnitude of Reverdy's poetry, and had understood also the extrareligious character of his mysticism.

[3] *Ibid.*, p. 36.

Reverdy. He accepts the fact that death is the greatest enemy of man and the invincible one. But this fact creates in him neither a sense of defeat nor of cynical disdain. Disdain of death would be accompanied by disdain of life, and although he admits the tragic basis of life, he refuses to disdain living. The alternative is to transmute life within our limited number of years. How to transmute it becomes the preoccupation of his life and work.

Reverdy's work is the overflow of this metaphysical quest. If he became a writer it was because that happened to be the only means of expression at his disposal at the moment of spiritual awakening. Had he been trained in art (like his father), or in music, his poetic contacts with the physical world would have been represented just as readily by lines or notes.

From 1915 on, the stratifications of his life,—rather eventless from the point of view of social involvements or emotional crises, —are the slow unwinding of his work. After his first volume of collected poems, already cited, there was the exposition of his *ars poetica* in *Le Gant de Crin,* and the eventual collection in three volumes of his complete writings, including the previously mentioned *Le Livre de Mon Bord,* and two volumes that comprise his total poetic writings from 1913 to 1949. Throughout the entire work, whether prose or poetry, the principal theme and thought is the quest for the absolute in the various strata of reality. It is significant to note that although he sidestepped the coterie of the surrealists, he preceded them, then became their contemporary, sharing their metaphysical aspirations; but he evolved his destiny independently and in solitude though remaining on friendly terms with surrealist artists and poets, just as he stayed faithful to his earlier affiliation with the cubists without making it a total involvement. Living in the monastery climate of Solesmes and taking only occasional trips to Paris and its hotbeds of literary theory, he integrated nonetheless within his work the many metaphysical *élans* of concern of the artists of his time.

First of these was the concept of reality. Unlike metaphysical

poets of past epochs, Reverdy always considered reality irrevo-
cably involved with mysticism. His *mystique* does not annihi-
late reality. Because of this he has often been called a "realist."
But we must be careful to understand that what he calls reality is
not the accepted concept of the real. For him reality is what lies
beyond "the deception of the senses." It is neither on earth nor in
heaven, but as he terms it "over the roofs." In his sturdy hands
he will take the clay of earthly objects and through language
transform them. Were he to abandon the plane of reality, he
explains in an essay entitled "Fausses Notes" (False Notes)
appearing in the art magazine, *Verve* (1952) he would end up in
nothingness. The poet must stay in reality, after having first made
a "leap toward the heights, like drops of water, surging out of the
river," but only to return, the better "to be absorbed after having
thrown off darts of diamonds with which light had adorned them."

More than any other of the poets discussed here, Reverdy
could have shunned and despised exterior reality. If Rimbaud
was repulsed by his birthplace, Charleville, and early in life ran
away from it, it was Reverdy's destiny to spend his days on earth
in the dreariest of environments. The town of Narbonne where he
was born is one of the least attractive of Mediterranean cities.
There is none of the colorful atmosphere of vegetation or the
picturesqueness of Mediterranean villas. It is somber and squalid,
a worker's town, lacking the glitter of most coastal cities. The
monotony of its houses and streets is depressing. Others of
Reverdy's meridional colleagues came north and settled in Paris.
Reverdy's stay in the capital, which for so many other writers
became the city of enchantments, was of short duration. He could
not afford to live in Paris, and he went to live in the town of
Solesmes simply because it was one of the cheapest places to exist
for a poet whose livelihood was precarious and inevitably irregu-
lar. If Narbonne is a sad town, Solesmes is positively dreary. Its
streets lined with solemn, uniform poplars, are inundated by the
melancholy bells that toll in the monastery. There is a silence that
is almost unearthly in Solesmes, where the transients that come

by are mostly attracted there for meditation and devotional retreat. Reverdy talks often in his poems of roads that turn. After seeing Solesmes one might add that they turn and go nowhere. Dreary houses line the streets and are surrounded by farm country. To be stuck in such a desolate spot without possessing the religious power of transcendence that comforts most of the inhabitants living in the shadow of the great monastery, could only have been tolerated by a poet having within him the power of transformation. The monks with whom I spoke at the monastery confirmed the fact that Reverdy never went to Mass although his wife was a most devout and practicing Catholic. But he spent innumerable hours in the monastery reading and particularly talking with the monks whom he admired as lay thinkers rather than for their religious beliefs. These endless conversations were his main distraction from the monotony of his existence. When his need for the companionship of his artist friends became too acute he went on one of his many brief fugues to Paris to re-charge the battery of his mental vitality, which burned like a quiet but constant flame in the chill atmosphere of Solesmes. Reverdy's metaphysical power over his daily drab environment becomes the more miraculous when the picture of the two dreary locales of his existence are brought to mind. But if in a similar environment Jean-Paul Sartre's Roquentin has nausea and finds his life absurdly useless, the poet in Reverdy demonstrates the victory of imagination and its power to give elasticity to the view from our window: it is the triumph of inscape over landscape.

In a similar case of incongruity between the poet and his environment, Stéphane Mallarmé had found release in the world of verbal abstractions. In his sonnets he found refuge in meta-phors of the void and in rarefaction of objects divesting them-selves of their concrete dimensions and weights. Quite to the contrary, Reverdy does not obliterate the reality but transfigures it, endows it with an unwonted, unpredictable quality that places things on the brink of revelation in a posture of expectancy. They convey the moment when the magician touches the object with his

wand, just as it is about to but has not quite turned into something else. This transitionary quality injects a vibrancy in the objects and into physical nature that is often more compelling than the actual occurrence of phantasmagoric transformation, just as the present participle of a verb has more power of provocation than the past participle. One might say that the network of Reverdy's imagery presents the earth in transition.

According to Reverdy, man's leaps of imagination are valid only when they meet with an equal degree of linguistic power. The literary image, even as the pictorial, has an existence independent of the natural order of things. It is neither a quality of man who created it nor consistent with the objects of this world. It resides outside both the see-er and the objects of his vision, yet has its own inherent reality. "Poetry is neither in life nor in things—it is what you do with them and what you add to them,"[4] he reflects in *Le Livre de Mon Bord*. The only metaphysics possible for him consists in rendering matter dynamic and thereby reaching the absolute through matter.

It can therefore be said that the poet is against reality yet deals constantly with it. When, on the one hand, Reverdy says: "The poet is a furnace in which to burn reality,"[5] and in the next breath asserts that "the poet is essentially a man who aspires to the domain of the real," there is not really the contradiction that the words seem to indicate. In a most lively image Reverdy illustrates this apparent contradiction: "The poet is a transformer of current—from the high tension of reality to the incandescent filament which gives light."[6]

In other words, unlike his precursors, the symbolists, he accepts the exterior world just as he refuses to disdain life, but at the same time he constantly affirms man's insatiable hunger for the marvelous. In this quest, the enemy will not be reality but nature. The distinction which he makes between the two has been

[4] P. 74.
[5] P. 72.
[6] P. 53.

accepted as fundamental by the surrealists. Reality is what you make it; the rational laws by which we judge physical nature are the inflexible element, and must be surmounted by man's imagination. He says in *Le Livre de Mon Bord:*

> The innermost quality of man is his inexplicable need for the marvelous. And that is his sharpest point of divorce from nature. We no longer believe in miracles—nothing is more obvious. But the miracles in which we no longer believe are as nothing in comparison with those that each man carries in reserve within his innermost self and which his imagination offers him at all time.[7]

In his acceptance of the exterior world he points up better than any critic of the time the point of default of symbolism. He minimizes the importance of the dream, which had been the crux of the aspirations of both the romanticists and the symbolists. For Reverdy it is only a means to an end: the tunnel that passes under reality, a gutter of reality. The poet dreams, but he dreams of life, of his hypothesis of life, in which he learns to love life better: "One learns to love reality better sometimes after a long detour by way of dreams."[8] His dream then is hard and durable, as the studies in concrete which are the dream realizations of the artist. "It was an unheard-of adventure, that of the artists of the concrete, when they extended this domain toward that of poetry, the immense field of the undefinable," he observes in the *Verve* article. It is their example that he chose to follow rather than that of the musician whom the symbolists imitated. In following the techniques of music, poets had met with their most dangerous pitfall, a danger from which we have not yet (1952) liberated ourselves, deplores Reverdy. For by simulating the only art that does not need to evoke reality, they stumbled into a vagueness not only of expression but of mind: an exit out of life leading not to the infinite but to nothingness.

No, the dream and its imprecisions, may be a temporary opiate

[7] P. 12.
[8] P. 114.

to the poet, but he must not become addicted to it, for it will lead
to sterile fields. Not the musician but the artist should be the
modern poet's counterpart. It is the artist that has succeeded in
attaining not an escape but a marvelous kind of new reality
through the object.

"If man disappears, the earth remains, the inanimate objects,
the stones in the road. If the earth disappears, there remains all
that is not the earth. And if all that is not the earth disappears,
there remains what cannot disappear—one may wonder why—
because one cannot even think it and in the long run this is really
what reality is, so far from the mind and mirror of man, who
cannot even conceive of it." (*Verve*)

This ultimate material reality which he defines in old age, is
what he earlier named "surreality," and it is upon an approxima-
tion of this that he wove the network of his poetry. It is the field
of mental perception and physical sensitivity wherein unapparent
relationships are grasped between objects. Beyond these relation-
ships lies the infinite, i.e., the realm at whose borders our
faculties fail. But within the charmed circle of these relationships,
imperceptible to the common breed and attained as if through a
mystic chance by those who may call themselves poets for lack of
a better word, the artist has the impression of real creativeness.
Less optimistic than Saint-Pol-Roux, Reverdy concedes that it is
an illusion, but it is the guiding force, nonetheless, of the artist's
work and more satisfying to his mystic thirst than any cult.

The test of the quality of a being is then not the degree of inner
(dream) or outer (rarefication) escape in which he engages, but
the objects toward which he radiates and by which he is repre-
sented, or with which he is identified by the immediacy of the
image. Otherwise, he is unthinkable, nonexistent. In the deserts
of nonexistence there is no real art. By his penetration of the
concrete, the quality and limits of the mind can be recognized
and judged. Man's roots are in heaven but as a tree upturned,
whose leaves touch the soil, it is this contact with the tangible that
gives promises of illuminations.

Undisturbed by polemics, personal affiliations, or schisms with colleagues—as is the case with the surrealists—Pierre Reverdy came closer to defining the spiritual and aesthetic position of the modern poet than anyone else in France in his time. A more striking personality, Apollinaire, left a more fragmental *poetics* and did not have the benefit of a long life span to give it consistency. But the test of the value is not in theory, it is in the poetry itself. Although Reverdy, in a cruel moment says of the critic: "When certain critics speak of poetry, it is a little as if veterinarians tried to treat human ills," nonetheless let us attempt to find in the poetry—to the degree of our receptivity—the elements which the poet in his prose statements indicated as his points of orientation.

Reverdy's first collected works suggested that very combination of heaven and earth that was to serve as the locale of his poetry: "Les épaves du ciel," heaven, the infinite, coupled with "débris," suggesting shipwreck, but very concrete and objective remains of the unthinkable infinite. Making his début in the literary world, significantly at a time of war, he considered death, rampant everywhere, not the mysterious intruder as in Maeterlinck's symbolist representations, but a common denominator of life, not a robber of life but its spouse.

Reverdy's universe is an immense blackboard on which part of the great design has been erased. The poet's intention seems to have been to focus his spotlights on the bits which remained here and there. He seemed not to care to guess at the connections. In fact the main distinction he later indicated between prose and poetry was not one of form. (There is really no need to draw a distinction between Reverdy's own poems in prose and poems in free verse.) The difference lies for him between juxtaposition and reasonable connection, the independence of parts in contrast to the succession of ideas. He is not an architect but an interpreter of lines, the broken, disconnected lines of life, blocked sometimes by those of death.

DEPARTURE
The horizon bends
 The days are getting longer
 Voyage
A heart leaps in a cage
 A bird sings
 About to die
Another door will open

At the end of the hall
 Where there is glowing
 A star
A dark woman
 The lantern of the train departing

[*L'horizon s'incline*
 Les jours sont plus longs
 Voyage
 Un coeur saute dans une cage
 Un oiseau chante
 Il va mourir
Une autre porte va s'ouvrir

 Au fond du couloir
 Où s'allume
 Une étoile
 Une femme brune
 La lanterne du train qui part]⁹

The connections are lacking because often they are unknown to the poet himself. This undirected work, the product of a divine chance, casts a charm over the shadows which constitute life and which have no outlet from the compact walls of the earth.

His world of detached images is a depopulated world in his earliest poems—not incomprehensibly so since its basis is war-time, depleted Paris. It is a world constantly on the verge of stopping in its movement. One of the strangest sensations throughout Reverdy's poems is the constant awareness we have of

⁹ "Départ," *La Plupart du Temps* (1915–22), NRF (Paris: Gallimard, 1945), p. 165.

the turning of the world, like a cardiac who is the more conscious of his heartbeat in the fear that it might stop at any moment.[10] Indeed, several times the earth actually stops in its rotation at Reverdy's bidding as objects assume their infinite repose: "The world shuts up shop silently and all at once."[11] Many of these poems are, like Mallarmé's *Igitur*, the poet's sensation of death while still in life.

SOUND OF BELL

All is snuffed out
 The wind passes singing
 And the trees quiver
The animals are dead
There is no one left
 Look
The stars have stopped shining
 The earth stops turning .
A head is leaning
 With hair sweeping away night
The last bell tower left standing
 Strikes midnight

[*Tout s'est éteint*
Le vent passe en chantant
 Et les arbres frissonnent
Les animaux sont morts
Il n'y a plus personne
 Regarde
Les étoiles ont cessé de briller
 La terre ne tourne plus
Une tête s'est inclinée
 Les cheveux balayant la nuit
Le dernier clocher resté debout
 Sonne minuit][12]

[10] Shortly after Reverdy's death, speaking of him with Aimé Maeght who knew him intimately in his last years, I discovered that as his poetry had suggested to me, Reverdy had indeed been a cardiac most of his life.

[11] "Au Cercle qui Ferme les Yeux," *Main d'oeuvre* (1913–49) (Paris: Mercure de France, 1949), p. 197.

[12] "Son de Cloche," *La Plupart du Temps*, p. 170.

Upon this earth constantly bordering on eternity, the simplest objects have a geometric infinity, and contain a dose of the eternal. As a result the poet walks in a forest not of familiar symbols as was the case for Baudelaire but where the familiar things like a tree, a bird, a flower, a roof are strange and outside of natural phenomena. Reverdy possessed, along with the surrealists, that new poetic eye which discerns the eternal in the concrete and is no longer satisfied to associate the infinite with the realm of abstractions. Reverdy achieved this "new measure between the hand and the eye" by a most unobtrusive yet exact technique.

First there is protraction and contraction. Walls are forever moving away, rooms stepping out of their dimensions, windows out of their frames, the horizon falling off or several appearing at the same time. A small detail of a perceived object suddenly looms immense, becomes more important than the whole and completely overthrows our concept of proportion or symmetry. Then, objects step out of line by the unexpectedness of their movement. It is "the perspective of chance."[13] Trees take weird positions, houses sway, a window draws away its pane, a wall moves back, a roof rises, a door bends, the earth bends. Or else, movement stops where one expected it: the pendulum stops, the stars stop in their heavenly course. Things start contradicting the laws of nature: flowers are black and leaves never green, and the sun sings with a sweet sound; color mingles with the sound.

It is evident that Reverdy was a contemporary of Chirico. Many of his verbal images are sister-visions of Chirico's solitary streets and arches and unfriendly windows. This is the obvious similarity. There is a more subtle one: the material effect of intangible force: "the sun swells at the tip of a stalk of colored waterfall."

SUN
Someone has just gone by
And in the room

13 "Mille Murmures dans le Rang," *Main d'Oeuvre*, p. 83.

> *has left a sigh*
> *Life deserted*
>> *The street*
>> *An open windowpane*
> *A ray of sunshine*
> *On the green plain*
>
> *[Quelqu'un vient de partir*
> *Dans la chambre*
>> *Il reste un soupir*
> *La vie déserte*
> *La rue*
>> *Et la fenêtre ouverte*
> *Un rayon de soleil*
> *Sur la pelouse verte]*[14]

Or the effect of estrangement is produced by the negative verb used with a positive reality. The *tour de force* that can be achieved by a "ne—pas" or "autre!"

A lamp that is not lit, the door that does not open, the house where one does not enter! The static tableaus that he unfolds before us are beyond the dimensions of space, and free from "the armor of time," and only touched by the sense of space that resides in his heart. Indeed, the use of the present tense gives an undetermined time measure.

At times the simplicity of his work is marred by a relapse into symbolist technique, to which he himself is conscious of being drawn: the symmetrical, rational coupling of abstract with concrete. That is the source of the monotony which sets in sometimes in his poems. But when the coupling rises above the analogy and enters into the realm of reality then it enhances rather than lulls the vision. When synaesthesia is accepted at its face value, there is a veritable galaxy of images: silence falls heavily on the ground without breaking, hands ring, minutes sparkle at the tip of branches, the mountain whistles with its tail lost at the shores of the humid lashes of the sea. In "Ronde Nocturne" he constructs a stairway to heaven:

[14] "Soleil," *La Plupart du Temps*, p. 186.

On the horizon, someone softly rises to heaven
The stairs are creaking
> *It is an artificial thing*
It is a parable or a passageway
The hour that was escaping flies on a single wing

[A l'horizon sans bruit quelqu'un montait au ciel
L'escalier craque
> *Il est artificiel*
C'est une parabole ou une passerelle
L'heure qui s'échappait ne bat plus que d'une aile][15]

There are symbols, but fortunately his symbols are not too mysteriously significant, too philosophically contrived. They are: a man, a house, a train, a woman's voice, a room, a curtain, a tree, a bell, a flame. They have representative qualities, but they are concrete, there is vagueness not in the symbols themselves but in their fortuitous encounter with each other. It is the triumph of the part over the whole. The part is greater than the whole, for were you to see the whole you would give it *limit*. But seeing vividly that little patch of the whole, stripped of its usual associations, you feel that its scope is boundless.

NOMAD
The door which does not open
The hand which passes
> *Afar the breaking of glasses*
The lamp is smoking
The sparks which are lighting
The sky is blacker
> *Over the roofs*
Sundry animals
Shadowless

> *A look*
> *A dark speck*
The house no one enters

[15] From "Ronde Nocturne," *La Plupart du Temps*, p. 168.

[*La porte qui ne s'ouvre pas*
La main qui passe
 Au loin un verre qui se casse
 La lampe fume
 Les étincelles qui s'allument
 Le ciel est plus noir
 Sur les toits
Quelques animaux
Sans leur ombre
 Un regard
 Une tache sombre
La maison où l'on n'entre pas][16]

Reverdy's world of detached visions falls "between two worlds," earthy but not earthbound: through it the poet wanders in solitary fashion, unwilling to compromise with nature's yardstick. The lonely journey undertaken by those who have the power to discern chips of heaven in the bric-a-brac of earth makes of them giants among their fellowmen:

Those who are a source of disdain
Those who contain the drop of eternity that life demands
Those who have never known their limitation
Passing along the road with only heaven for a roof bend their heads
The stars have got caught in their hair
Scorching their heads
 And all that passes in a cavalcade
 Where metal clangs and catches fire

[*Ceux qui sont une source de mépris*
Ceux qui portent en eux la goutte d'éternité nécessaire à la vie
 Ceux qui n'ont jamais connu leur mesure
 En passant sur la route qui n'est recouverte que par le ciel
 baissent la tête
 Des étoiles sont restées prises dans leus cheveux
Une brûlure dans la tête
 Et tout ce qui passe tourne en cavalcade
 Où le métal résonne et s'en flamme][17]

[16] "Nomade," *ibid.*, p. 181.
[17] From "Les Jockeys Camouflés," *ibid.*, p. 240.

It is the simplest words of the language which convey his eternity:

> *Everything would frighten in the midst of this world*
> *In the world*
> > *Where music has another tune*
> *The measured steps another number*
> *And glass another reflection*

> [*Tout ferait peur au milieu de ce monde*
> *Dans le monde*
> > *Où la musique a un autre air*
> *Les pas comptés un autre nombre*
> *Et la glace un autre reflet*][18]

Finally the frontiers are passed: "The roots of earth hang out beyond the limits of earth." ("The Red-Head," *La Plupart du Temps.*)

The final lap of the journey is less stoical, the anguish more insistent, though still succinct. As in the case of André Breton, Eluard, and Aragon, the stress of World War II temporarily arrests the mystical anguish by the overwhelming proportions of the physical and human catastrophe it unleashes. In "Le Chant des Morts" (The Song of the Dead) though the technique is the same, the images are not those of a transformed world but of a mutilated one.

> *Motionless and too real in matter*
> *Nothing.*

His own inner abyss becomes harder to endure, the image of death masks at times the presence of the absolute as it did not do during World War I.

> BEYOND MEASURE
> *The world is my prison*
> *If I am far from what I love*
> *You are not far bars of the horizon*

[18] From "Le Reflet dans la Glace," *La Plupart du Temps*, p. 334.

Love and liberty in a sky too empty
On a land too marked with grief
A face lights and warms the hard things
That were death's property
From here on I speak
With this face
These ways this voice
With my heart resounding, pounding
A fire-screen, a tender shading
Between the night's familiar walls
Beguiling circle of unfruitful solitudes
Pile of bright reflections
Regrets
All these debris of time crackle in the hearth
One more plan tossed in the fire
One more cue missed
Little left to take
From a man about to die

[Le monde est ma prison
Si je suis loin de ce que j'aime
Vous n'êtes pas trop loin barreaux de l'horizon
L'amour la liberté dans le ciel trop vide
Sur la terre gercée de douleurs
Un visage éclaire et réchauffe les choses dures
Qui faisaient partie de la mort
A partir de cette figure
De ces gestes de cette voix
Ce n'est que moi-même qui parle
Mon coeur qui résonne et qui bat
Un écran de feu abat-jour tendre
Entre les murs familiers de la nuit
Cercle enchanté des fausses solitudes
Faisceaux de reflets lumineux
Regrets
Tous ces débris du temps crépitent au foyer
Encore un plan qui se déchire
Un acte qui manque à l'appel
Il reste peu de chose à prendre
Dans un homme qui va mourir][19]

[19] "Outre Mesure," *Main d'oeuvre*, p. 434.

Some of the later poems dramatize the struggle Reverdy waged between an ever increasingly blighted reality and the diminishing but still vigilant powers of the poet to resist what he calls "the dead weight."

Apparently, however, the powers did not sustain the poet to the end of his life. It is one thing to die with a diffident smile and a prophetic song on one's lips at the age of thirty-eight as did Apollinaire, and quite another to become old, ill, and destitute, to be bypassed by literary fortune, to have had to witness the humiliation of one's country defeated and occupied first by the enemy then by the so-called allies. The sight of the American military in the countryside of Solesmes had particularly irked Reverdy. In his last years reality took its total vengeance on Reverdy as can be seen in the exclusive deluxe edition of two series of poems dating from 1956, published posthumously in 1963 by the Maeght Foundation: *Une Aventure Méthodique* and *La Liberté des Mers*. Illustrated with lithographs by Reverdy's lifelong friend, Georges Bracque, the work is destined to exclusivity for a number of years. On the basis of the excerpts of *La Liberté des Mers* published in Maeght's journal, *Derrière le Miroir* it is indeed the work of two artists both overcome by age. It does not possess the luminous quality of the rest of Reverdy's poetry. The lifelong struggle against his dreary environment seems to have ebbed with the ebbing of his own life. There is a sense of claustration as images of "no exit" accumulate: immobile, empty countryside, doors without glass panes, dark corners, dead suns, the stickiness of night—and the image of soldiers interspersed (far after the occupation American soldiers had been left stationed in the department of Sarthes). These oppressive images of the physical world correspond to the inner attrition of age and oblivion; "the sunless lamp of a snowbound midday" suggests the slowing up of the life tempo: "your life too slow," "petrified flesh, mind frozen with horrors." In a passage called "L'or du temps" he speaks of empty masterpieces and "the shadow of oblivion." His

vision has become a half-closed eye awaiting a signal, and the signal appears to be death, with not a glimmer of hope left for renewed auroras: "Not even in the hollow of a benumbed head, the least memory of the eternal return of the flames of the dawn." His head is no longer in the stars for the gravitation of the soil has finally overpowered him: "The riches are in the air while at ground level the crowd under the rain displays its rags." It is the picture of the poet immobilized behind the bars of his window where there looms a head and a bust in the posture of immobility.

This is a volte-face hard to reconcile with the rest of Reverdy's writings. Devoid of poetic imagery, direct and obvious in its communicative element, it is apocryphal as well as posthumous, for the *poet* had died even before the man's demise.

This then is the work of unobtrusive Pierre Reverdy who witnessed three generations of literary coteries, who survived two wars, emerging neither as a heroic war bard, nor as a spectacular figure, but walking quietly in the margin of world events, in the margin of poetic revolution. However, he has produced a poetry which is far from marginal.

With the simplest words in the French language, the universal words and the earthy ones, and some of the translucent ones interspersed, he labeled the most common forms and beings with a mystic significance. If, as we can see, the flame died at the end, Reverdy had been for the young surrealists the director of the most avant-garde poetic journal, *Nord-Sud*, where they had been given a chance to try out their wings; they had admired Reverdy not simply for talking about transforming the world, but for having provided a basis for the revitalization of the poetic image and it had left on the world the imprint of his love of life. For life had been for him, at the height of his poetic activity, not the antithesis of death, not a passage, but an absolute and total condition, that "carnival where [he] lost [his] time," as he said in "Le Chemin Tournant" but in which he had for so long suc-

cessfully overcome the human sterility of his daily surroundings and the dreary monotony of the natural landscape because his eyes created their own horizons and were able to look straight into the sun.

THE ROAD

6

breton
and the
surrealist
mind –
the
influences
of freud
and hegel

Surrealism, like the legendary phoenix, was born of death and ashes. The group of young writers and artists who chose to be linked under this banner participated in the burning and the funeral of an ideology which they had embraced only a few years earlier and were quickly abandoning as futile and futureless.

The demise of Dada in 1924 is generally passed over humorously or indulgently, or even anecdotally, in the annals of literary history. And in view of revivals of the Dada spirit on a universal plane later in the twentieth century, it would appear that Dada slept in a deep coma to be eventually revived. But as the years go by and the literary currents take on their consequential perspectives, the important question is not whether Dada really died or

not; it is, rather, the act of rejection involved in the funeral of dadaism that takes on added significance.

Dada had been an acute state of protest against society, literature, and those ideologies which had contributed to the destruction and chaos of World War I. The rebels were young men, who came to Paris from all over the world, and attributed the political failures to ineffective thinking. They attacked *logic*, which had proved a tragic basis for action. They attacked by the same token the artist who had fled into his ivory tower and let the world crumble around him.

The Dadaists summarized their sense of futility by the word "rien." They endured their nihilism not with tears but with a mocking smirk, a shameless disdain of the reality which embraced them and which appeared so wanting. All the exhibitionism and antisocial vindictives associated with dadaism were motivated by this concerted protest of the moment.

But the moment passed, and the Dadaists realized that the futility of Dada was even greater than the futility of the reality against which it protested. From then on the attitude of revolt for revolt's sake ceased, and the concerted efforts were directed toward means of surmounting the initial nihilism. It dawned on these young writers and artists that perhaps it was not man's mind that was wanting, or even the world of realities that was absurd, but the limited utilization of the mind and of the objects of its experience. Before becoming an art, surrealism became a philosophy and a way of life. The Dadaists, transforming themselves into surrealists under the leadership of André Breton, sought a philosophical foundation for their art. Nietzsche, who had proved so popular at the dawn of the century, seemed to them too destructive and egocentric in his notion of reality; Kierkegaard's anguish was too passive to give an impetus to new thought. What the surrealists needed was supporting evidence for their dream-wish that something more resourceful than logic might be found to endow life with fuller significance, and that the objects of thought might have a more elastic reality. Their

adamant desire to transform this absurd, unappetizing world had a deeply metaphysical motivation. But since they wanted outlet for their mysticism without recourse to religion, the transcendence had to occur *hic et nunc*. The purpose of their existence and art, then, was to seek both physical and metaphysical satisfaction by pushing back the frontiers of logical reality and revealing the infinite possibilities within the scope of the concrete world. This process implied a closer association between the one who sees and the object of his sight. The venture was an act of creation and an expression of vertiginous freedom on the part of the artist. To Breton it meant a deeper, more passionate consciousness of the sensory world. Eluard saw it as a loosening of the horizon's belt through an increased fertility of the senses, the abandonment of accepted perspectives and the cultivation of prescience. For Louis Aragon it meant the discovery of "the face of the infinite in the concrete forms" discerned along the paths of earth.

In reexamining the age-old concepts of reality and in attempting to break down the antithesis between matter and mind, which had been accepted for so long, surrealists found support in Hegel; and in searching for a basis for the faith they had that the mind's scope could outreach its determined logical powers, they looked into the investigations that Freud had made into the unconscious. The initial emphasis on psychic automatism and enthusiasm for dream revelations in surrealist writings point to Freud as the earlier of the two Germanic influences.

It was while he was a student of psychiatry, before World War I, that André Breton, the future leader of the surrealist movement, first came in contact with Freud's studies. In 1916 while an intern at the neurological center in Nantes, he had occasion to practice psychiatry and psychotherapy on the wounded. In 1919, while still preoccupied with Freud, he was beginning to turn his interests from medicine to literature; psychoanalysis proved a convenient bridge for him between the scientific attitude of objective investigation and a literary mind's philosophical introspection. Freud granted the young poet-medico an interview

in Vienna in 1921 in answer to a letter from Breton, which he called "the most touching that I have ever received."[1] Breton found the greatest psychiatrist of our time, as he considered Freud, very reticent, except for his obvious dislike of France, which had remained the only country indifferent to his work. Indeed Freud was translated into French much later than into English; *Der Witz und seine Beziehung zum Unbewussten,* published in 1905, translated into English in 1917, did not appear in French until 1930, as one surrealist writer deploringly points out.[2] In sharp contrast with this general lack of interest on the part of the French, Breton and his *confrères* gave plenty of publicity to Freud and to his discoveries, in their two major periodicals, *La Révolution Surréaliste* and *Le Surréalisme au Service de la Révolution* (1924–33). In his very first manifesto, dated 1924, Breton gave Freud ample credit* for his discoveries in dream interpretation, his method of investigation, and the new rights he thereby granted to the human imagination. Breton's knowledge of the history of psychology made it possible for him to judge the originality of Freud's work and to name in a most scholarly manner all his predecessors; he was indiscreet enough to suggest a correction to Freud's bibliography of *The Interpretation of Dreams,* much to the embarrassment of the author. He foresaw as the ultimate achievement of dream study the marriage of the two states, in appearance so contradictory, of dream and reality, into one sort of absolute reality which he called surreality.

The simplest and most obvious influence of Freudian psychology can be found in the accounts of dreams written by practically every one of the fifty or so bona fide surrealists who contributed to the surrealist periodicals. Both writers and artists, more in the spirit of experimentation and investigation than of pure creative expression, participated in the activity of relating or writing

[1] André Breton, "Interview du Professor Freud," *Les Pas Perdus* (Paris, 1924), p. 118.

[2] Jean Frais-Wittman, "Le Mot d'Esprit et ses Rapports avec l'Inconscient," *Le Surréalisme au Service de la Révolution,* Vol. II, p. 28.

* My later research showed a more direct source was Dr. Pierre Janet. See Balakian, *André Breton* (Oxford, 1971), pp. 26–34.

dreams, and with as much candor and even less inhibition than Freud, interpreted their dreams. Robert Desnos, the most remarkable of these dreamers,[3] could fall into a state of dreaming at the least provocation and as a result produced a rich flow of verbal images for the admiring colleagues present. There were various categories of dreams: the natural dream, the prophetic dream, and most often the self-induced one, such as the flamboyant, libido-ridden dreams of Dali. There were "experimental" dreams, such as Tristan Tzara's "Grains et Issues" in which "the hands have been pulled out of all the clocks in the world" and we see a population hungrily awaiting "the most extravagant innovations."[4] In the analytical commentary which accompanies the part-prose, part-verse transcription of the dream, Tzara states that when the dream becomes accepted as a complementary rather than contrasting experience to the waking part of life, our notions and feelings will be transformed to such an extent that the rules which govern our actions now will become as inapplicable as Euclidian geometry is to the widened range of today's universe. The dream, for him, transforms phenomena, by facilitating the synthesis which is the basis of poetic knowledge.

In *Les Vases Communicants*, dedicated to Freud, André Breton envisaged existence as a composite of two urns, the dream and the state of wakefulness, constantly connected with each other and contributing to each other's intensity. He noted not only the added keenness of the mind but the greater rapidity of thought in the dream. In observing the effect of the dream on imagery he found the same type of displacement of objects and things, and verbal condensations in the poet's dream-thought as Freud had observed in his clinical cases as well as in his own dreams. In this work Breton gave Freud credit for having been the first to pro-

[3] For a while Desnos went regularly to Breton's apartment and fell asleep right after dinner, making ecstatic pronouncements upon awaking. His sleeping séances became deeper and more complicated until one night Breton had to fetch a doctor to wake Desnos.

[4] Tristan Tzara, "Grains et Issues," *Le Surréalisme au Service de la Révolution*, Vol. VI, p. 56.

nounce himself on the question: "What happens to time, space, and the principle of causality in dreams."[5] Sending him a copy of the book, he paid tribute to Freud's "keen and marvelous sensitivity," and stated that the purpose of his book was to show on what roads of psychological conquest Freud had directed the surrealists.

Verbal expression linking the visions of the dream state with conscious perceptions is also the core of one of the most original of Paul Eluard's works, *Les Dessous d'une Vie ou la Pyramide Humaine,* wherein the poet envisions human experiences in the form of a pyramid, the narrow peak of which is the limited range of the lucid state, and the broad base the receptivity of the full, solid subterranean strata of the subconscious, the dream where all his desires are born, where receptivity is keener than the sense perceptions of his waking hours. He can hear the language of the deaf and dumb and with the "pure faculty of sight" can envisage such images as "perpendicular green" upon which he picks "raspberries white as milk."

Another aspect of Freudian influence was the practice of automatic writing, which was considered a safer road toward the subconscious mind than the interpretation of dreams.* This process became for the surrealists a form of self-administered psychoanalysis: placing themselves in a state of stupefying attentiveness they tried to shut out all outside disturbances and to give free play to the inner powers of association of words and the images which these suggested. Most of what they called "Textes Surréalistes" is fundamentally automatic writing. Those of Paul Eluard and Tristan Tzara are particularly fecund in uncanny imagery. In his *Genèse et Perspective Artistique du Surréalisme,* Breton stressed automatic thinking as the common basis of surrealist poetry and art, and declared it to be the sole mode of

[5] Breton, *Les Vases Communicants* (Paris: Cahiers libres, 1932), p. 16.

* Note: further investigation of the notions of automatic writing have led me to the conclusion that Dr. Pierre Janet rather than Freud was Breton's source for the cultivation of this form of mental process.

expression fully satisfactory to the eye and ear, for the rhythmic unity which it produced corresponded "to the nondistinction more and more established of the functioning of the senses and of the intellect." He categorically claimed that a work cannot be called surrealist unless it embraced the entire psychophysical field.

A third form of Freudian experimentation was the intentional simulation of states of mental abnormality. The "Fol" of Saint-Pol-Roux became a more important character of poetry. *L'Immaculée Conception* was a collaboration between Breton and Eluard which set out: "to prove that the mind, poetically conditioned, is in a normal man capable of reproducing in their broad lines the most paradoxical and eccentric verbal manifestations . . . without risk of lasting trouble, and without compromising its faculty of equilibrium."[6] In this work the writers set themselves a triple aim: to imitate delirium, artificially assume the various forms of insanity, and thus establish a method of investigating the widest range of mental activity. On this point precisely Breton's view differed from Freud's. He thought that so-called normal man could capitalize on his observations of the "great wanderings of the human mind," which were generally designated as pathological. In "L'Art des Fou, la Clé des Champs," he finds the work of the insane unwittingly closer to the great secrets of life and "a reservoir for mental health"[7] for those who are locked up within the confines of a narrow and self-perpetuating rationalism. His plea for greater tolerance of the insane found its most eloquent terms in *Nadja*, where he involved himself personally in the behavior and linguistic communication of the deranged but charming waif he encountered in one of his aleatory walks through the streets of Paris.

The most flamboyant and provocative exploitation of this vein has of course been Salvador Dali's in his paranoiac paintings.

[6] Breton and Eluard, *L'Immaculée Conception* (Paris: Editions surréalistes, 1930), p. 28.

[7] *La Clé des Champs* (Sagittaire, 1952), p. 227.

Cultivating what was in him a natural dose of paranoia, Dali was to crystallize as we shall see in a later chapter the unbridled force of his mind to contract an infinite number of free associations between objects, and through the representation of these he was to suggest a totally fluid universe shaped according to the artist's private specifications.

These exercises in uninhibited, and sometimes erotic, writing and exploration of sensations beyond the control of reason were to sharpen, to renovate poetic imagery, and to incorporate into the poet's technique Freud's observations on the role of language in dream and dream interpretation: the condensation that results in a density of imagery; displacement of the senses of time and space in the vision; the importance of figurative language. Freud had noted, and the surrealists have actually illustrated in their poems, that concrete terms owing to the evolution of their connotation and to their subsequent mutation of role, produce more frequent and more rapid mental associations than do conceptual ones: consider the many disturbing uses to which elementary words like "table," "homme," "sable," have been put in surrealist imagery, or provocative ones like "épave," "miroir," "sein," "pyramide," "reverbère," etc., which are often the kernel of the surrealist image and play central roles similar to the clocks, stairs, platters, and umbrellas of surrealist paintings. Incorrect meaning attributed to words, which Freud explains as the simultaneous expression of more than one dream-thought, due to psychic disturbance in the subject, are ever dominant in surrealist writing. However, herein lies a major difference between Freud and the surrealists, for the latter do not consider these misuses as indications of frustrations but rather of the richness and versatility of the poet's imagination. Finally, the strong element of absurdity common in dreams, and a certain type of unsought humor revealed in the hallucinations of the deranged mind were intentionally practiced in surrealist writing to demonstrate a super-sense of reality.

Another element derived to a large extent from Freudian

studies was the understanding of a certain brand of humor that Breton was to investigate extensively in his *Anthologie de l'Humour Noir* (1939–40). Freud had distinguished certain types of humor that have a liberating effect and sublimating power on the agent of that humor. Breton, finding in Freud his definition, composed his anthology as a series of illustrations of this transcending black humor which guards the creative artist from succumbing to the suffering inflicted on him by the exterior world or by the human condition. By objectivizing his anguish he overcomes at the same time the narcissist mechanism that generates self-pity.[8]

The surrealists' tributes to Freud continued to the end of the psychologist's life. When Freud was rumored to be imprisoned by the Nazis in 1938, Breton wrote an indignant letter in a London periodical, in which he declared that Freud had been "a life of inspiration which we hold as dear to us as our own,"[9] that in his attempts to seek "human emancipation in the widest sense" he had been the reincarnation of Goethe; he designated Freud as "he from whom so many of us derive our finest reason for existence and action."

Here are strong words of praise; but despite their adherence to Freud the surrealists did not find him as responsive to their work as they had been to his. Upon receiving Breton's *Les Vases Communicants* he had had to confess in his letter to the author that it was not at all clear to him what surrealism was. "Perhaps I am not made to understand it, he said, for I am so far removed from art."[10] The reason he could not understand it was that the surrealists were launched on a much more adventurous investigation than he; theirs was not an observation or interpretation of the subconscious world but a colonization. In spite of their admiration of Freud, the poets observed shortcomings not in the

8 Cf. Introduction, *Anthologie de l'Humour Noir* (Sagittaire, 1950).

9 Breton, "Freud at Vienna," *London Bulletin*, no. 2 (1938), p. 2.

10 Breton-Freud, Correspondence, *Le Surréalisme au Service de la Révolution*, Vol. V, p. 11.

psychologist's *method* but in *its application and conclusions.*
They felt that Freud had been too reticent in his interpretation of
dreams; they deplored the fact that he denied the existence of the
prophetic dream. The dream as a clinical interpretation of the
disintegration of personality—with which Freud had been exclu-
sively concerned—was one thing, but as a form of literature and
art it could not be justified unless it also revealed the *unification*
of the personality of the artist: his adjustment to two planes of
reality, no longer visualized as contradictory. This had been
suggested by Freud, but *unintentionally:* he had, says Breton,
"without knowing it found . . . in the dream the principle of
the conciliation of opposites."[11] The greatest weakness seen in
Freud was precisely the fact that he drew too definite a barrier
between the exterior world and the dream experience. It was not
sufficient to show the effect of conscious experience on the dream;
the surrealists wanted to go one step further and show the effect
of the dream state on consciousness. Breton justifies the poet's
stepping ahead of the psychologist master by a quotation from
Freud himself:

"Poets are in the knowledge of the soul our masters, for they
drink at sources not yet made accessible to science. Why has the
poet not expressed himself more precisely on the nature of the
dream?"[12]

The interpretation of dreams, psychoanalysis, the study of the
irrationalities of the insane, utilized as methods of explaining
quirks and frustrations of neurotics, were inconsequential to the
surrealists. Breton derides the fact that psychologists would inter-
pret the surrealist Yves Tanguy's paintings on the basis of
childhood sin obsessions. As he states in his second manifesto:
"it is not surprising to observe that as surrealism progresses, it
applies its attention to something other than the solution of a
psychological problem no matter how interesting it may be." A

[11] Breton, "Réserves Quant à la Signification Historique des Investigations sur
le Rêve," *ibid.*, Vol. IV, p. 9.
[12] Breton, *Les Vases Communicants*, p. 163.

point was reached in the thinking of the surrealists where Freud could not accompany them. It was "désolant," as Breton pointed out in his "Réserves Quant à la Signification Historique des Investigations sur le Rêve," that although an alleged monist, Freud had said: "psychic reality is a particular form of existence which must not be confused with material reality."[13]

On the contrary, Freud's methods had pointed the way to that substratum of consciousness wherein the distinction between the sensory and the intellectual functioning of the mind is erased, and thereby the disparity between the sensory evidence of the outer world and the psychic reality experienced by the mind yields in favor of their inherent unity. Consequently, the greater freedom of mental activity which Freud's methods made possible was not to be enjoyed as a means of *escape* from exterior reality but for better knowledge of the world of matter. Breton deplores man's nightly exile from consciousness and the neglect of this potential reservoir of life and thought. The dreamlife should not be considered subservient to the wakeful state, used merely to interpret and clarify consciousness. Man had an actual *need* for the dream experience, and the sharper his mystic or artistic sensitivities were, the more he needed the dream experience. What Freud took in dream interpretation for symbols of the conscious life, Breton and his colleagues wanted to grasp as naked realities, significant and even downright essential to the better and more complete knowledge of existence. Man had essayed "interpretation" of the world for so long a period; was it not time at last to pass to the more adventurous and fruitful task of *transforming* it? The forces of the mind that produced the state of the dream could if properly utilized give a much needed encouragement to the effort of transfiguration. This was not an evasion of reality, or a release of the spirit from its earthly bonds, but an *expansion*, an enrichment of human existence. What the surrealists were basically doing was revising through the study of the dream their notion of reality. It

[13] *Ibid.*

is at this point in the development of their thought that Hegel lent them support.

The surrealists' appreciation of German literature, their companionship with several German colleagues, principally the artist Max Ernst, as well as a defiant attitude toward the existing political postwar regime in France, made them inclined to become germanophiles during the 1920's and in the early pre-Hitler 1930's. They reintroduced to the French public a wealth of German literature, the most striking example of which was a luxurious and powerfully illustrated new edition of Achim von Arnim's *Contes bizarres*[14] (the nineteenth-century translation by Théophile Gautier fils). In interpreting one of his own dreams, Breton speaks of his subconscious longing for understanding between France and "the marvelous country of thought and light which in one century gave birth to Kant, Hegel, Feuerbach, and Marx."[15] As late as 1935 in one of their general manifestoes the surrealists declared "hopelessly *chauvine*" Julian Benda's demand for reparations and his disinclination to forgive the Germans.[16] In that same year when Breton was asked in an interview what he thought of the intellectual state of things in Germany, he asserted, despite his great antipathy for Hitler's regime, that the surrealists' confidence in German thought had not been shaken, that they considered it the most pertinent to contemporary civilization, and that they had faith in the uninterrupted cultural lineage proceeding from Hegel to Engels. He stated that the surrealists considered themselves recipients of that heritage, which in their opinion should not be called German but European; and in defining their position toward German philosophy Breton made the subtle distinction of calling it not "German philosophy," but "in the German language."

[14] The German literary influences are discussed in my book, *Literary Origins of Surrealism*.

[15] See "Du Temps que les Surréalistes Avaient Raison," *Documents Surréalistes*, ed. Nadeau (Paris: Aux Editions du Seuil, 1948), p. 311.

[16] *Ibid.*, p. 51.

The only mention of Hegel in the first manifesto had been an inconsequential one within a quotation from Gérard de Nerval. But by the 1930's when the surrealists considered themselves within the throes of an intellectual and moral "crise de conscience," it was the consensus of opinion that Hegel had become the pillar of their thinking. In his second manifesto Breton declared that the Hegelian concept of the penetration of the exterior world into subjective existence had remained uncontested. In his "Qu'est-ce que le Surréalisme?" he pointed out that the influence of Hegel was most felt as the surrealists realized that they were concerned with the long-range problem of knowledge as well as the immediate one of expression. In a pertinent article on the notebook kept by Lenin of Hegel's principal concepts, André Thinion called attention to the fact that in 1932 when he and his colleagues were taking such an active interest in Hegel and published in French for the first time fragments of the Hegel-Lenin dialogue, Hegel's *Science of Logic* had not yet been translated into French. In his introduction to the Lenin notes, published in *Le Surréalisme au Service de la Révolution,* Thinion asserted that in France the surrealists "with the exception of a few professional philosophers, are alone in claiming derivation from Hegelian thought and in referring constantly their activities to this ideology."[17] He states that these ideas are of the highest importance to the surrealists and have had the power of shock on them, have led them to grasp the evolution of material and intellectual existence.

Which were these thoughts that Lenin had underlined and which clarified the surrealists' notion of the human world? It was Hegel's stress on the superiority of the concrete over the abstract, his belief in the inner unity of contradictory conditions or phenomena, and particularly his definition of knowledge as the linking of thought with its object. The surrealists inferred from Hegel that the true understanding of existence depended on the

[17] A. Thinion, "En Lisant Hegel," *Le Surréalisme au Service de la Révolution,* Vol. III, p. 1.

knowledge of the interrelation of the subjective and the objective, which in turn meant a refusal of the kind of idealism that sought something finer than the concrete manifestations of reality. The metaphysical experience, then, could be reached not through transcendence but through a successful tuning of mind with matter. As Tristan Tzara said, "it amounts to the conciliation of man in the making with the reality of the exterior world."[18]

This was indeed the objective of Breton and Louis Aragon in *Nadja* and *Le Paysan de Paris* respectively. In trying to blend his coherent perceptions with the irrational one of Nadja, a lovely but insane young woman, Breton aimed at what he considered a superior existence, in which the contradictions caused by the nonparallel vision between Nadja and himself would be overcome purely by the effort of the mind and the acuteness of perceptions. For after all, says Breton, relying on a quotation from Hegel, the test of one individual's superiority over another is not in the search for existence on a superior sphere but in the power to express better than someone else this selfsame world. In *Le Paysan de Paris* Aragon sought the marvels of daily chance meetings and chance events which transformed ordinary living. The unexpected disorder in physical and social laws, which caused this chance meeting of objects, persons, and situations, was the only satisfying human knowledge of the infinite, for to grasp the concrete forms of disorder was the outer limit of the mental faculty. In both these works dealing with philosophical search for the absolute the measuring stick is knowledge of the concrete forms and objects, and the mind's elasticity in transforming them.

This return from purely abstract thinking to a need for understanding of the concrete was what another surrealist, René Crevel, called the possibility of man's acting upon his universe. In this universe it is the object that seized anew the eye of the poet and the painter. According to Paul Eluard's definition of the poetic

[18] Tristan Tzara, "Présentation d'Une Exposition de Papiers Collés de Picasso," *Documents Surréalistes,* p. 277.

activity, it consisted in inventing objects by deviating from their admitted physical properties and accepted roles, and thereby changing the world. Breton called this process a "crisis of the object" in his *Le Surréalisme et la Peinture* and gave Hegel due credit for his part in the upheaval; for in this deviation from the natural object the surrealists were avoiding one of the dangers pointed out by Hegel in his *Aesthetics:* the servile imitation of nature and its limit-setting properties. It is not only in the deviation of the object but in the relative position of the subject and the object that Hegel serves as guide. Breton notes in the introduction of his *Anthologie de l'Humeur Noir,* that in indicating this very difference in perspective Hegel succeeded in pointing out the true difference between romanticism and modernism: the romantic draws the object within himself and makes an abstraction of it, while the true modern projects himself into the concrete existence of the object.

Hegel's imprint can also be noted in the philosophical significance attributed by the surrealists to the creation of the metaphor. For them it is not a mere form of speech but the crystallization of concept. The power of their thinking, the profoundness of their emotional experience is judged by the originality and density of the metaphor. Even as Hegel had deemed the genius of metaphorical diction to be a test of the potency of the mind and a rejection of simple reality, the successful metaphor becomes in surrealist writing, as we shall see, the measure not merely of literary satisfaction but of a victory over ordinary existence.

Finally Hegel's disdain of the prosaic mind is cited in support of a similar attitude shared by the surrealists. They consider the poetic art almost a priesthood and as the epitome of human creativeness, as in fact Hegel called it the universal art and the one best capable of representing the successive positions of life.

It might appear that the two influences pointed out here were in opposing directions: one toward greater subjectivity, the other toward a keener comprehension of the object of man's awareness. Yet there is a basic affinity in the kind of impact they had. Faced

with a world of paradoxes, the surrealists were primarily seeking an answer to their longing for innate unity among the contradictions; they tried to satisfy their passion for complete contact with the world and their desire to apply to its representation the inner resources of intuitive intelligence, which René Crevel so aptly called: *L'Esprit Contre la Raison.* Both Hegel and Freud indicated a path of freedom: liberation from exaggerated abstraction on the one hand, deliverance from excessive lucidity on the other.

But the surrealists could not subscribe totally to the system of Hegel any more than they could wholly adhere to Freud. The failing discovered in the case of Hegel was "the idealist error," i.e., Hegel had considered real things to be a degree of realization of the absolute idea; whereas in Breton's understanding of the word and in the poetic and artistic interpretation given to it by the surrealists, the ideal is not an independent concept but the result of man's mental transposition and translation of the material universe.

Thus, both Freud and Hegel proved to be influences in the most salutary sense of the word: they pointed a direction but raised an objection strong enough to lead to subsequent originality on the part of their disciples. As can be observed by examining these two influences, one of the basic characteristics of the surrealist mind is its uncompromising will to find a foolproof unity in the universe. Through contingency with Freud and Hegel the surrealists were able to outgrow their initial nihilism and advance a credo of hope, based on faith in the potential capacity of the human mind for synthesis, synthesis of the human dream and material reality. In both philosophical outlooks, so contradictory on the surface, the surrealists found ground for the fundamental support they were seeking, reassurance for their monistic philosophy. As Crevel spoke of Hegel: "Knowledge is the eternal and infinite rapprochement of thought with its object."[19] He saw in Hegel the weapon with which to fight the narcissism of those

[19] René Crevel, "Résumé d'une Conférence," *Le Surréalisme etc.*, Vol. III, pp. 35–36.

who incorporate the world into their own meager, mediocre anguish, thereby obliterating it.

"The narcissistic individual, the one who has remained in the expressive stage, has eaten up the universe and because he has devoured it, suppressed the objects, becomes himself the object, and thereby not only becomes insufficient unto himself but destroys himself. In the island whose outline is that of his little person this isolated being succumbs before the mirror he has questioned—he has questioned the most mediocre, the most vain, the most superficial of waters."

In his "Psychodialectique" Crevel continues by pondering the exact contribution of Freud. He has thrown light upon the unknown recesses of the subconscious and measured it against consciousness. But what is to be the result? Is he just accentuating the antithesis? When will the synthesis take place? Psychological dualism only produces questions. If the brilliant experiments of Freud merely encourage this "inquietude," he will have contributed to a futile "psychodialectic," said Crevel.

Likewise, for Breton dream experiment is valid only as a means of proceeding from the abstract to the concrete, from the subject to the object, which, he says, is the sole road to knowledge. The findings of Freud, then, must serve to solidify the Hegelian philosophy of reality with its emphasis on the concrete. The constant shuttling between the subject and the object, which Crevel deplored, would be replaced by a permanent integral connection cementing abstract and concrete reality into a single framework of dream-wakefulness. That is the poetic and artistic task that the surrealists set themselves.

Considered in this light surrealism was a twentieth-century integration of art and philosophy. Believing their efforts to run parallel to those of the modern scientists, they have tried to give proof that the arts are not behind the sciences in man's progress toward knowledge. Theirs was a gallant endeavor to surmount the superficial absurdity of life. We shall note in what follows, their concrete achievements in literary language and pictorial representation.

7

the
surrealist
image

In his first manifesto, published in 1924, André Breton, who remained all his life the principal generator of the surrealist movement, declared that surrealism was a new mode of expression, which he and his colleagues had discovered and wished to put at the disposal of others. When in the following year he took over the direction of the periodical, *La Révolution Surréaliste*, he stated that the principal aim of its founders was to raise the French language from the abject insignificance and stagnation to which it had been reduced under the influence of successful but mediocre authors like Anatole France. Six years later, in his second manifesto, he once more contended that the chief activity of surrealism was in the field of verbal reconstruction, and that social and political questions were of secondary concern. In

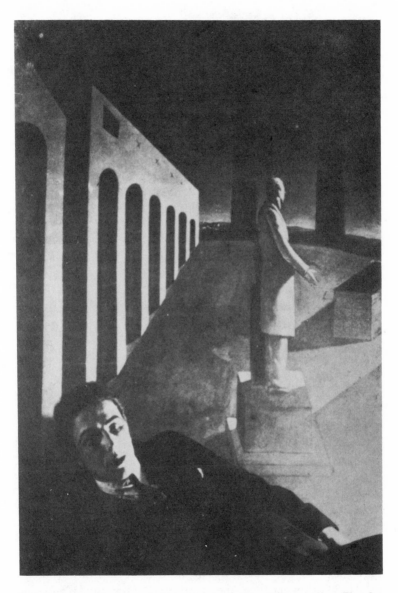

André Breton photographed in front of *The Enigma of a Day* by
Giorgio de Chirico.

Entretiens (1952), considering surrealist activities in retrospect, Breton again asserted that their purpose was "essentially and before all else" to put language in "a state of effervescence."

Now linguistic innovations are an essential function of the *ars poetica*, whether we look back on the enrichments of vocabulary achieved by the Renaissance poets, the discriminate choice of words of the classicists, the emotional flexibility of language discovered by the romanticists, or the elasticity of connotation cultivated by the symbolists. As Shelley pointed out in his *Defense of Poetry*, the poet, through his use of language, establishes the analogies among life's realities, but every so often when these associations have grown stale and lost their power of conveying integral thought, it is up to him to refresh his imagery and thereby preserve the vitality of language.

Breton, together with Louis Aragon, Paul Eluard, Tristan Tzara, and some fifty other poets and artists (all under thirty), well versed in the history of literature, aesthetics, and philosophy, and possessed of a very strong capacity for convictions, felt that they had arrived at a crucial moment in the development of the French language. They considered literature at an *impasse* and called the manner of writing of their elders degrading and cowardly. But instead of confining themselves to a local renovation of the poetic form, they welcomed all poets of any nationality who wished to participate in their systematic cult of the latent possibilities of language. They believed that their linguistic revolution could not only revive literature but lead to a new understanding of the objects designated by language and thereby situate them at the center of a new *mystique*.

A number of works are available which mark a consensus of opinion and establish the bases of surrealist composition: Breton's two manifestoes, Aragon's *Traité du Style*, and a series of articles to be found in the annals of *La Révolution Surréaliste* (1924–29) and *Le Surréalisme au Service de la Révolution* (1931–33), among them the significant "Essai sur la Situation de la Poésie" by Tristan Tzara.

The creative role of language was strongly stressed in the surrealists' concept of poetry. Poetry was no longer to be an expression of ideas or emotions but the creation of a series of images, which would not necessarily owe their existence to an a priori subject. "Images think for me," said Paul Eluard in "Défense de Savoir." And Aragon explained in the *Traité du Style:* "In our time there are no longer any ideas; they are as rare as smallpox, but it goes without saying that there are images caught, and for once well caught, real slaps in the face of any kind of good sense."[1] Breton called ideas vain and ineffective compared to the force of the sudden, unexpected image. In his famous article, "Misère de la Poésie," he tried to come to the rescue of Aragon, accused of subversion in his poem, "Front Rouge." But as far as its aesthetic value was concerned, he dismissed the controversial poem as being a hundred years behind the times despite its so-called modern subject. The fact that it had a definite subject matter to develop belied the contemporary state of poetic evolution, which according to Breton banishes unity of subject matter from the poem. It is Breton's belief that the speed of thinking is not superior to that of linguistic expression, which, therefore, should not be subservient to logical thought. Words brought together by creative intuition could explode in a dynamic image which would be more provocative than are abortive thoughts seeking words to give them a countenance,[2] he explains in his second manifesto. Images, then, are not to be *directed* by thoughts but should be conducive to them, and the function of the poem in regard to the reader is what Eluard called "donner à voir," *to give sight.* It is up to the reader to participate in the creative act of the author by deriving from his own pool of personal associations his particular stream of thought. And in order to allow the reader freedom of mental association there must be a compression of language and a minimum denominator of self-evident meaning.

[1] Aragon, *Traité du Style* (Paris: Gallimard, 1928), p. 48.
[2] Breton, *Manifestes du Surréalisme* (Editions du Sagittaire, 1946), pp. 60–61.

Now the surrealists did not have in mind the type of imagery put into the French language by Verlaine and Mallarmé, i.e., terminology abstract in meaning and so undefined in connotation, in Verlaine's poetry, that it suggests moods rather than visions, or, in the case of Mallarmé, so hermetic as to remain in the Closed Book of one man's mind. On the contrary, their vocabulary is concrete in shape and color, in texture and intent, sometimes so precise as to be exclusive in use and technical in meaning. The words serving as stimuli or irritants to the senses were to produce their own images. Language was to be endowed with a hallucinogenic quality, and if expertly used, could grant pleasures beyond those induced by narcotics. Breton compares the spontaneity with which these images offer themselves and their habit-forming character to the stupefying state of mind produced by artificial paradises. In this state of subconscious stimulation the poet is alerted to the sensations that words can produce much in the manner that the painter is attracted to objects, which mean a different thing to each artist and speak a different language to each spectator. The surrealist poet in his use of words was approaching the painter's technique, and that is how a closer bond was established between poetry and art than ever before, and a greater gap between poetry and the literary forms that continued to have as their aim the expression of ideas.

A serious study of the quality and range of words was then, the *sine qua non* of poetry. As we have seen, a generation before the surrealists, Guillaume Apollinaire had envisaged the possibility of experiments and investigations in this field. Breton and his colleagues went so far as to establish a Central Bureau of Surrealist Research to experiment with writing and to accept communications relative to their research from outside their ranks. In a chapter of *Les Pas Perdus*, characteristically called "Words without Wrinkles," Breton stated that the greatest poetic act was the understanding of the full destiny of words. He suggested ways of doing this: by studying the words themselves, the reaction of words to each other, the appearance of words and the effect of the

figurative meaning on the literal. To such considerations could be attributed provocative surrealist titles as "Le Revolver à Cheveux Blancs" (The Whitehaired Revolver), "Clair de Terre" (Earthshine), "Les Yeux Fertiles" (Fertile Eyes), "L'Homme Approximatif" (Approximative Man), "Le Poisson Soluble" (Soluble Fish), "Le Paysan de Paris" (The Peasant of Paris).

Breton explained that it took him six months to write his poem, "Forêt-noire" (of which the actual word count is *thirty*), for he virtually "coddled" the words to determine the space they permitted between each other, their tangency with innumerable other words which would not appear in the poem, but with which the written words came in contact in the author's mind during the process of composition. The most evident demonstration of the spontaneous suggestive power of words was the glossary composed by the surrealist poet, Michel Leiris, which consisted of basic words and the images they evoke, as for example: "humain —la main humide, moite. L'as-tu connue, cette main? ingénu—le génie nu; langage—bagage lent de l'esprit; révolution—solution de tout rêve; rumeur—brume des bruits qui meurent au fond des rues; suicide—idée sûre de sursis."[3] Although seemingly playful, Leiris' verbal associations have as their basis a keen phonemic character and reveal his sensitivity to linguistic structures.

The poet's tolerance to words had to be increased; he could help himself by dismissing the wrong words from his mind. Which are the wrong words? Those that have wandered too far afield from their concrete specifications, those that have served too often to form rhymes, those that have received the tag "poetic" through excessive usage in poetry. Abused words can gain a new value if their primitive meaning is sought out. Sometimes it is even advisable to give a word the wrong meaning, for words do not really tell a lie, and if they come to the poet's mind at a given moment it is because they fulfill a poetic necessity. Breton discovered that he sometimes unwittingly used a

[3] Michel Leiris, "Glossaire," *Révolution Surréaliste*, Vol. III, pp. 6–7.

word whose true meaning he had forgotten; looking it up later he would find that his use of the word was not etymologically incorrect.

For a more drastic interpretation of the meaning of words we can refer to Aragon's *Traité du Style,* in which he claims that dictionaries do not cover the full connotation of words; there is meaning contained in each syllable, according to him, and inherent in the very spelling of the words. Words are what another surrealist, Arpad Mezei, called "multidimensional,"[4] in an evaluation of surrealist accomplishments in *Le Surréalisme en 1947.* Etymology, which is only one of its dimensions, has unfortunately been overstressed and has become its dead weight, according to Breton. Michel Leiris considers it a perfectly useless science; the poet must look for the secret ramifications of words in the entire domain of language, the canals created by the association of sounds, of forms, and ideas. When this inner working of words is understood, language becomes prophetic and supplies a thread with which to guide us in the labyrinth of the mind, he explained in connection with his "Glossary."

To discover, then, what one might call the high voltage of words was to be the key to surrealist poetry. But in the composition of the poem, what is even more important than the right word is the happy marriage of words into illuminating (not elucidating) associations, which become the basic structure of the poetic image. The surrealists found in automatic writing a rich hunting ground for the capture of word associations. It assumed the same importance in the technical equipment of the surrealist as the practice of scales to the musician. In this quasi-hypnotic state the hand writes or draws (for the same thing can be done in art) almost alone, and the pen or pencil transcribes spontaneously the subconscious affiliations we feel between the words. These "Surrealist texts," as they are called, must not be taken for poems. They are just a means of developing or enriching poetic

[4] Arpad Mezei, *Le Surréalisme en 1947* (Edition Pierre à Feu, 1947), p. 59.

consciousness; they also break down traditional word associations which are too deep-set to be warded off consciously, and which are not only ineffective in imagery but even detrimental to the component words involved in the tedious alliance. Words should be drawn together not by emotional kinship but by what Baudelaire called "sorcellerie évocatoire" (incantatory bewitchment), or in the more recent terminology of Aragon, "puissance incantatorie" (power of incantation). Sometimes it is nothing more than assonance or alliteration, sometimes symmetry of appearance, sometimes antithesis. Of such nature are expressions like "femmes fugaces" (fugaceous females), "le très coquet caméléon de l'entendement" (the very flirtatious chameleon of understanding), "le désert vertical" (the vertical desert), "l'aigle sexuel" (the sexual eagle), "l'adorable déshabillé de l'eau" (the adorable deshabille of the water), "les arêtes des buissons et des navires" (the fishbones of the bushes and the boats), images taken at random from the poetry of Eluard and Breton, the effectiveness of which is entirely dependent on the rhythmic attuneness, generally impossible to carry over into direct translation.

To go one step further, this unexpected linking of words became the foundation of the new metaphor, which, instead of being based on analogy, is derived from divergence and contradiction. A more recent surrealist, Jean Brun, has put it somewhat emphatically in saying in "Le Problème de la Sensation et le Surréalisme": "The capital fact of the entire history of the mind lies perhaps in this discovery of surrealism: the word 'comme' is a *verb* which does not signify 'tel que.' "[5] The surrealist associates what we normally dissociate and the word "like" is inappropriate because the connections are nonsequential or psychic rather than rational. It is a principle to be remembered in reading almost any poem of Breton, Eluard, and most of the other surrealists; it is the trademark of authenticity. It renovates the entire notion of the metaphor, when for instance André Breton can say in "Le Revolver à Cheveux Blancs":

[5] Jean Brun, "Le Problème de la Sensation et le Surréalisme," *ibid.*, p. 90.

> *The seasons like the interior of an apple from which
> a slice has been cut out.*

> [*Les saisons lumineuses comme l'intérieur d'une pomme dont
> on a détaché un quartier.*]

Or in Péret's "Et les seins mouraient":

> *He showed the north horizon
> and the horizon opened up like the door of a god
> stretched itself like the tentacles of an octopus*

> [*Il montra l'horizon du nord
> et l'horizon s'ouvrit comme la porte d'un dieu
> s'étendit comme less tentacules d'une pieuvre*][6]

A number of years later the technique still persists in René Char's *Le Poème Pulvérisé* (1947) when he envisages that the soot of the poker and the crimson of the cloud are but one: "L'encre du tisonnier et la rouge du nuage ne font qu'un."

The metaphor used to be considered the most effective means of representing the *image*—which was preconceived in the writer's mind. Now the cart is placed before the horse, and it is the unusual metaphor that creates the even more extraordinary image, which is composed of two or more elements having no logical relationship with each other. One of the first to state the principle clearly was, as we have seen, the so-called cubist poet, Pierre Reverdy, whom the surrealists revered as their master. Breton quoted him in his first manifesto and praises him again in his 1952 review of surrealist outlook, *Entretiens,* for his "magie verbale." Reminiscing about Reverdy's discussions of the nature of the poetic image, Breton esteems him as an even more important theoretician than Guillaume Apollinaire. In *Le Gant de Crin* Reverdy had defined the image as the spontaneous meeting of two very distant realities whose relationship is grasped solely by the mind. Reverdy, moreover, observed that the more remote the relationship was between the two realities, the stronger became

[6] Benjamin Péret, *Main Forte* (Editions de la Revue Fontaine, 1946), p. 72.

the resulting image. On the other hand, the power or even the life of the image was threatened if it were to be totally acceptable to the senses. Following this line of thinking, Breton finds that comparison is therefore a poor axis for the image, and that a radical modification is necessary in the very structure of the analogy. The surrealist image has to be a far-fetched—or rather deep-fetched—chance encounter of two realities whose effect is likened to the light produced by the contact of two electrical conductors. In the ordinary image, the terms of which are chosen on the basis of similarity, the difference in potential between them is negligible and no spark results. The value of the surrealist image, therefore, consists not in an equivalence but in the sub-traction of one set of associations from the other. The greater the disparity, the more powerful the light, just as in electricity the greater the difference in potential of the two live wires the greater the voltage. The resulting spark of imagery is first dazzling to the mind, which subsequently accepts and appreciates its reality. Thus by their inadvertent function the metaphors and resulting images increase the poet's scope of understanding of himself, and of the subtle relationships in the world about him. Says René Crevel: "The writer makes his metaphor, but his metaphor un-veils, throws light on its author."

Images constructed according to this notion contain a dose of absurdity and that element of surprise, which, in the opinion of Guillaume Apollinaire, was to be one of the fundamental re-sources of the modern mind. This type of poetic imagery rises on the same foundation as the "fortuitous meeting," in the words of Max Ernst, of two objects in a surrealist painting as we shall note in detail in the following chapter. The effect that Dali created by placing a telephone and an omelette on the same range of vision in his painting, *Sublime Moment,* is a result of the same tech-nique as the juxtaposition in a verbal image such as "un couvert d'argent sur une toile d'araignée" (a silver plate on a cobweb) in Breton's poem "Sur la Route qui monte et descend." Benjamin Péret's poetry is the constant locale of strange encounters. More

than anyone else among the surrealists he has practiced the rule
of juxtaposition of distant realities, beginning with Lautréa-
mont's famous formula: "beau comme." Describing the nudity of
his mistress:

Beautiful like a hole in a windowpane
beautiful like the unexpected encounter of a cataract and a bottle

The cataract looks at you, beauty of bottle
the cataract scolds because you are beautiful
bottle
because you smile at her and she regrets being a cataract
because the sky is shabbily dressed
because of you whose nudity is the reflection of mirrors.

[Belle comme un trou dans une vitre
belle comme la rencontre imprévue d'une cataracte et d'une bouteille

La cataracte vous regarde belle de bouteille
la cataracte gronde parce que vous êtes belle
bouteille
parce que vous lui souriez et qu'elle regrette d'être cataracte
parce que le ciel est vêtu pauvrement
à cause de vous dont la nudité reflète des miroirs][7]

If there is something that particularly characterizes his object
matings, it is the frenzied movement that seizes them. The gravita-
tion is a rapid one; in fact often it results in abrupt collisions.
Instead of one image being absorbed into another, as is often the
case with André Breton, Péret's chase each other:

The wind rises like a woman after a night of love.
it adjusts its binoculars and looks at
* the world with the eyes of a child. The world*
* this morning is like a green apple, which will never*
* ripen, the world is acid and gay*

[7] From "Dormir Dormir dans les Pierres" (1927), collected in *Poètes
d'Aujourdhui*, Pierre Seghers, 1961, p. 85.

[*Le vent se lève comme une femme après une nuit d'amour. Il
ajuste son binocle et regarde le monde, avec ses yeux d'enfant.
le monde, ce matin est semblable à une pomme verte qui ne sera
jamais mure, le monde est acide et gai.*][8]

His central image is that of a traveler, whether it is a human one
or an object that we would generally consider stationary. His
generous use of adverbs contributes to the creation of his totally
mobile universe, in which the commodities and comestibles of
modern man, the food for his eyes and for his mouth, mingle
freely with the primary, prehuman phenomena of nature such as
star, sea, bird, and river. As if a prestidigitator he makes things
appear and disappear, abruptly replace each other, and he suc-
ceeds perhaps to a greater extent than any other surrealist in
introducing that element of surprise:

*And the stars that frighten the red fish
are neither for sale nor for rent
for to tell the truth they are not really stars but apricot pies
that have left the bakery
and wander like a traveler who missed his train at midnight
in a deserted city whose streetlamps groan because of
their shattered shades*

[*Et les étoiles qui effraient les poissons rouges
ne sont ni à vendre ni à louer
car à vrai dire ce ne sont pas des étoiles mais des tartes aux abricots
qui ont quitté la boutique du pâtissier
et errent comme un voyageur qui a perdu son train à minuit dans une
ville déserte aux becs de gaz geignant à cause de leurs vitres
cassées*][9]

In his poem, "L'Union Libre," Breton employs what would on
the surface appear to be the hackneyed procedure of describing

[8] From *La Brebis Galante* (1924), Terrain Vague, 1959, p. 41.
[9] From "Quatre à Quarte," *De Derrière les Fagots* (1934), collected in *Poètes
d'Aujourdhui*, p. 93.

the beauty of the beloved through a series of analogies. Yet the associations of the physical characteristics of the woman are with such unexpected objects as footprints of mice, a forest fire, the brim of a swallow's nest, the slate roof of a hothouse, mist on window panes, cut hay, quicksilver, wet chalk, gladiola, sea foam, eyes like wood always under the axe, or whose water level is the sky and the fire, to mention but a few, that the reader is left without the slightest photographic image of the woman but with the spark suggesting her overwhelming power upon the poet.

Breton gave classifications for the surrealist image, for which examples can readily be found in his works and in those of other surrealists.[10]

1. *Contradictions.* For instance in one of his earlier surrealist texts Breton plays on the linguistic contradiction caused by the simultaneous use of the past, present, and future tenses to create the impossible phenomenon of the movement of nonexistent curtains on the windows of future houses:

> *Les rideaux qui n'ont jamais été levés*
> *Flottent aux fenêtres des maisons qu'on construira*[11]

In the much later poem, "Tiki" from the group called *Xéno-philes,* the same sense of contradiction is conveyed by the combination of two adjectives incompatible in their original concrete meanings though having a junction in their extended connotation:

> *I love you on the surface of seas*
> *Red like the egg when it is green*
>
> [*Je t'aime à la face des mers*
> *Rouge comme l'oeuf quand il est vert*]

[10] Breton, *Les Manifestes du Surréalisme* (Sagittaire, 1946), p. 63.
[11] Breton, "Textes Surréalistes," *Révolution Surréaliste*, VI, p. 6.

2. *One of the terms of the image is hidden.* This can be noticed in a section of Eluard's "La Rose Publique," consisting of a series of incomplete images:

> *All along the walls furnished with decrepit orchestras*
> *Darting their leaden ears toward the light*
> *On guard for a caress mingled with the thunderbolt*

> [*Le long des murailles meublées d'orchestres décrepits*
> *Dardant leurs oreilles de plomb vers le jour*
> *A l'affût d'une caresse corps avec la foudre*]

3. *The image starts out sensationally, then abruptly closes the angle of its compass.* Witness the following line from Breton's "La Mort Rose," in which he juxtaposes his dreams with the sound of the eyelids of water and suddenly finishes the image with an unsatisfactory "dans l'ombre":

> *Mes rêves seront formels et vains comme le bruit*
> *de paupières de l'eau dans l'ombre.*

Under this heading would come all the unsuccessful images which do not measure up to the expectations aroused by the beginning of the metaphor.

4. *The image possesses the character of a hallucination.* Typical of this is the entire poem, "L'Homme Approximatif," of Tristan Tzara with its agglomeration of animal, vegetable, and mineral words, coming every so often to a head in this strange refrain:

> *For stony in my garments of schist I have dedicated my awaiting*
> *to the torment of the oxydized desert*
> *and to the robust advent of the fire*

> [*Car rocailleux dans mes vêtements de schiste j'ai voué mon*
> *attente*
> *au tourment du désert oxydé*
> *au robuste avènement du feu*]

Or Michel Leiris' vision of the sun in his "Marécage du Sommeil":

> *When the sun is but a drop of sweat*
> *a sound of bell*
> *the red pearl falling down a vertical needle*
>
> [*Quand le soleil n'est plus qu'une goutte de sueur*
> *un son de cloche*
> *la perle rouge qui tombe le long d'une aiguille verticale*]

In an early prose writing of Benjamin Péret, *La Brebis Galante*, 1924, we appear to be witnessing the vision of a man in a barn watching the cows eat hay when suddenly the hallucination begins:

> the roof of the barn cracked from top to bottom. A white sheet appeared through the opening and was torn away by a wind that I could not feel. Then, slowly, it descended to the ground. Then the earth opened up. And I saw, along a strictly perpendicular line, a little red fish descend from the roof slipping down the sheet and sinking into the ground. It was followed by a second and a third. Finally their number grew as quickly as their dimension and the rarefaction of the air in the high atmospheric strata permitted it. The wind swelled and the barn slipped under the ground. When I say slipped . . . it sank or they flew away, for the barn had divided into two. One half left with the straw and the other half with the cows and each in a different direction, arriving at the same spot: the mountain of squirrel skin.[12]

With the last dazzling image in which the mountain is compared with the skin of the squirrel Péret combines the most immovable entity with the most agile and mobile of creatures.

5. *The image lends to the abstract the mask of the concrete.* In this category would fall at least half of the surrealist images. They are numerous in Breton's poetry. Take for example simple trans-

[12] Péret, *La Brebis Galante* (new edition; Le Terrain Vague, 1959), p. 23.

fers such as the following: eternity incorporated in a wrist watch, life in a virgin passport, thought becoming a white curve on a dark background, lightness shaking upon our roofs her angel's hair. Or there are double-deckers such as in *Clair de Terre:*

> *And in my handbag was my dream this smelling salt*
> *That had only been used by the godmother of God.*
>
> [*Et dans le sac à main il y avait mon rêve ce flacon de sels*
> *Que seule a respirés la marraine de Dieu.*]

or his definition of life in *Fata Morgana:*

> *Life might be the drop of poison*
> *Of non-sense injected into the song of the lark*
> *over the poppies.*
>
> [*La vie serait la goutte de poison*
> *Du non-sens introduite dans le chant de l'alouette*
> *au-dessus des coquelicots.*]

Philippe Soupault in his image of sleep defines the natural junction of the tangible and the oneiric:

> *Sound of slumber*
> *bee and night*
> *the beauteous familiar things in the corner*
> *said goodbye*
> *for ever and until tomorrow*
> *with the despair of the finite and the infinite*
> *which touch each other*
> *like hands unaware of each other*
>
> [*Son du sommeil*
> *abeille et nuit*
> *les belles familières qui sont au coin*
> *ont dit adieu*
> *c'est pour toujours et demain*
> *avec le désespoir du fini et de l'infini*
> *qui se touchent*
> *comme les mains qui s'ignorent*][13]

13 Philippe Soupault, "Aller Là," *Poésies Complètes,* GLM (1937), p. 163.

6. *The image implies the negation of some elementary physical property.* Eluard will startle his reader by telling him that the earth is blue like an orange; and in Breton's poetry you might hear the sound of wet street lamps or of a bell made of straw, or find him wishing for the sun to come out at night, or be assured that the tree he has chopped down will forever remain green.

7. Finally there is the broad classification which would include *all images that provoke laughter;* such as in Benjamin Péret's "Au Bout du Monde":

> *Stupid like sausages whose sauerkraut has already been*
> *eaten away.*

> [*Bêtes comme des saucisses dont la choucroute a déjà été*
> *mangée.*]

The master of the "gay and acid" is of course Benjamin Péret. Drawing from the daily images their absurd and humoristic ingredients, Péret never reaches the pitch of black humor of Lautréamont. There is in him too much of what the French call "bonhomie," the healthy, exuberant sense of life, the inner sunshine of his own disposition:

> *There would be in the hollow of my hand*
> *a little lantern*
> *golden like a fried egg*
> *and so light that the soles of my shoes would fly like a*
> *fake nose*
> *so that the bottom of the sea would be a telephone booth*
> *and the phone would be forever out of order*

> [*Il y aurait dans le creux de ma main*
> *un petit lampion froid*
> *doré comme un oeuf sur le plat*
> *et si léger que la semelle de mes chaussures s'envolerait comme*
> *un faux nez*

en sorte que le fond de la mer serait une cabine téléphonique
d'où personne n'obtiendrait jamais aucune communication][14]

or in "Vive la Révolution:"

> *He was beautiful like fresh glass*
> *Beautiful like the smoke from his pipe*
> *Beautiful like the ears of a donkey that brays*
> *Beautiful like a chimney*
> *Which falls on the head of a policeman*
>
> [*Il était beau comme une vitre fraîche*
> *Beau comme la fumée de sa pipe*
> *Beau comme les oreilles d'un âne qui brait*
> *Beau comme une cheminée*
> *Qui tombe sur la tête d'un agent*][15]

The composition of a poem is like an upside-down pyramid, beginning with a word or metaphor, leading to an image and through conscious or unconscious associations to a series of images. Some of these poems consist of simple series, one image provoking the next one. René Char's *Artine* begins in this manner—in the bed prepared for him there were:

an animal wounded and blood-tinged, the size of a *brioche*, a lead pipe, a blasting wind, a frozen shell, a fired bullet, two fingers of a glove, an oil spot, there was no prison door, there was a taste of bitterness, a glassmaker's diamond, a hair, a day, a broken chair, a silkworm, a stolen object, a line of overcoats, a green tamed fly, a coral branch, a shoemaker's nail, a wheel of a bus.

In other cases the images are integrated although their connections are not logical. Breton's "Au Regard des Divinités" is an image-poem that completes a full circle of interwoven, mystifying

14 From "Mille Fois," *De Derrière les Fagots* (1934), collected in *Poètes d'Aujourdhui*, p. 90.
15 Péret, *Main forte*, p. 72.

metaphors, where darkness longs for light and the dream figures
cling to physical form.

> "*A little before midnight by the waterfront*
> "*If you see a woman all disheveled following your steps*
> > *pay no heed*
> "*It is the azure. You need have no fear of the azure.*
> "*There will be a tall fair vase in a tree*
> "*The steeple of the village with colors mixed*
> "*Will be your rallying point. Take your time*
> "*And remember. The brown geyser that darts into the skies its*
> > *spray of fern*
> "*Salutes you.*"
> > *The letter sealed at three corners with a fish*
> *Passed now into the suburban light,*
> *Like a defier's sign*
> > > *The while*
> *The beauty, the victim, locally called*
> *The little pyramid of mignonette*
> *Unstitched for herself a cloud like*
> *A sachet of pity*
> > > *Later the white armor*
> *Used for household tasks and other things*
> *The unhatched child, the one that was to be*
> *But silence*
> > > *A fire has already kindled*
> *In her heart a wild novel of cloaks*
> *And daggers*
> > > *On the dock, at the same hour,*
> *Just so the dew balanced its pussy head*
> *The night,—and the illusions would get lost.*

> *Here come the White Fathers from the vespers' mass*
> *The great key hanging over their heads*
> *Here come the grey heralds; and last her letter*
> *Or her lip: my heart is a cuckoo for God*
> *But while she speaks, only the wall is left*
> *Beating in a tomb like a festered veil*
> *Eternity is looking for a wrist watch*
> *A little before midnight by the waterfront.*

["*Un peu avant minuit près du débarcadère.*
"*Si une femme échevelée te suit n'y prend pas garde.*
"*C'est l'azur. Tu n'as rien à craindre de l'azur.*
"*Il y aura un grand vase blond dans un arbre.*
"*Le clocher du village des couleurs fondues*
"*Te servira de point de repère. Prends ton temps,*
"*Souviens-toi. Le geyser brun qui lance au ciel les pousses de*
 fougère
"*Te salue.*"
 La lettre cachétée aux trois coins d'un poisson
Passait maintenant dans la lumière des faubourgs
Comme une enseigne de dompteur.
 Au demeurant
La belle, la victime, celle qu'on appelait
Dans le quartier la petite pyramide de réséda
Décousait pour elle seule un nuage pareil
A un sachet de pitié.
 Plus tard l'armure blanche
Qui vaquait aux soins domestiques et autres
En prenant plus fort à son aise que jamais,
L'enfant à la coquille, celui qui devait être . . .
Mais silence.
 Un brasier déjà donnait prise
En son sein à un ravissant roman de cape
Et d'épée.
 Sur le pont, à la même heure,
Ainsi la rosée à tête de chatte se berçait.
La nuit,—et les illusions seraient perdues.

Voici les Pères blancs qui reviennent de vêpres
Avec l'immense clé pendue au-dessus d'eux.
Voici les hérauts gris; enfin voici sa lettre
Ou sa lèvre: mon coeur est un coucou pour Dieu.

Mais le temps qu'elle parle, il ne reste qu'un mur
Battant dans un tombeau comme une voile bise.
L'éternité recherche une montre-bracelet
Un peu avant minuit près du débarcadère.]

In the case of Robert Desnos, who was able to fall asleep and dream so freely, the process of coupling the concrete and the

abstract reached a stage where the distinction was absolutely lost and substance flowed into shadow and became dissolved in "Poèmes à la mystérieuse": (from *Corps et Biens*, 1926)

I dreamed so much of you
that you lost your reality
can I still touch that living body
 kiss on that mouth the birth
 of the voice that is dear to me,
I dreamed so much of you
that my arms in embracing your shadow
 so used were they to cross each other on my breast
 that they would be clumsy in encircling your contours perhaps.
And were I to see before me what haunts me day and night
I would no doubt become a shadow
O sentimental scale of things
I dreamed so much of you that surely the time is passed
 for me to wake. I stand asleep my body prey to all
 appearances of life and love, exposed to you who count
 alone for me today
More unlikely am I to touch your brow and lips
Than the first brow or lips that come along
I dreamed so much of you
 walked so much, talked, slept with your phantom that I can only
 be perhaps and for all of that a phantom among phantoms
 and shadow a hundred times more than the shadow that
 turns and will turn with happy gait on the sundial of
 your life.

[J'ai tant rêvé de toi
que tu perds ta réalité
est-il encore temps d'atteindre ce corps vivant
 et de baiser sur cette bouche la naissance
 de la voix qui m'est chère.
J'ai tant rêvé de toi
que mes bras habitués en étreignant ton ombre
 à se croiser sur ma poitrine ne se plieraient pas
 au contour de ton corps peut-être.
Et que, devant l'apparence réelle de ce qui me hante
 et me gouverne depuis des jours et des années

Je deviendrais une ombre sans doute,
O balances sentimentales.
J'ai tant rêvé de toi qu'il n'est plus temps sans doute
 que je m'éveille. Je dors debout le corps exposé à
 toutes les apparences de la vie et de l'amour et que toi,
 la seule qui compte aujourd'hui pour moi, je pourrais moins
 toucher ton front et tes lèvres,
que les premières lèvres et le premier front venu.
J'ai tant rêvé de toi
tant marché, parlé, couché avec ton fantôme qu'il ne me
 reste plus peut-être, et pourtant, qu'à être
 fantôme parmi les fantômes et plus ombre cent fois
 que l'ombre qui se promène et se promènera
 allègrement sur le cadran solaire de ta vie.]

Where there occurs a veritable nondistinction between substance and phantom, Desnos is much closer to symbolist form than surrealist despite his cult of the dream, for the dream tends to devaluate substance instead of enriching it.

Where Eluard adheres more closely to the phantasmagoria of the concrete the "insolite" has greater immediacy. The poet finds himself in a magnetic field wherein by the attraction of one image to another the objects of reality are deviated from their traditional roles. The result is an incongruous unit which transmits a marvelous vision of the world, a panorama whose landscapes are picked not from within the range of the human eye, but from the combinations with which language can feed the imagination. A good example of this type of poem is Paul Eluard's "Nous Sommes":

You see the fire of dusk alighting from its shell
And you see the forest plunged deep in its dew
You see the naked plain on the flank of the trailing sky
The snow high as the sea
And the sea straining toward the azure.

Stones, perfect polish, soft woods, veiled reliefs
You see the cities in tints of melancholy gilt
And sidewalks with excuses overflowing

A spot where loneliness has built its monument
Smilingly, and love its sole abode.

You see the animals
Cunning counterparts to each other sacrificed

Immaculate brethren with shadows intertwined
In a desert of blood.

You see a handsome child playing, laughing
Much smaller he appears
Than the tiny bird at the tip of the twigs

You see a landscape tasting of oil and water
Whence rock is barred, where earth abandons
Its green to summer's blanket of fruitfulness

Women stepping down from their ancient mirror
Bring you their youth and their faith in yours
And one her light the veil which draws you
Makes you see secretly the earth without you

It is with us that all will come to life.

Fauve, my real banners of gold
Plains, my good adventures
Useful pasture throbbing cities
Men will come to lead you.

Men out of the sweat and blows and tears
But who will gather one by one their dreams

I see men, true, feeling, good, useful
Throw off a weight slighter than death
And sleep from joy at the sound of the sun.

[Tu vois le feu du soir qui sort de sa coquille
Et tu vois la forêt enfouie dans la fraîcheur

Tu vois la plaine nue aux flancs du ciel traînard
La neige haute comme la mer
Et la mer haute dans l'azur

Pierres parfaites et bois doux secours voilés
Tu vois des villes teintes de mélancolie
Dorée des trottoirs pleins d'excuses
Une place où la solitude a sa statue
Souriante et l'amour une seule maison

Tu vois les animaux
Sosies malins sacrifiés l'un à l'autre
Frères immaculés aux ombres confondues
Dans un désert de sang

Tu vois un bel enfant quand il joue quand il rit
Il est bien plus petit
Que le petit oiseau du bout des branches

Tu vois un paysage aux saveurs d'huile et d'eau
D'où la roche est exclue où la terre abandonne
Sa verdure à l'été qui la couvre de fruits

Des femmes descendant de leur miroir ancien
T'apportent leur jeunesse et leur foi en la tienne
Et l'une sa clarté la voile qui t'entraîne
Te fait secrètement voir le monde sans toi

C'est avec nous que tout vivra

Bêtes mes vrais étendards d'or
Plaines mes bonnes aventures
Verdure utile villes sensibles
A votre tête viendront des hommes

Des hommes de dessous les sueurs les coups les larmes
Mais qui vont cueillir tous leurs songes

Je vois des hommes vrais sensibles bons utiles
Rejeter un fardeau plus mince que la mort
Et dormir de joie au bruit du soleil.]

By cultivating that very sense of deformity and disproportion which Edgar Allan Poe long before the surrealists had attributed to the poet, they seem to have gone into direct competition with the scientist; for the kind of linguistic reality they grant to the infinite could be likened to the mathematical reality given to the infinite by the number $\frac{1}{0}$ or the concrete symbol of the imaginary in the numerical term of the square root of minus one.

What kind of syntax or sentence structure holds together these images? Here we come to a misconception that often arises concerning the ambiguity of the surrealistic style: the contention

that surrealists disdain grammar. The early Dada writings and some of the extreme tongue in cheek statements of the surrealists have done much to give this impression. But as Aragon admits, surrealism is not a refuge against style.[16] On the contrary, in the best of their works the surrealists' grammar is impeccable. The most incomprehensible sentence could be parsed, for it is not the structure that is ambiguous but, as we have seen, the mating of words and the incongruous image that results. The surrealists, freed of the exigencies of rhyme, do not have to resort even to the tedious inversions so frequent in classical and romantic verse.

There are two basic structures in the surrealist poem: sentences which follow the conventional order of subject, verb, and object, as in most of the poem of Eluard quoted above; or a series of noun or adjective clauses which do not pretend to be parts of complete sentences but succeed each other as if they were enumerations of plain nouns and adjectives. Sometimes the two types of composition are joined into one long sentence or stanza. For example in "L'Homme Approximatif," one hundred and twenty-three breath groups form one complete sentence, and nineteen images appear before the principal verb.

The use of verbs is particularly interesting. As Robert Desnos expressed it very appropriately, the tense most often used is the present.[17] Moreover, there can be noted a preponderance of the simplest verbs: *avoir, être, voir, aimer,* the impersonal *il y a,* which in their imprecision permit the loosest form of bonds between nouns, leaving it to the noun to establish the vision. Another significant use of the verb is the frequent occurrence of the infinitive—noncommittal, democratic, since it favors no particular subject.

The freedom of the imagery is further enhanced by the suppression of words of transition: no *ainsi, donc,*[18] *or,* and the like,

[16] Aragon, *Traité du Style,* p. 189.

[17] Robert Desnos, "Confession d'un Enfant du Siècle," R.S., VI, p. 18.

[18] Breton tells us in "Signe Ascendant" that he detests the word "donc," p. 112 in *La Clé des Champs.*

since the continuity is outside of the jurisdiction of grammar and lies in the sensory associations of the reader. Indeed by the flexibility of the form the autonomy of the reader, in interpreting the poem, is increased.

In the place of connective words there occurs a great deal of juxtaposition and apposition, producing those stupefying parallels of concurrent realities of which we become aware in this type of writing.

In sum, what essentially separates the surrealist way of writing from the poetry of the preceding generations is *not* its break and emancipation from metrical form; nor does the difference lie in any disregard for grammatical structure. It is, rather, in the use of words: an enrichment of the active vocabulary of poetry, a release from verbal inhibitions, a selection of word association beyond the barriers set up by logic, a new metaphor built upon these incongruous word groupings, and the images resulting from the association of one metaphor with another—which one might call the square of the metaphor. Finally, these images are cast into grammatically accurate sentences connected primarily on the basis of sensual synchronization.

What the surrealists have done is not to sacrifice clarity but to decide that this asset of prose was a liability in poetry. For French had assumed too long with M. Jourdain that what is not prose is verse. Poetry was discovered to be a different type of intellectual activity, consisting of what one might call mental deviation and linguistic alchemy.

It was a terrible test to which language was subjected, a veritable "trial of language" as Aragon had called it. That language which foreign critics have often condemned as unpoetic, as too specific, too rigid to express the ineffable dream vagueness necessary to true poetry, was now being destined to a plane of mystery and irrationalism beyond anything attempted in any of the so-called poetic languages. Recognizing this renaissance of poetry and the linguistic experimentation related to it, Apollinaire had made this challenging statement as early as 1918: "As

far as can be seen there are hardly any poets today except of the French language."[19]

It is too early yet to estimate the extent of the transformation surrealism will bring about in the French language, just as the effects of Du Bellay's sixteenth-century *Défense et Illustration de la Langue Française* were not crystallized until the seventeenth century. The surrealists have written too much, confused liberty with license at times, and probably made five unsatisfactory images for every successful one. There has been much trial and error, and unfortunately the surrealists consider every word that falls from their pen so sacred that they have freely published their errors. But the fact remains that their vociferous rejection of standard styles has affected nonsurrealists as well as surrealists and is beginning to have an effect on the poetic language of other countries as well. The surrealists consider their experimental work only the beginning of a tremendous upheaval which will test man's ability to integrate his perceptions over and above the miscellany of nature and thereby make of the poetic image not a representation of reality but an invention of the human mind directive of things to come.

It is evident that in coming into contact with this type of poetry words such as *understanding, explanation, expression* are inappropriate. *Knowledge, empathy, disturbance* are the type of terms that best convey the surrealist poet's aspirations and his relationship with the reader. "Beauty must be convulsive, or it is not beauty," said Breton in *Nadja.* In other words it has to shake up and shape up our reality.

The crucial difference between previous linguistic revolutions and the surrealist one is that this time the transformation of the word is not an end in itself or even a means to the more effective communication of what *is.* Rather, we see that language creates, it makes concrete the ineffable dream. For the surrealist poet, and as we shall note for the surrealist artist as well, the absolute and

[19] Apollinaire, "L'Esprit Nouveau et les Poètes," *Mercure de France* (December 1, 1918), p. 394.

the infinite are within range of his pen or pencil, dependent on his power over words (or lines), on his ability to shuffle them, seizing their chance meetings, and on the variety of combinations he can produce with them. His mysticism constantly draws on this reservoir of language; and he finds that language is an inexhaustible reservoir. Through the word, the impossible is made possible, nature can be endowed with metaphysical properties, sensuality takes on new proportions: visions dispersed on the face of the earth, going abegging, undiscerned in their individual solitudes, are drawn to the new linguistic magnet and brought together into a new synthesis of imagery, which in turn creates a new synthesis of existence.

A fundamental and common subject of poetry such as love can be entirely altered and identified not with universal, emotional experience, but with an unusual disturbance of physical surroundings as in Breton's "L'Air de L'Eau":

> *Your flesh sprinkled by the flight of a thousand birds of*
> * paradise*
> *Is a high flame lying in the snow*
>
> [*Ta chair arrosée de l'envol de mille oiseaux de paradis*
> *Est une haute flamme couchée dans la neige*]

or it can be connected with cosmic awareness:

> *They say that yonder the beaches are black*
> *With lava lapped up by the sea*
> *And they roll out at the foot of a great snow smoked peak*
> *Under a second sun of wild canaries*
> *What is this far-off land*
> *Which seems to draw its light from your life*
> *It trembles so real at the point of your lids*
> *Kind to your complexion as an immaterial cloth*
> *Just out of the half-open trunk of the ages*
> *Behind you*
> *The ground of a lost paradise*
> *Casting its last dim fires between your limbs*

Ice of darkness mirror of love
And lower toward your arms opening
Bringing proof with the spring
To come
Of the nonexistence of evil
The full blossomed apple tree of the sea

[On me dit que là-bas les plages sont noires
De la lave allée à la mer
Et se déroulent au pied d'un immense pic fumant de neige
Sous un soleil de serins sauvages
Quel est donc ce pays lointain
Qui semble tirer toute sa lumière de ta vie
Il tremble bien réel à la pointe de tes cils
Doux à ta carnation comme un linge immatériel
Frais sorti de la malle entr'ouverte des âges
Derrière toi
Lançant ses derniers feux sombres entre tes jambes
Le sol du paradis perdu
Glace de ténèbres miroir d'amour
Et plus bas vers tes bras qui s'ouvrent
A la preuve par le printemps
D'après
De l'inexistence du mal
Tout le pommier en fleur de la mer][20]

The expression of the eternity of love, essayed by all the eloquence of centuries of poets, seals in Breton's language its indubitable permanence by the simplest and the most effective contradiction of words:

I have found the secret
Of loving you
Always for the first time

[J'ai trouvé le secret
De t'aimer
Toujours pour la première fois][21]

[20] Breton, *Poèmes* (Paris: Gallimard, 1948), p. 148.
[21] *Ibid.*, p. 150.

It is jesting yet passionate in the collision of the elements in Péret's "Un Point C'est Tout":

> *But I love you like the shell that loves its sand*
> *where someone will unnest it when the sun takes the shape of*
> *a bean*
> *when it begins to germinate like a pebble baring its heart*
> *under a showering rain*

[*Mais je t'aime comme le coquillage aime son sable*
où quelqu'un le dénichera quand le soleil aura la forme d'un haricot
qui commencera à germer comme un caillou montrant son coeur sous
l'averse]

Saint-Pol-Roux had felt that henceforth art had to consist of invention, but he had not had sufficient resources to accomplish the act of creation. The surrealists found in a linguistic revolution the tool of their earthbound *mystique*. Whereas it is generally assumed that imagination acquires its resources in remembered realities, the imagination of the surrealists is the power of utiliz- ing words to produce unremembered, previously nonexistent realities—but realities just the same, in the full, concrete, dimensional sense of the word. The abstract words are banished and with them the generalizations of experience. The concrete words kindle in their associations a reality of intensified immediate existence which makes escapism no longer necessary. The *mystique* of language disclosed by the surrealists has as far as the French language is concerned begun the alchemy and bewitchment dreamed of by Baudelaire and Rimbaud, paralleled as yet in no other language, but equaled and sometimes even surpassed in the *mystique* of the object cultivated simultaneously by the artists who participated in the same spiritual crisis and in the aesthetic revolution which it released.

8

*the
surrealist
object*

—the eyes must reflect what is not

—ANDRÉ BRETON

The upheaval of the word was to have its counterpart in the crisis of the object. Early in the century Apollinaire had discerned that the essential intention of the cubists was an almost metaphysical leap in space, which lifted the object from nature's frame and reoriented it in the infinite. In *Les Peintres Cubistes* Apollinaire was not afraid of attributing the label "religious" to the "inhuman" effort of the artist to bridge the gap between imitation and creation. Although like Saint-Pol-Roux, Apollinaire was becoming aware that henceforth all artists must join in a common aspiration to increase their powers of imagination, the artist rather than the poet took the first step in turning the wish into reality. The concepts of Lautréamont and Rimbaud were to be illustrated in art before they reached maturation in poetry, but it

170

was also the poets who turned out to be the best critics of that art and recorded the consciousness of creation behind the work of art.

In his poems inspired by Picasso's art Paul Eluard paid the artist his most powerful tribute when he characterized him as one who provokes visions, giving others the power to see, making the act of seeing more important than the object to be seen.

In his remarkable book of art criticism, *Le Surréalisme et la Peinture*, André Breton is so overwhelmed with the debt owed to Picasso, that he includes him in the surrealist fold and would like to have the label of cubist removed from him.

But what Breton would do in a spasm of enthusiasm must be somewhat modified in the cooler atmosphere produced by the passage of time. There is the same type of gap between the surrealists and the cubists in art as between the dadaists and the surrealists in poetry. Picasso and Braque, as well as the early Chirico, began primarily as destroyers rather than creators. Picasso, sensing the need to deviate from the accepted form of the object, distorted it, brought to it different perspectives simultaneously, or dissected it, made it unrecognizable. Chirico altered the climate of both living and inanimate forms, denuded the frame, created a vacuum in which sparse objects pause as if in finality, shedding their known robes and acquiring new ones that must be guessed. The simplest figures became the most mystifying because of the unrestrictive character of simplicity.

But Chirico stopped at the limit of space and later deviated, to the disappointment of the surrealists, into more acceptable channels, while Picasso continued to keep his emphasis on deformation.

It is the later generation with its twofold artistic and poetic inspiration that was to produce the crisis of the model and then proceed to a radical mutation of the object. In its work it was immeasurably aided by André Breton and his coterie of writers whose experiments with the word induced a new consideration of the object as well.

Never had a nonartist, not even Baudelaire, been so closely linked with art-creation as Breton. In his opinion these artists, who had come to Paris from various parts of Europe, and had attached themselves to the surrealist writers, were bringing about a revolution comparable to the mathematical upheaval caused by the advent of non-Euclidean mathematics. They were to be inventors, as Saint-Pol-Roux had sensed, marking a very evolved step in the development of the human mind: the possession of the ability to enlarge and control its sense perceptions.

In his penetrating articles on "Surrealism and Painting," and particularly in "Genesis and Artistic Perspective of Surrealism," Breton states that the emancipation of the object is the result of the artist's release from the obsession of usage. The important thing for the artist is not to see or hear but to *recognize*. Inspired by Rimbaud's nostalgia for antediluvian vision, unbridled by set perceptions, Breton believes that instead of seeking the actual, current appearances of things, one must look for the latent or forgotten significance. This does not imply the pursuit of rare objects; often the simplest ones are the most enigmatic, the most charged with possible contacts with our mental activity, so that actually the things that surround us are not really objects but become the subjects of our spiritual environment. But their subjective quality does not deprive them of their concrete dimensions. Surrealist art is not abstract art. Instead of purifying them into a state of abstraction, the artist, quite to the contrary attempts to heighten their physical reality. The painter's job was to study objects, break down their normal associations,—a process of *dépaysement* (disorientation) and endow objects with new functions and new relationships.

Just as the surrealists conducted experimental activities with the high voltage of words, so they combined forces with artists such as Giacometti, Dali, and Max Ernst to acquire an unexpected knowledge of objects, by discovering the representative range and power of certain objects such as a silver bowl, a piece of velvet, a painting of Chirico. The important thing was not the

choice of object as much as the circumstances of its viewing and its location or position in relation to other things or beings. They called their experiment: "Research on irrational knowledge of the object." Its principal purpose was to destroy the conventional value of the object and to replace it by a representative value, just as the usual connotation of the word, as we saw in the previous chapter was replaced by another one, perhaps closer to the primitive meaning. Through adroit questions and spontaneous reactions it was revealed to what extent the object could be related to the psychic life of the viewer. The intensity of the psychic stimulus is judged by the vividness and richness of associations which it arouses.

The laboratory experiment, moved to the plane of artistic production, sets new standards of values for the artist's work. Instead of the age-old adherence to a faithful representation of familiar objects and landscapes, the surrealist painter seeks a new objective. His success is to be judged by the degree of fusion the work permits between the ability to perceive, and the inner hallucination that is set in motion and given a concrete representation. It can be seen how closely pictorial and verbal creativeness are thus linked.

This was not an attempt to transcend the physical world but to transmute it, not to rise above but to change at will the climate by rejecting the entities which did not coordinate with the artist's inner world and by concentrating on those that did. When, therefore, the common denominator of perception is erased and replaced by a purely subjective grasp, the objects bear the same estrangement from accepted standards of perspective as the actual perception of one individual differs from another's. The world, and therefore the work, of each artist bears his exclusive stamp and can resemble no other and by the same token can readily be distinguished from all the rest.

The mind no longer accepts passively the data of the sensations but controls them by directing the eye and the touch. The perception thereby attained is not something abstract but very

material. Breton points out that surrealist art is very far removed from the abstract or from so-called pure art, which on the contrary dematerializes the object into an idea. It also becomes quite evident that the artist has wandered far from symbolism and impressionism. The generalized role that the symbol bestows on the concrete is the exact reverse of the character of the surrealist art object which is a study in the particular delivering the object from its general role to bestow on it a specialized new one. This attitude is close to the situation noted in Reverdy's poetry in which the world was seen full of unfamiliar objects, or familiar ones that expressed the unknown, rather than as a forest of familiar symbols. Of such deviated, changed objects the daily marvels of the earth are composed for the artist. In their power of stimulation they can surpass the mystical dreams of the past. This is the same "merveilleux quotidien" that illuminated the Paris of Aragon in *Le Paysan de Paris*. The poet had come to the realization that he could be a materialist without being a determinist: accept the objective reality of matter but not allow it to be interpreted merely by his rational faculties. When material reality could be grasped by the united efforts of reason and imagination, then the poet could become a visionary of the miracles in the field of reality which far surpassed those of legend or those of pure fantasy. But this exercise of the mental qualities gave the word imagination a new connotation—it was not to be any longer subservient to memory but was to feed on a deep-set psychic intuition. This poetic position was appropriated by the artists as well when they realized that the power of objects could be enhanced in the same manner as the power of words.

The artist's mind and eye, as the poet's, were subjected to rigorous training. Henceforth, the artist's hands were to create the objects projected from his mind, after its process of selection and alchemy: "what is seen in him," just as the poet's pen transcribed, at times insensibly, the dictates of his metaphoric vision. Art, even as poetry, was to become not an escape from the narrowness of lived reality, but the overflow of intensified life

experience. Characterizing vision as frustrated or impaired the Belgian surrealist Paul Nougé explained in his article on "Les Images Défendues" (The Forbidden Images) which appeared in the fifth issue of *Le Surréalisme au Service de la Révolution,* that the artist can enrich his existence by recognizing and learning to control the freedom of the eye: "The eye 'hat still sees what no longer is, the star; on the screen the vanished image; which does not see what passes too rapidly, the bullet, this smile; which does not see what is too slow, the grass that grows, old age; who recognizes a woman and it's another one, a cat and it is a shoe, his love and it is emptiness—the freedom of the eye should have warned us long ago."

Observing in retrospect the writings of this massive alliance of artists and poets of that most creative period between the two world wars, one becomes aware that the greatest quality of surrealist work was the evidence it gave of the remarkable level and intensified use of all known mental faculties and the exploration of latent ones. The artist (whether through the word or through the line) who could establish the most intimate relationship between exterior reality and his inner world was deemed the most successful creator of the aesthetic absolute, the most to be envied, the most to be extolled. The degree of closeness was obviously dependent on the flexibility and adaptability of the imaginative faculty. Dali defined the creative works thus conceived as "meteors of imagination."

But beyond that, the artist must also have the ability to arouse in the spectator the curiosity to grasp his image. In the same article quoted above, Paul Nougé said: "it is not enough to create an object, it is not enough for it to be. We must show that it can, by some artifice, arouse in the spectator, the desire, the need to see." When the painting no longer acts as a sedative but as a stimulus, arrests the mind in its restless, dissatisfied wanderings, and fixes its attention in a position of significant immobility, similar perhaps to the stillness of a religious ecstasy. Then indeed the work of art has achieved its moment of miracle for the viewer

ceases to see at random and recognizes his own creative power to transfigure the universe. Not in escape or in sublimized emotion do we find the objectives of the work of art, but in the kind of communication which Breton has called "convulsive" beauty and which Paul Nougé identified with the sense of the marvelous: "The marvel is embodied. An unforeseen evidence joins with bonds of flesh and blood his (the spectator's) disconnected limbs. In this fashion does the painting sometimes exist." If this miraculous empathy can occur at all it is because all men at some time or another are subject to the profound need of deviating from the circuit of the orderly connection between things, and the greatest revelation that can come to them is to discover that they are not hermetically sealed within it.

We have noted the method of exercise of the poetic imagination and its literary manifestation; the artistic feats displayed the same pitch of philosophic concern and mental orientation.

The most obvious demonstration of the irrational understanding of objects is to distort them in the work of art. Cubists and early surrealists give the most frequent evidence of this occurrence. Picasso's *Guitar, Fish and Bottles*, dating from his early period, later ones such as *Bird on the Branch*, or *Vase of Flowers*, are striking illustrations of this principle; so are Dali's melting watches, Max Ernst's furnace-like mass called *The Elephant of Célèbes*.

The distortion does not stop with things or animals. It takes on a more dramatic significance with the representation of humans. In Picasso the tendency became his pictorial signature and ran a wide range of variations from simple facial distortions and double perspectives of full face and profile, to complete destruction of the human form, a veritable dehumanization, which was to become one of the points of departure of the surrealists. Picasso's busts of women where just the faces are disturbed are followed or supplemented by others in which the body is not constructed but deciphered, reduced to its functions, with particular violence

done to the breasts; the softness that circular line suggests is suddenly transformed into hardness by the abrupt manner in which the circle is placed on the cold frame, or elongated and adjusted with nails as in *Woman in Chemise.*

The reduction of man to the level of things was demonstrated in the most total way, of course, in the works of Marcel Duchamp: his nudes, his virgins, his newlyweds, all indicating perhaps his basic inclination to fuse the process of physical creativeness with the power of artistic creation. Miró's curved lines echo Duchamp's straight ones, jumbled representations such as *Portrait of Madame Mills in 1750,* or *Head of a Woman.*

The dehumanization is complicated in Max Ernst's paintings by a merging of human and animal characteristics as in *Portrait Voilé.* This process is also inherent in the creation of new living beings attempted by many of the artists of this cubist-early-surrealist epoch: the ghost concepts of the twentieth century, such as the early model of *The Seer* of Chirico, or the later unearthly model of Dali, called *Le Grand Masturbateur.*

In his book, *Picasso,* Paul Eluard calls this distortion of the natural human line an effort to integrate the universe:

"Language is a social fact. But may we not hope that one day design, like language, like writing, will become so; and with these will pass from social to the universal plane? All men will communicate through the vision of things; and that vision of things will serve them to express the point that is common to them: to them, to things, to them as things, to things as them. On that day, a true clairvoyance will have integrated the universe to man— that is to say, man to the universe."[1]

A final aspect of dehumanization is the total disappearance of man from his portrait. He finds himself represented simply by the objects which characterize him. Here again the pioneers are Chirico and Picasso, in works such as *The Evil Genius of a King,* and *Glass, Pipe·and Matches,* or in the more subtle and evolved

[1] Paul Eluard, *Pablo Picasso,* trans. Joseph T. Shipley (New York: Philosophical Library, 1947), p. 40.

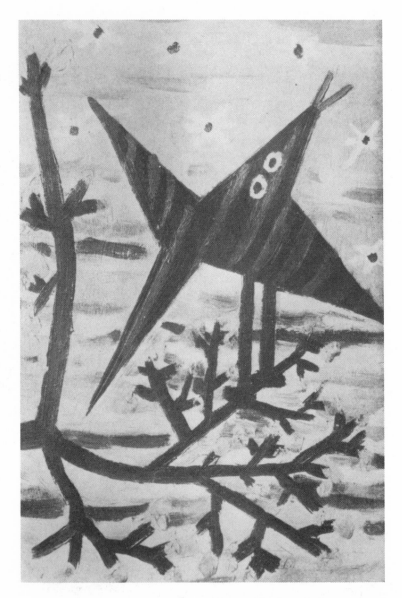

Picasso: *Bird on the Branch*. 1928.

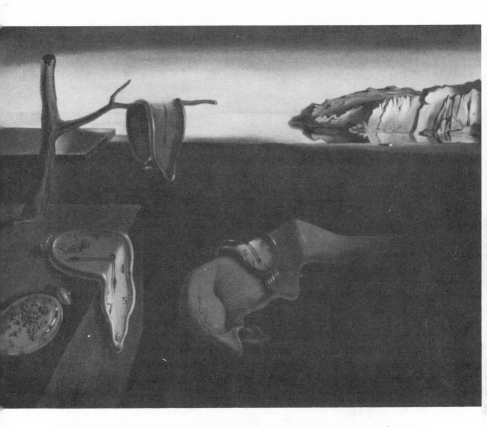

Salvador Dali: *The Persistence of Memory*. 1931. Oil on Canvas, 9½ × 13″. Collection, The Museum of Modern Art, New York. Given anonymously.

Max Ernst: *The Elephant of Célèbes*. 1921. The Tate Gallery, London.

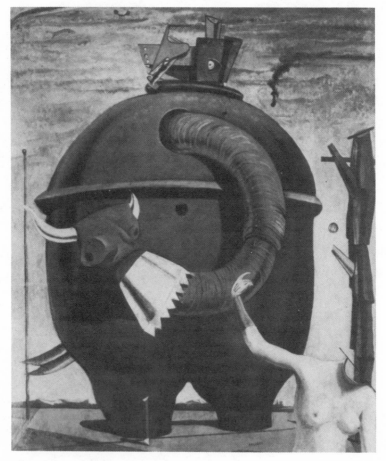

Joan Miró: *Head of a Woman*. 1938. Pierre Matisse Gallery, New York.

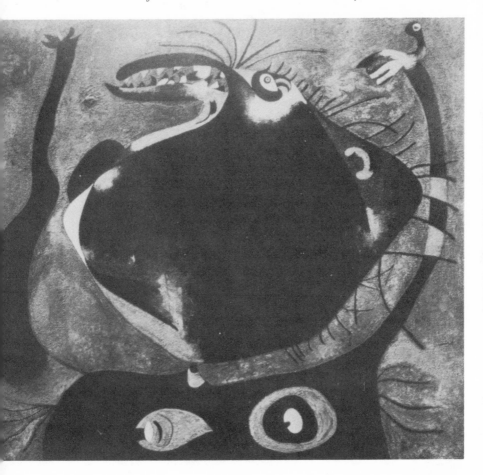

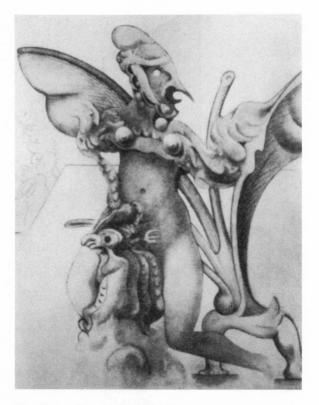

Max Ernst: *Portrait Voilé.* 1934.

Giorgio de Chirico: *The Seer.* 1915. Oil on canvas, 35½ × 27½″. Collection, The Museum of Modern Art, New York. James Thrall Soby Bequest.

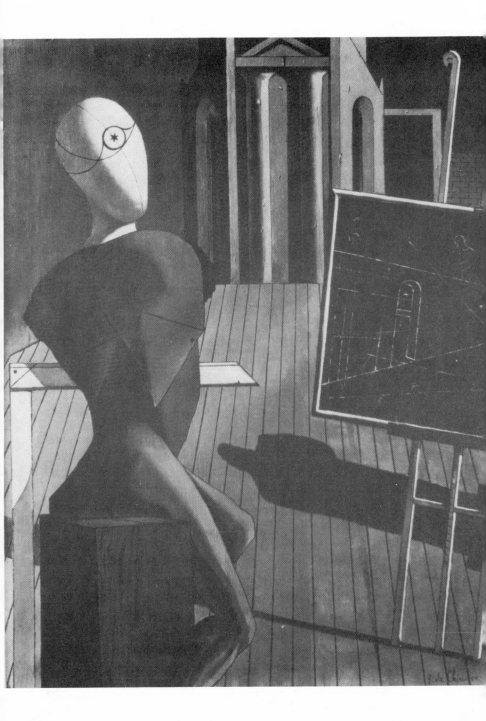

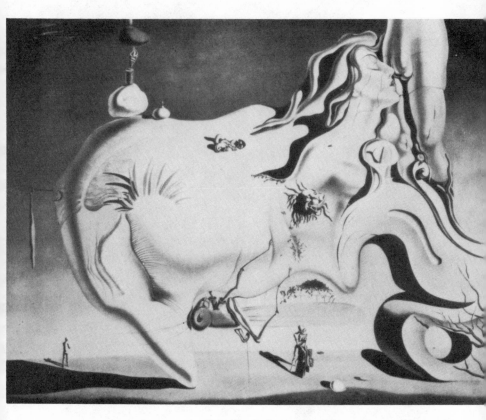

Salvador Dali: *Le Grand Masturbateur*. 1929.

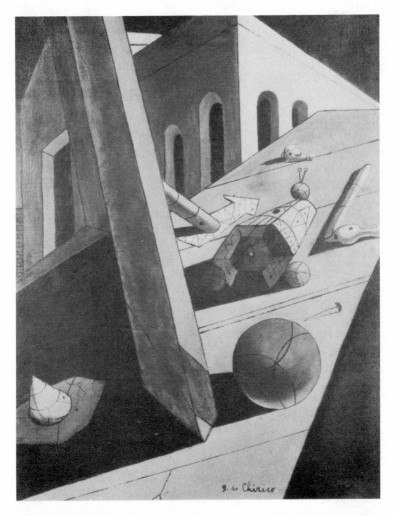

Giorgio de Chirico: *The Evil Genius of a King*. 1914–15. Oil on canvas, 24 × 19¾″. Collection, The Museum of Modern Art, New York. Purchase.

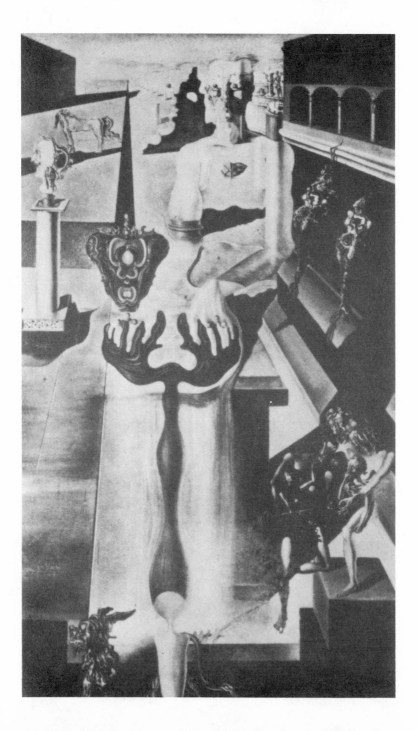

Salvador Dali: *Invisible Man*. 1929–33.

Joan Miró: *The Hunter (Catalan Landscape)*. 1923–24. Oil on canvas, 25½ × 39½″. Collection, The Museum of Modern Art, New York. Purchase.

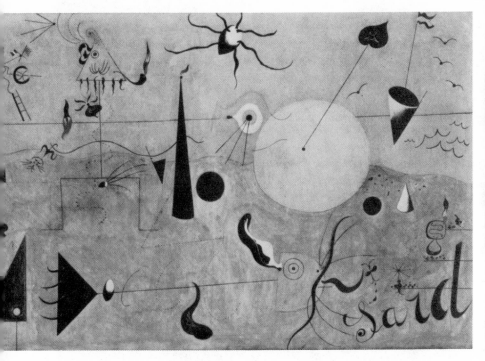

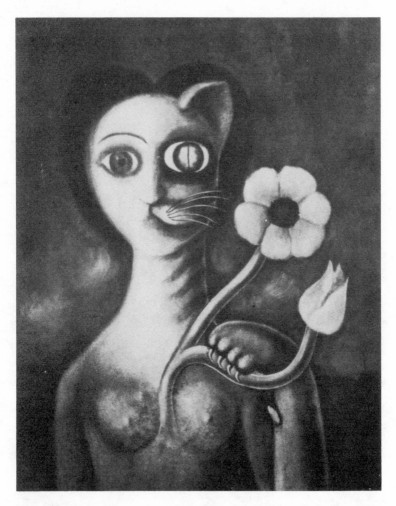

Victor Brauner: *Woman into Cat*. 1940. Pierre Matisse Gallery, New York.

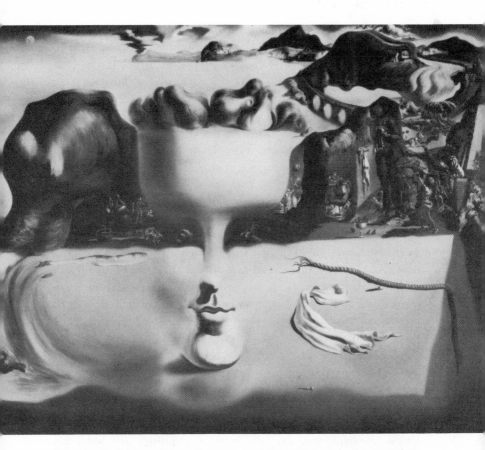

Salvador Dali: *Apparition of a Face and Fruit Dish on a Beach.* 1938. Courtesy of the Wadsworth Atheneum, Hartford; Ella Gallup Sumner and Mary Catlin Sumner Collection.

forms that representation takes in Dali's *Invisible Man,* where his mind's images are projected into concrete line and form, and in Joan Miró's *The Hunter (Catalan Landscape),* where the notions of aim and target are the crystallization of the function represented.

Although this attack on the human form, a pronounced characteristic of the surrealist image, is a radical departure from the technique of imitation in art, it is only an initial step in the lifting of the silvering from the artist's mirror. The next steps are more intricate, more germane to surrealism, and demonstrate more clearly the schism between cubism and surrealism.

Distortion is at most a narrow field of composition. Although the outer image represents the inner eye, in art as in poetry the mere representation of images is not a rich expression of creativeness and may eventually lead to attrition. It suggests an inbred, circumscribed world. If, as so much evidence suggests, the modern artist's and poet's basic motivation is an inclination toward mysticism, the relationships in the outer world must not be limited to their connections with the inner self, but on the contrary have to be envisaged in a broader network of mutual associations on the objective plane of reality. The object is the unit, as the word was seen to be a unit in the previous chapter, but the integrated vision does not rise out of the object any more than it did out of the word. Rather, it derives from the metaphor, which translated into art, means the possibilities of association between objects.

In its simplest form this means that single objects can be seen to contain elements of dual association or function. For example Victor Brauner's *Woman into Cat* incorporates catlikeness into the eye, the hand, and produces as it were a double flower sprouting from the breast. One of the most provoking of this type of dual image is Dali's *Apparition of Face and Fruit-dish on a Beach* where the outer limit of the eye structure is the bottom of the bowl, and the table on which the bowl rests assumes the fluctuations of the face it latently contains.

But the next level of development is much more fertile. As we have seen, the verbal surrealism of poetry rests on the linking of images that destroy the conjunction of comparison "as" and seek their bases of association in haphazard and chance meetings of ideas and visions, made possible by the free volleying of thought. Similarly, in pictorial art we find the unexpected juxtaposition of objects brought together by the power of an inner eye. It is noteworthy that the poets were not alone in having recourse to the poetic pronouncements of a previous generation. Where the poets leaned heavily on Saint-Pol-Roux and Reverdy, the artists particularly clung to—and made famous—a statement of Lautréamont that epitomized this technique:

"Beautiful like the fortuitous meeting, on a dissection table, of a sewing machine and an umbrella."

Out of it Max Ernst developed his famous formula of "the fortuitous meeting of distant realities" going a step further in declaring that all such associations were to have a purely temporary status and might surrender at any moment to new combinations. The process is described in detail by André Breton in his discussion of the art of Max Ernst in his *Le Surréalisme et la Peinture:* "to assemble these dissimilar objects according to an order which was different from theirs and . . . to avoid as much as possible all preconceived plan."[2]

These chance encounters were stimulated by automatic drawing and "collage." The first result was the weird estrangement of the object, produced by its separation from the objects that have generally adhered to it, sheltered or nurtured it. This might be called the coming of age of the object, weaned from its source, left to seek out relations other than the familiar ones. The sense of detachment created by the object's new position in outer reality corresponded to the inner isolation that the artist and poet have felt in the present century despite their coteries and fraternal, collective aspirations. But the break with inner and outer links

[2] Breton, *Le Surréalisme et la Peinture* (New York: Brentano, 1945), p. 55.

did not leave them long in a sterile vacuum. The new associations in pictorial representation were to possess as high a voltage as the verbal ones.

In a very fertile article called "l'Ane Pourri," which appeared in the sixth number of *Le Surréalisme au Service de la Révolution*, Dali analyzed the power of the paranoiac mind to make the field of image conjunction totally unlimited so that "comparison" virtually ceases to exist. The linking of any number of realities becomes a gratuitous act controlled by the power for "simulacre," i.e., of seeing in each object two or an infinite quantity of others, the range and number dependent on the power of desire and obsession: "such a limit does not exist or is solely commensurate with the paranoiac capacity of each individual."

Dali's position was that paranoia, which in its acute stage which we call abnormal or pathological, is basically a mental mechanism that can be cultivated and controlled by the artist to extend the scale of analogies, and to demonstrate the high incidence of subjectivity in what we call "the world of reality." The miracle, according to Dali, is that the resulting configuration is acceptable and recognizable by the viewer. "The paranoiac uses the exterior world to impose the obsessive idea with the disturbing particularity of making the reality of this idea valid to others. The reality of the exterior world serves as an illustration and proof, and is put at the service of the reality of our mind."

This psychic operation is very much akin to what Rimbaud had called "the simple hallucination" through which he could see "quite frankly a mosque in place of a factory, a school of drummers made up of angels, carriages on roads in the sky, a parlor at the bottom of a lake, etc.," as he explained in *A Season in Hell*.

Although Dali's associates did not possess the natural grain of paranoia with which he was richly endowed, the paranoiac understanding and representation of the object, and the determination of its contingencies with other objects became the basic technique of surrealist art at the outset, and the examples are too numerous

to cite. It forms the core of Dali's surprises, "absurdities," challenges, ludicrous ones such as *A Chemist Lifting with Extreme Precaution the Cuticle of a Grand Piano*, or subtle, provocative ones like *Aerodynamic Chair*, in which a seat is hoisted on top of an autumnal tree against whose trunk is placed a nude woman and a dresser with a backdrop of water and mountain, suggesting the desolation of volcanic aridity.

The juxtaposition in Marc Chagall's *Time Is a River Without Banks* is the fusion of such distant realities as a fish, a violin, a hand, and a swinging pendulum cracking down into a countryside, and in its shadows, a couple making love undisturbed. In the cosmic fresco-like paintings of Max Ernst the juxtaposition sometimes reaches cataclysmic proportions, and the free intermingling of objects eventually causes a breakdown of the barriers between the vegetable, mineral, and animal kingdoms, as for example in *Nature at Daybreak*.

Once the barriers are down and a new promiscuity has been established between exterior entities which were previously located on separate planes, the next step is the overflow of the nonform abstract image into a concrete objective existence; this is not abstract art, but just the opposite: the materialization of the abstract, the crystallization of the mental image. It is exactly the path Breton traced in his study of dreams in *Les Vases Communicants*, i.e., to enrich life with the dream provision by going "from the abstract to the concrete, from the subjective to the objective, following the only road of knowledge, we have succeeded in freeing a part of the dream from darkness and we have found a way to make it contribute to the greater knowledge of the fundamental aspirations of the dreamer and to the better appreciation of his immediate needs."[3]

The distortions of form and perspective, and the absurdities of unexpected object associations, can be used as means of conveying mental hallucinations, dream images, simulation of insanity

3 Breton, "Réserves Quant à la Signification Historique des Investigations sur le Rêve," *Surréalisme au Service de la Révolution*, no. 4, p. 11.

Salvador Dali: *Aerodynamic Chair*. 1934. Collection of De
Beers Consolidated Mines, Ltd.

Marc Chagall: *Time Is a River Without Banks*. 1930–39. Oil on
canvas, 39⅜ × 32″. Collection, The Museum of Modern Art,
New York. Given anonymously.

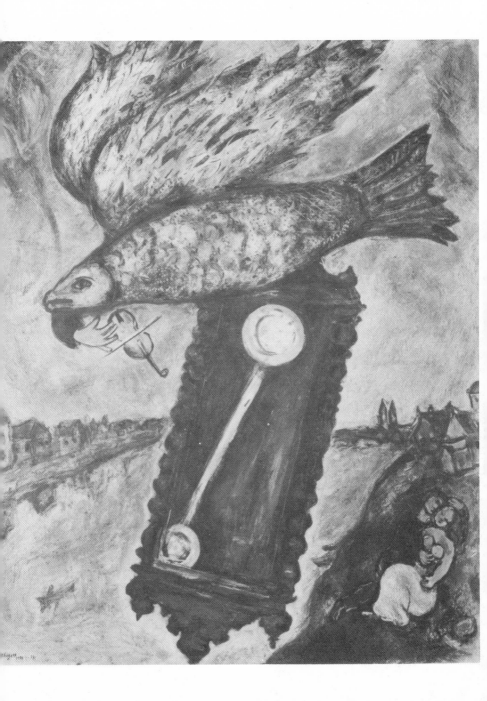

Max Ernst: *Nature at Daybreak*. 1938. Galerie Beyeler, Basel.

Man Ray: *Primacy of Matter on Thought*. 1931.

Max Ernst: *L'Oeil du Silence*. 1944. Collection of the Washington
University Gallery of Art, St. Louis.

Salvador Dali: *The Feeling of Becoming*. 1930. Collection of Louise Crane, New York.

René Magritte: *Le Modèle Rouge.* 1935. Collection of the
Nationalmuseum, Stockholm.

Yves Tanguy: *Le Ruban des Excès*. 1932. The Tate Gallery, London.

Yves Tanguy: *Vieil Horizon*. 1928. Photograph courtesy Pierre Matisse Gallery, New York.

Yves Tanguy: *Multiplication of the Arcs.* 1954. Oil on canvas, 40 × 60″. Collection, The Museum of Modern Art, New York, Mrs. Simon Guggenheim Fund.

(as in the case of Dali's paranoiac paintings), and most important: the mystic vision divorced from religious symbolism.

Of this character is Man Ray's *Primacy of Matter on Thought*, which shows the tangibility of form melting into the fluidity of abstraction. It is reminiscent of Desnos' confusion of the living contour and the phantom-image. The configuration of the dream hallucination in Max Ernst's paintings takes extraordinary proportions. It produces the ornate mysticism of *L'Oeil du Silence* with multiple eyes emanating from stone, and top-heavy gargoyles resting on abysmal waters of silence. The bird obsessions prevalent in his minotaurs and other monsters that burgeon in unexpected places are instances of the simulacre technique. For the resulting phantom is painfully concrete and recognizably living although its shape is both extrahuman and nonanimal. In fact, Max Ernst's landscapes are based on a subjective reorganization of the animal, vegetable, and mineral kingdoms.

Dali's *Symbol of Anguish*, his *Accommodations of Desire*, his *Persistence of Memory*, translate into concrete reality the silent but tense conflict between measured time and the unaccountable infinite. Perhaps one of the most potent metaphysical images thus composed by Dali, and one of the simplest as far as drawing, is the one called *The Feeling of Becoming*, in which a man hides all but his head behind a sheetlike curtain held up against the forces of gravity and casting a shadow over distant rocks while it acts itself as a foil to an unexpected shadow of something no doubt present in the unseen foreground.

But despite the originality of such artistic concepts and their execution, the technique so far described and illustrated in surrealist paintings is a partial compromise with reality. The shape is changed, the forms are mingled freely, the concrete is associated with the abstract, but imagination is still largely conditioned by known experience, and, to a certain extent at least, the objects are recognizable.

A more total creativity occurs when an attempt is made at virtual fabrication of new objects, and thereafter objects inter-

mingle in an atmosphere all their own, governed by new laws of perspective, and against a new visual horizon. The most evolved forms of surrealist art are concerned with such metaphysical objects and their space-horizon in what would seem to be a nonoxygen atmosphere.

The most vivid illustration of this type of surrealist art is René Magritte's *Le Modèle Rouge* which starts by being a foot and ends up with the properties of a boot. It is not a double object, such as the ones that suggested at the same time a woman and a cat or a face and a bowl as in the examples previously cited. This time the object has a fantastic unity as it appears before the viewer: it reposes on pebbles, neither with the pressure of a foot nor that of a boot, but with a weight all its own, suggesting uncanny functions which cannot be associated with any known ones. The container (the boot) and the thing contained (the foot) have achieved an entirely new reality as a new object.

The pursuit of the original object became a collective preoccupation of the surrealists in all fields of artistic expression. Miró populated his paintings with these strange forms, contingent upon each other though completely incompatible with each other in matters of shape, color, or size. Giacometti actually constructed new objects, tactile in their suspended position, dimensionally accurate as an engineer's composition, but intended to satisfy a dream-need rather than a rational or a utilitarian one. Breton, as always the recorder of surrealist activities, called them "phantom objects" and has demonstrated his own such fabrication under the title *poème-objet* in surrealist expositions.

As one contemplates the whole range of surrealist expression, the objects and landscapes of Yves Tanguy tower as the most creative manifestations of the entire phantasmal gallery. Tanguy's groupings and enigmatic spaces between objects seem to have been guided to their positions by a sort of divine chance. They suggest spasmodic shocks of atom movements and carry their long shadows before them as if lit up by a sun low in the heavens or as if the sun were below them and not above. Group-

ings seem to possess separate horizons suspended in a sphere freed of measured time. The colors appear to be those of mingled spectrums of two different suns whose beams might perchance have crossed: ruddy tints of oxidation lacking all character of warmth, and blues not of azure but of mineral.

The mingling of the concrete and the abstract, which we noted in the poetry of surrealism, is brilliantly illustrated both in the titles used by Tanguy such as *Le Temps Meublé*, or *Le Ruban des Excès* and in the paintings themselves where shapes are strikingly three-dimensional and at times seem to pop out of their nonsubstantial frames.

He can suggest hallucinations as the tormented whirlpools of *L'Humeur des Temps.* Tanguy displays versatile, unexpected juxtapositions, confusing our sense of proportion as in his *Un Grand Tableau qui Représente un Paysage*, or by creating discordances in form through the promiscuity of incompatible shapes. One of his most frequent metaphysical techniques is to confound the laws of gravity, leaving things suspended in the furrows of his skies, or we are faced by the uncanny phenomenon of seeing an object fly (not fall) down the sky instead of up, in a landscape which he calls—ironically one might say—*Vieil Horizon.*

Here we are as close to facing pure creation as has been given to any artist. As one gazes at Tanguy's canvases one has the feeling that if man ever achieves his desire to be propelled on to other planets, what he will find in other worlds must resemble the objects and landscapes devised by Yves Tanguy: his flight will be as free of gravity as the positions and attitudes of these objects on Tanguy's canvases. Suspended without accompanying motion as in *Les Amoureux*, he will perhaps partake of Tanguy's mystical vision: strata of neither solid nor liquid consistency, the heavy leaning upon the light weight, a semi-light and its self-contained shadows, shapes suggesting dolmens and cactus but with a relationship to the world that is neither that of the plant nor of a

stone, for the substance on which they repose is neither earth nor air, but contains the colors of silence or of an arctic sunset.*

In a revealing evolution that can be observed in Tanguy's work, the objects of his imagination become heavier, more jagged in form, the colors more clashing. Getting larger, closer to the foreground the objects lose more and more the freedom of their space separation. Heavier and lower the objects move in the frame until we come to his final, immense painting called *Multiplication of the Arcs*, completed just before his death. Here the objects are piled upon each other, asphyxiating in their crowded proximity; they suggest the final counting of the numbers as he takes stock for the last time of the entities of his universe. As one contemplates these metaphysical landscapes one realizes that Tanguy accepted the material world as the sole but infinite end. He went from one anguished level of inanimate objects to another, which in its unearthliness denied that quality of the earthly and the human that the surrealists in all forms of art have refused to accept: the notion of the *finite*. Although the surrealists had originally found so much to reject in the world, socially and politically, they were eventually able to adapt their surroundings to their dream by concentrating their rebellion upon one unacceptable concept, the notion of finitude. This rejection is vividly evident in Tanguy's paintings just as it is eloquently expressed in Aragon's words: "the idea of limit is the only inconceivable idea." In the long run, it is also indicative of the basic character of our age.

As one observes the imitators of Ernst, Dali, and mostly of Tanguy, multiply all over the world, one feels that the artist has synchronized with the scientist who has projected his instruments and eventually his person into outer space. One tends to agree with artist-philosopher Ernst that "In yielding quite naturally to

* It is a pity that in the ten years that have elapsed since the first edition of this book Tanguy has been so much imitated that the provocative character of his perspectives, objects, and colors has been somewhat diminished.

the vocation of pushing back appearances and disturbing the relationships of realities, it (the genius of the artist) has contributed with a smile on its lips to the speeding up of the general crisis of conscience which must come to a head in our time."[4]

Surrealism in art has had a prevailing unity over the years, unmarred by the artists' peregrinations from country to country and hemisphere to hemisphere. (It is amusing to observe the Museum of Modern Art's practice of classifying these artists in terms of their current or final citizenship.) Neither is the signet of surrealism related to any particular mood or plastic technique, but rather to a metaphysical approach to reality, translatable in as many ways as there are individuals. Behind the juxtaposition, the simulacre, the distortion, destruction and creation of objects that populate the canvas-universe of the artist, there is what Hegel called modern, i.e., the projection of the inscape upon the material world and the restructuring of that physical matter by each, according to his creative power, whether we call it paranoiac or simply imaginative. For if Dada was bent on destruction, surrealism was in search of the power of creation. In a world in which abstract idealism had become intolerable, and otherworldly transcendence unacceptable, the artist used the object, as the poet used the word, for a means of personal freedom and for the transfiguration of the universe.

The apocryphal aspect of the universe in a Tanguy painting is more relevant to our time than the angels of Raphael, for it conveys in succinct eloquence modern man's current obsession: to extricate himself from the established order of earthbound measurements and to discover a new relationship between his mortal self and the infinite reality with which he considers himself in daily contact.

Only man is vanity, all else enduring, is the conclusion one might reach as one contemplates these works of art from which little by little man and his relationship with other humans vanish,

[4] Max Ernst, "Comment on Force l'Inspiration," *Le Surréalisme au Service de la Révolution*, no. 6, p. 45 (the final sentence of the article).

giving way to the things that might survive him, perpetuating his imprint, just as the scientist's instruments outreach the vision of his human eyes. In both cases there is produced a vicarious sort of transcendence, which may perhaps lay the foundations of a new metaphysics.

THE BEND IN
THE ROAD

9

the
post-surrealism
of
aragon
and
eluard

Surrealism has come to have two meanings: it was originally the closely-knit spiritual union of artists and writers who operated under the common trademark, worked out their artistic problems together, wrote for the same periodicals, sometimes even collaborated on works. But as we have seen, in its broader sense it represents a spiritual crisis that stems from the ideological developments of the nineteenth century, and has succeeded in producing a technique of writing and painting that conveys a materiomystical vision of the universe. When just prior to World War II Aragon and Eluard broke up with André Breton they obviously ceased to be "surrealists" in the limited sense of the word; but were they able to shed so lightly and so abruptly the surrealist

state of mind which had served as the original motivation for their writing?

Too often the negative influences that helped shape the surrealist movement are mistaken for its positive precepts. In the preface to an anthology of Aragon's poetry (1946), Claude Roy attributed the "fecundity of surrealism" and its appeal to basically different personalities, to an inner contradiction in the character of the movement: a will to change the world versus a wish to give up the world for a nirvana. It is true that the surrealists had two aims, but I do not think that there was any real conflict between them; for the will to change and the will to renounce did not refer to the same type of existence.

The young surrealists of 1920 reacted nihilistically to a certain atmosphere: the smug urbane world whose limited logic they held responsible for war and social chaos. These young men, unlike their elders Claudel, Péguy, and Maurras, found no inspiration in war. When the newly organized surrealists were deriding established traditions and institutions, they were condemning what to them symbolized bigotry and lack of vision. When, at a banquet in honor of Saint-Pol-Roux, a surrealist fanatic cried out "A bas la France!" he was referring to the "France" in the throes of postwar failures.

The surrealists were tired not only of the social status quo but of the literary one as well; they coupled, therefore, their antisocial behavior with artistic anarchism. To them the inefficacy of language had been as responsible for the stagnation of society as the fallibility of thought and action. Literature had been too easy, too wordy. The artistic revolution intimated in the works of Baudelaire and Rimbaud had been sidetracked and muffled by the philosophical abstractions of Academicians and by the rarefied imagery of the symbolists. As Aragon points out in his *Chroniques du Bel Canto* (1947), the fundamental motivation of the new poetry, regardless of names and labels, could have been more broadly summed up as "rimbaldisme." The early surrealist antagonism to language was the antidote to the poetry of the two

preceding generations, which on the whole had deviated from the course indicated by Rimbaud.

This double attack aimed at the society and literature of the beginning of the twentieth century had an essentially circumstantial character. Of the positive credo that the surrealists had been developing at the same time, there was only one element manifest in the iconoclastic demonstrations which had gained so much notoriety: the courage to be uncompromising.

If surrealism had just been a means of expressing youthful revolt and rejection, one could be persuaded by Aragon's assertion: "I have never been part of a school," in the preface to his World War II poems, *En Etrange Pays dans Mon Pays Lui-même*, that he was no longer a surrealist. But Aragon's early affiliation had not been merely a social or aesthetic rebellion of youth. He had been deeply involved in the metaphysical anguish of those surrealists who sought to transform this world to satisfy their longing for the absolute. It is not his word but his work which can best reveal the extent to which he actually deviated from the surrealist point of view in his later life.

In 1939 Louis Aragon was mobilized; because of his long record of unpatriotic acts (five years before he had been arrested for publicly insulting the flag) he was kept under the watchful eyes of the authorities; a year later, after having gone through every harrowing experience of the defeat of the French army, he was discharged with three of the highest decorations. Soon there began to appear in various periodicals in the unoccupied zone of France poems he had written during the "phoney" war, and during the early months of his stay in Carcassonne following his demobilization. Later collected under the title of *Le Crève-coeur*, these poems relate the dreary months of waiting behind the lines, his anxiety in being separated from his wife, the tragic retreat, the soldier-poet's anguish upon hearing of the surrender of Paris on a mild evening in Normandy where the bouquets of retreat were borne to him on the sweet breath of roses in bloom; gardens of France, lilacs of Flanders, stood out in dismal irony in the

whirlpool of images that crowded the poet's senses as fear sped the army's flight back. Out of the disaster, poetry surges with an urgent mission which Aragon is not abashed to call "noble"; for poetry seems to him the last foothold on dignity left in his moment of abject humiliation. In his youth he had derided the photographer's realism; now he was no longer loath to beat the camera's lens at its own game as he described the defeat of his country. In the years of the occupation he continued to write of his love for his country and for his wife. The late subversive, instead of collaborating with the enemy, as might have been expected from his peacetime performance, became a fervent patriot, the morale builder of the French people, the bard of the United Nations, a backbone of the Resistance.

But when pictures of heroism, devastation, treason, assassination, pillage, murder, human separations invaded the works of Aragon, did they indicate a return to narrative verse, and a recapture of classical eloquence?

Quite the contrary. The surrealist state of mind prevails in the majority of these writings. Once, in philosophical splendor, Aragon had imagined "the concrete form of disorder"[1] as the outer limit of what the human mind could grasp. Now, confronted with a more complete disorder than dreamed of in his philosophy, he set out to capture it poetically as no camera could register it. In his days of orthodoxy Aragon had defined surrealism as "the unruly and ardent use of the stupefying image"[2] which, as he believed, continually revised our entire universe. Now he created the stupefying image of disaster, together with its numerous associations, which expressed better than words of despair the mournful transformation of his world.

In *Le Crève-coeur, Les Yeux d'Elsa, Cantique à Elsa, La Diane Française* and *Le Musée Grevin* Aragon's picture of the retreat, the surrender, and the occupation is a pool of concrete images, disjunct or in ironic contradiction with each other: brilliant

[1] Aragon, *Le Paysan de Paris* (Gallimard, 1926), p. 236.
[2] *Ibid.*, p. 81.

colors of flowers, interspersed with deep shadows of death; sweet breath of flowers borne on a whirlwind of panic; the echo of tanks, the enigmatic silence of waiting; bouquets of retreat, red as the roses of Anjou, red as the fires of destruction. His country is a bark abandoned by its oarsmen; his people's blood is a wine of poor vintage; the people, the pastures, the dreams all intermingled, juxtaposed, on a single level of reality. In the moment of loss he takes stock of his daily surroundings and becomes aware of their eternal significance. Already keenly conscious of the important role of the poet, he sees poetry as an elemental need:

> *The humming of a song that lightens the tread of heavy feet*
> *A demi-tasse at dawn*
> *A friend encountered on the road to the grave.*[3]

Among his war poems the ones most certain of lasting value are* "En Français dans le Texte" and "Brocéliande," collected in 1947 under the telling title of *En Etrange Pays dans Mon Pays Lui-même.* Written in 1942, they employ the subtlety of double entendre to trick the censor, and double meaning suited perfectly the surrealist talent for avoiding the obvious. Thanks to the censor, Aragon escaped in these poems that easy realism to which he occasionally resorted in his earlier war verse. In these series of poems he raises the incidents to a plane of universality by using one of the basic techniques of surrealism: the exploration of the myth, which replaces the circumstantial reality of history with the metaphysical reality of the legend:

> *Since the assayers of gold have closed up their counters*
> *And all greatness has passed us by*
> *I'll take you back Legend and make you my History*

[3] Aragon, *Cantique à Elsa,* "Ce que Dit Elsa."
* The added time-perspective, I find, indeed supports my judgment. In fact, the others, which were more passionate because more intimately linked to circumstantial events, have lost much of their impact, as they are no longer dramatized by the immediacy of the events.

The "peasant of Paris," who had had to resort to artificial devices to change the peaceful metropolis into something marvelously different in his earlier days, utilizes in many of these poems all his verbal powers of association to create *in absentia* a new hymn to Paris by means of a series of pictures of the city which the war had forced him to leave. Not tears, not the thoughts, but the avalanche of images tells the story: events are liberated from their tape measures of time, and past and present heroes intermingle, the invisible becomes visible, the vast lines parallel the tiny detail; the exalted is mated with the absurd, the permanent with the transitory: Notre-Dame rising above the Seine like a magnet, boxes of sardines lying desolately on display; the terribly concrete reality of absence in the sound of loosened shutters beating against window panes; objects left absurdly well arranged in an atmosphere of disorder. Despite the frequent lack of transition or continuity between the metaphors, they pool their resources to create an unforgettable unity of impression.

Brocéliande, the forest of Brittany, where once reigned the magician Merlin of Celtic mythology, gave Aragon his best opportunity for using myth to express the catastrophe of his country. Here, the self-avowed materialist conjured up all the mystical resources of pagan marvels, Christian miracles, and the wonders of man-made machinery to convey the supertemporal image of destruction and regeneration, which the combined evidences of all his senses and the expression of his deepest emotions were not, by themselves, able to relate. Just as he had felt that poetry was not to be retained in an ivory tower but to be shared by all, he came to realize that the marvelous, which he had sought, as the treasured possession of the privileged, was really the legacy of all. He chided those who were "drowning at the portholes of hope" and invited them "to open up for us their enchanted forests." It was an invitation to dreaming in the midst of unbearable reality:

"Impossible is a word that's banished from the earth." The legend was part of France's national existence. It was, therefore,

its truth. In evoking it one would be passing it from one generation to another so that "not one moment may the dreams remain unemployed."

The wondrous hail, the curse of the locust, and modern bombs assume a single reality as they evoke simultaneously the odor of death and of moss in the magical forest. They give destruction a three-edged reality, until finally the stone cries for mercy. The eventual resurrection of the people is either that of Christ, or that of Orpheus; there is no difference for Aragon, for him both hold the veracity of the myth. The regeneration is accompanied by a reawakening of earth and the miracle of multiple harvests. It is a composite symbol of France, possessed on one temporal level of all her past and present legend and reinforced by the salutary vision of her future.

Aragon's basic qualities as man and artist were revealed here: his social consciousness which sought to alter the unwanted reality of the circumstances, and at the same time the artist's clash with the temporal situation; for the poet was defending with a single stroke his two most precious possessions: civic liberty and the liberty to dream as an artist. The dream had been a war casualty too, the dream had been deemed a crime, put in quarantine; to preserve its liberty it had to go underground, for it refused to remain inactive. The visions in "Brocéliande" signal the rescue and presage the victory of the other freedom.

What Eluard wrote during the trying years could also fall into two groups: the directly circumstantial verse representing the basic local color of events and his subtler interpretations of the disaster. In *Vérité et Poésie* and *Au Rendezvous Allemand,* the militant tone of anger and indignation sometimes overpowers the surrealist manner. *Le Livre Ouvert,* a selection of poems written between 1938 and 1944, includes fewer of the heavily documented pieces. But whether Eluard was describing the defeat of Paris or the less obvious consequences of the disaster, he generally retained his basic surrealist tendency to disregard arbitrary

divisions between the concrete and abstract worlds. Even the essentially circumstantial poem "Liberté," whose timeliness and simplicity of language gave it a fame beyond its literary merit, was brought into the surrealist orbit of perception by the breaking down of the abstract concept into series of images whose common denominator consists of the subconscious associations they hold with his notion of liberty. Except when indignation makes him lose his identity as an artist, his word-images of good and evil, life and death, poverty and fear, or even the undefinable word "misère" are vivid metaphors representing distortions of perspective, undulations or splurges of color, a sudden brilliance, a striking detail.

Ever since the days of his "miroir sans tain" (the mirror without silvering)[4] Eluard had been an expert at materializing the invisible. Obsessed more than ever by the presence of death, which he has considered the greatest challenge to the human imagination, he succeeded in representing its earthly presence in other than negative terms. He coordinated the subjective and objective hollows which the dead created in the material world when with reluctance they departed. By strategic use of the incomplete image he vivified the missing: absence of hearts, absence of towns, emptiness of prison cells.

The dominant characteristic of Eluard in his earliest surrealist poetry was the love theme. In his later period, love remained for him, as well as for Aragon and Breton, an expression of the innermost recesses of human personality. A spontaneous physical and spiritual relationship with the loved one makes her the intermediary between the creative sensibility of the poet and the sensations to be conjured from the earth. In her are reflected the beauties of the material world and the impressions of the poet. Love makes the senses keener and the imagination more acute, delivers the poet better than anything else from the notions of time and space; love is at the same time the center and the cir-

[4] Eluard, *Les Dessous d'une Vie*, p. 17. First introduced in this work the image is used frequently elsewhere.

cumference of his universe: "world where without you I have nothing."[5] From personal love to communion with all of humanity is a natural step and one which inspired him to say, despite all the hatred about him: "I love for the sake of loving and I shall die of love."[6]

It is in *Poésie Ininterrompue*, written immediately after the termination of hostilities, that Eluard gave his most complete expression of his parallel loves for his wife and for humanity, and the ultimate relationship of these feelings with the universe. With the surrealist's belief that this world is all, and that there is enough here if only we develop sufficient elasticity of insight, he proceeded from the narrow perception of the blind of eye and of heart to the apocalypse of the visionary. He draws upon multiple perspectives as he and his loved one rise step by step, widening the scope of their senses and exploring their powers of divination. First the range of sight is limited: walls, trees, rain; along with the physical barriers there is an isolationist aspect to the love enclosing the two in a world of elemental needs. And this relationship has in the background the stolid contradictions in universal man: his slow-moving barbarism, his stagnation, confusion of instincts, his blindness, and on the other hand his flashes of insight:

> *Man of lingering barbarisms*
> *Man like a stagnant pool*
> *Man with his dulled instinct*
> *And exiled flesh*
> *Man with hot-house lights*
> *With closed eyes man with flashes of lightning*
> *Man mortal and divided*
> *His brow hope-bled*
> *Man past-ridden*
> *And full of regrets*
> *Isolated, of the day to day breed*
> *Stripped responsible*

[5] Eluard, *Le Livre ouvert*, "Je veux qu'elle soit Reine," p. 52.
[6] Eluard, *Poésie Ininterrompue* (Gallimard, 1946), p. 17.

[*L'homme aux lentes barbaries*
L'homme comme un marais
L'homme à l'instinct brouillé
A la chair en exil
L'homme aux clartés de serre
Aux yeux fermés l'homme aux éclairs
L'homme mortel et divisé
Au front saignant d'espoir
L'homme en butte au passé
Et qui toujours regrette
Isolé quotidien
Dénué responsable]

Then, he proceeds to a closer contact with the disorder of the world. The pace quickens, movement sets in, words like *new, open, light, awake, dawn, laughter* precipitate a succession of images with which love repossesses the world. His vision fluctuates between darkness and light, between reminiscences and foresight. Exterior calamities and the miracles of love struggle to mold to their respective dimensions the human habitat. Moral conviction of right and wrong results from his gradual cognizance of the real world, which he then molds into the dream. But these are not phantom dreams; they are the quintessence of sensuous experiences of the most unrestrained contact with the light and warmth of the world. The earthly dreams have love as their center:

Through you I go from light to light
From warmth to warmth
Through you I speak and you remain the center
Of all things like a sun consenting to my bliss

[*Par toi je vais de la lumière à la lumière*
De la chaleur à la chaleur
C'est par toi que je parle et tu restes au centre
De tout comme un soleil consentant au bonheur]

There is no juvenile cry of revolt or weary pessimism but a virile struggle against the physical forces of evil with weapons

that have no superhuman qualities. It is a step by step rejection of the past, a gradual enrichment of existence, an entrance into a four-dimensional world of freedom in which the words *infinite* and *immortal* are the treasured possessions of those who have learned to hope and be faithful to life on earth:

> *Everything is emptied and refilled*
> *To the rhythm of the infinite*
>
> [*Tout se vide et se remplit*
> *Au rythme de l'infini*]

As they rise by degrees in the climate of love which thrives under "the sky's exploded screen," the images of earth are "reconquered" with greater and greater intensity, and their eyes open wider and wider upon a universe rife with miracles:

> *And midnight ripens fruit*
> *And midday ripens moons*
>
> [*Et minuit mûrit des fruits*
> *Et midi mûrit des lunes*]

Life is a limitless mirror where the eyes becoming immortal find the reflection of all things.

But the mirror was to break. Eluard suffered soon after the war the excruciating tragedy of losing his beloved wife, Nusch, in an accident. He and his friends did not think that he could survive the devastating blow or bear the resulting solitude. Yet, his next volume, *Une Leçon de Morale*, is a reiteration and a reinforcement of faith in the ability of a poet to transform the world and attain its inner unity. "Can one imagine earth and heaven divorced, can one think of a hand without fingers, a soul without a body, a dawn without light, a conscience without an aim" he asks in the preface to the volume. Therefore, though happiness is gone, he would consider it a "vice" to replace it with pessimism.

Wavering between dejection (le Mal) and self-persuasion (le Bien) the poet triumphs over despair:

> *Like a miner who thinks of light*
> *The light that rises in his heart*
>
> [*Comme un mineur qui songe au jour*
> *Le jour son coeur le fait monter*]

He finds comfort in measuring his loss against humanity's eternity: "And if I lose—others will gain." He turns to the future as Apollinaire had before him:

> *Here comes tomorrow to reign today on earth*
>
> [*Voici demain qui règne aujourd'hui sur la terre*]

His rise out of grief has a cosmic rather than emotional character, the heart outspaces space and life conquers death:

> *The heart has so much space it defies the stars*
> *It is like a wave that has no need to ebb*
> *It is like a spring eternalizing flesh*
> *The majesty of life that gives the lie to death*
>
> [*Le coeur a tant d'espace qu'il défie les astres*
> *Il est comme une vague qui n'a pas de fin*
> *Il est comme une source éternisant la chair*
> *La majesté de vivre désavoue la mort*]

Though motivated by special circumstances, these postwar works of Aragon and Eluard give clear evidence of the aesthetic continuity of surrealism: the survival of the cult of the image and the resulting *rapprochement* of the subject and the object; a mystical approach to temporal events; free association of metaphors with a disregard for logical sequence; and a composite expression of physical and spiritual love. Their *post*-surrealism was an evolution rather than a change: increasing consciousness of the social message of the poet; and with this feeling there arose an increasing wish to communicate with a larger public; this

objective brought about a modification of their use of language.

In the April 1947 issue of *Europe*, in an article about the surrealist, Desnos, Aragon proclaimed that with the passing of surrealism would also pass the excessive liberty that the surrealists, including himself, had given to words; and he urged a return to the elementary language of common sense. He said that he had learned once more to call things by their right names. But one must be wary of accepting verbatim the self-analysis of a poet! Obscurity was never a *sine qua non* of surrealism. It had been a reaction to the limitations that had been imposed on the meaning of words, as we have noted previously, just as free verse had been a protest against the abuse of the alexandrine. If the immediate result of the revolt had been complete loss of control of sense and form, it indicated only the swinging of the pendulum. The need for discourse manifested by Aragon and Eluard was not essentially a contradiction of former concepts of linguistic structure; from the first, surrealism had been seeking the elemental, naked reality of words. What made surrealist poetry obscure was not the misuse of words, but too succinct an association of ideas, too great a condensation of imagery, coupled with extreme verbal concisions. In his preface to *En Etrange Pays dans Mon Pays Lui-même* Aragon had pointed out that the secret of poetry for him was "to create indestructible liaisons of words." His belief in the conjuration of words is in the tradition of Baudelaire and of the linguistic doctrines of the surrealists: that writing should be a magical operation capable of producing enchantment. As long as for Aragon and Eluard the mating of words, originality of verbal associations, hypnotic alliterations remained a higher literary criterion than the expression of logical meaning, they never could actually achieve the banality of the newspaper lingo that they decided to emulate. During and after the war what they really eliminated from their style were eccentricities of language and not its power of 'multiple implication. The change, a somewhat forced one, did not fundamentally alter the works written in the 1940's.

The change in language became drastic only when the political schism between Breton and his followers on the one hand, and Aragon and Eluard on the other, became categorical. As early as 1925 the surrealists had felt that their aesthetic ideals bore a subtle relation to social consciousness. To transform the world meant social as well as spiritual change. For a while, therefore, they had all identified this desire for a new social order with the communist revolution and made attempts at union with the communist organ, *Clarté*. Victor Crastre explained the "drama" of the attempted union in two issues of *Les Temps Modernes* in 1948: "The surrealists discovered that without social revolution there could not be a surrealist revolution."[7] He quoted Breton, himself, as writing in *Clarté:* "The isolation of the poet, the thinker, the artist from the masses, which is mutually harmful, is a result of the tactics of those who feel that they themselves stand to lose from this association. I want to believe that there does not exist a work of the intellect which is not conditioned by a real wish to improve the living conditions of the people."[8]

But Breton, as well as many of his colleagues and disciples, soon realized that their poetic image of "revolution" was in direct contradiction with the specific sense given the word by the communists. The surrealists' orientation toward communism had been a philosophical one. The real object of their "torment" was "the human condition over and above the social condition of individuals."[9] But since they were concerned in enriching the life experience of humanity at large rather than in developing a few Nietzschean supermen, the social improvement seemed a prerequisite. In the 1920's interest in communism had been a gesture of effervescence on their part.[10] In the 1930's it had been a sentimental adherence to Lenin's concepts, and a means of protest

[7] Victor Crastre, "Le Drame du Surréalisme," *Les Temps Modernes* (July, 1948), p. 60.

[8] *Ibid.*, August, 1948, p. 305.

[9] Breton, *Entretiens* (Gallimard, 1952), p. 124.

[10] See "La Claire Tour," *La Clé des Champs:* "around 1925 only the Third International seemed to furnish the means of transforming the world," p. 273.

against France's foreign policies. The formal rift with communism came in 1935 following the cold reception that the surrealists received at the International Congress for the Defense of Culture, held in Paris, when the majority of them, including Eluard, signed the official manifesto severing all relations with the U.S.S.R.[11]

In a later statement, "Pour un Art Révolutionnaire Indépendant," written in 1938,[12] André Breton further clarified his stand: although his concept of art was revolutionary he could no longer consider current communism as representative of that spirit. Moreover, the artist, who found it hard to accept any kind of authority, certainly could not bend to foreign directives. Eluard supported Breton's stand prior to World War II, and it was not until 1943 that filled with the memories of comrades of the Resistance he returned to communist affiliations, which he maintained until his death in 1952.

Through all the surrealist polemics, Aragon maintained his original adherence to the Party, and even the Russian insults to surrealism did not affect his allegiance. He preferred to lose his former friends. But the penetration of the communist influence into his work was a gradual one. As we have seen in the poems of the war period and those collected soon after the war, his surrealism is tinged more with patriotic fervor than with communism. It is not until some years later that Aragon went as far as to declare

11 In *Entretiens* Breton goes over the incidents that led to the rift. Ilya Ehrenbourg had written a book, *Seen by a Writer from U.S.S.R.*, in which he had insulted the surrealists by treating them as loafers and suggesting that they had squandered their wives' dowries. Meeting him one day on a street in Paris on the eve of the Congress, Breton had given in to the impulse of slapping Ehrenbourg in the face. As a result Breton was not permitted to give his scheduled speech at the Congress. All the pleadings of his colleagues were of no avail. This refusal disturbed René Crevel to such an extent that he committed suicide as an act of protest on the eve of the meeting. Finally, Eluard was allowed to read Breton's statement but he was rudely interrupted in the middle of it and was not allowed to finish. After that, Breton would never again have anything to do with the U.S.S.R. and called it a land of tyranny.

12 This manifesto was signed by Breton and Diego Rivera, written in Mexico. Breton confesses in *Entretiens* that his collaborator was really Trotsky.

that all his work as an artist had to be henceforth attuned to the communist dream.

A collection of poems by Aragon, *Les Yeux et la Mémoire,* and one by Eluard, *Les Sentiers et les Routes de la Poésie,* both appearing in 1954, show to what extent communism eventually overwhelmed surrealism in these two poets. In these volumes one can no longer discern any of the verbal technique we have noted in the earlier postwar works. Aragon's verse has the epic tone of Hugo; and Eluard's simplicity, which with the surrealist perspective had a ubiquitous elusiveness, becomes in these posthumously published poems limpingly prosaic and monotonously evangelical in cadence.

It is amazing how in adopting the partisan line, two poets of such differing personality sound alike. The surrealist cult of the future, exemplified often in the prophetic dream or in the visionary image, is appropriated, narrowed down in meaning, and identified with the communist dream of a future utopia. Eluard dreams of a "paradise on earth" in which it would be the poet's function to prove himself "more useful than any other citizen of the tribe."[13] Aragon echoes the same ideology as he declares that every word he utters from now on will belong to tomorrow: "all dream of the future is a dream to live." To live in a world happy as the song of a turtledove! "Where the happiness of all is the happiness of each," such is his "new humanity." Even death is not really death to those who are harnessed to the "great dream" which, says Aragon, cannot fail; for they have shaken off the security of the kind of life that is greedily limited to itself:

> *Mourir n'est plus mourir à ceux-là qui s'attellent*
> *Au grand rêve de tous qui ne peut avorter*
> *Ils sont hommes d'avoir secoué la tutelle*
> *D'une vie à soi seul chichement limitée*
> *Et le héros d'hier lui donnant sa mesure*

[13] Eluard, *Les Sentiers et les Routes de la Poésie* (Gallimard, 1954), p. 126.

Chaque jour plus nombreuse à l'assaut de l'azur
C'est la nouvelle humanité.[14]

The rationalizing character of this latter-day verse of Aragon and Eluard negatively demonstrates to what extent the linguistic technique had been an integral part of the surrealist turn of mind; the acceptance of a mystical reality within the orbit of earthly existence. When the mysticism vanished the language vanished with it. War and the occupation of France had not destroyed in Aragon's and Eluard's poetry this metaphysical vision; but what the war could not do, the cold war and its indoctrination did. They lost their surrealist art only when they compromised and, giving up the search for the absolute, agreed to settle for merely a social transformation of the earth.

Strangely, the year 1959 offered an epilogue to Aragon's post-surrealism. The man who, for the previous decade allegedly had eyes only for the future had, it appeared, for three years been very much engrossed with the past: the year 1815, vividly, poetically restored in his novel, *La Semaine Sainte*, which won him tremendous acclaim and returned him, as it were, to the family of French literary men from whom his party had separated him for thirty-two years.

In the midst of this warm reception he found it in his heart to recall his surrealist past. In an article about a young novelist, Philippe Sollers, he reminisced about his own youth, contrasting the bonds of fraternity among the surrealists with the loneliness and isolation of young writers of the post–World War II period. At this late date he declared that he had never ceased to be a surrealist, and that he had never held any grudge against André Breton, whom he considered one of the truly great writers of France.

Life separated us, set us one against the other . . . All the newcomers and the old friends of my youth. They will never be

[14] Aragon, *Les Yeux et la Mémoire* (Gallimard, 1954), p. 101.

able to prevent my considering them as my own. Even with political abysses between us, which I am not ready to bridge. . . . I have always defended the skies of my youth.[15]

Some wanted to see in these statements a proof of a change of heart in Aragon. It may be so, although Aragon insisted that only as a communist could he have written *La Semaine Sainte*. However, the problem of his present or future political affiliations are not really significant for this study. What cannot be changed is that he, along with his friend Eluard, was part of the spiritual adventure called surrealism, and exemplified in dramatic fashion its evolution from early rebellion to optimistic faith in the powers of the human imagination to transform the world, fortified by a growing moral awareness of that world. If in a later stage the dream was reduced to political terms, the previous work has an existence independent of its author, and as the author cannot forget his former friends, his works cannot deny the surrealist imprint that they bear.

[15] Aragon, *Les Lettres Françaises*, November, 1958.

10

to
transform
the
world

While the poetry of Aragon and Eluard suffered deviations and then complete transformation after World War II, surrealism itself as a literary unit disintegrated when its members were dispersed to the four corners of the earth. After the war, the surrealist "evidence," originally only to be found in the works of individual poets or demonstrated in reviews such as *Les Quatre Vents* or *Medium,* established its imprint on poetic language and as a philosophy of life. Thereafter, surrealist activities no longer could be concerted, organized gestures or the demonstration of doctrines. But the untiring and uncompromising character of André Breton continued to serve as a stimulation to literary and artistic work which aspired to expand the field of human imagination.

231

Although Breton left France during the war and shrank from the idea of writing circumstantial verse, the war brought him great personal bereavement, the effects of which he could not exclude from his poetry despite his distance from the melee. Whereas Aragon wished his poetry "to read like a newspaper," as he explained in his *Chronique du Bel Canto,* Breton tried to keep the specifically circumstantial aspects of the world cataclysm out of his work. But anyone who saw Breton in those war years realized how impossible it would have been for him to separate his grief over Europe's disaster from his purely literary activities. Besides, was literature ever *pure* for André Breton? Perhaps more than anyone since Baudelaire, he had accepted writing as an integral part of his life experience.

This was a period of great travels for Breton in the Western Hemisphere, whose grandiose landscapes supplied him with a constant stimulus for the type of imagery that could counterbalance the message-compulsion created in him by the troubled times.

Les Etats Généraux (1943) contained a social message, preached tolerance, the basic oneness of the world. He envisaged a people rising to the sense of interdependence, realizing the wealth of human power that could be generated from the free intermingling of the genius of all races of the world, and first of all turning to the black and red races: "Because they have been for a long time the most abused." However, the message is illuminated by Breton's marvelous power over language, his constant discovery of lost words and their hypnotic uses which transform the world more than do his twentieth-century sociological ideas!

Breton's vein of imagery is inexhaustible and would grant total escape from the miseries of the world if he so desired—and it actually does so in some of his love poems. But Breton refuses to be transported by the image. Rather, he puts it to work in dramatizing the need to change the world.

Breton's notion of the absolute was altered by the war years as was that of Aragon and Eluard. His preoccupation shifted from

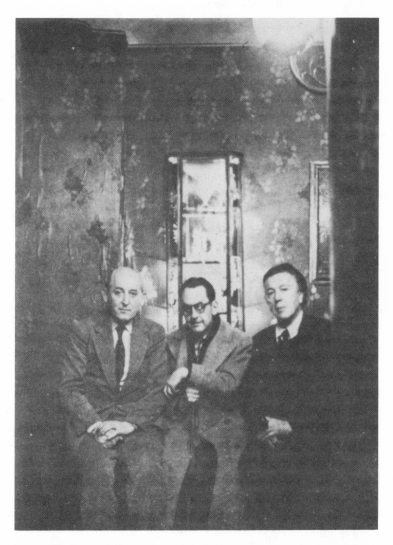

Benjamin Péret, Man Ray, and André Breton (LEFT TO RIGHT) re-
united in Paris about 1955.

the spiritual and sensual to the moral field, where his vision, he said, would hold an unlimited empire:

> *La vision nocturne a été quelque chose il s'agit*
> *Maintenant de l'étendre du physique au moral*
> *Où son empire sera sans limite.*

The transformation of the world must be sparked by an improvement in the moral caliber of man. Mallarmé's "coup de dés" has its counterpart in Breton's flipping of the coin to see which way the world will go. "Heads" would signal emptiness, but it falls on "tails," which represents the unconscious yet irresistible bent toward the better:

> *Pile ou face face la pièce nue libre de toute effigie*
> *de tout millésime*
> *Pile*
> *La pente insensible et pourtant irrésistible vers le mieux*

But unlike Aragon and Eluard, he kept free of political parties. Breton's moral concern was not channeled toward any contemporary social system. Instead, he saluted the nineteenth-century philosopher Fourier and called upon him as a humanitarian and a visionary to cast his light upon the drab ideas and aspirations of his time:

> *Fourier tranchant sur la grisaille des idées et des aspirations*
> *d'aujourd'hui ta lumière.*

In 1945 he wrote the *Ode to Fourier,* which he considered one of his principal postwar writings, while on a journey through the American Far West. The Petrified Forest seemed to him symbolic of the condition of the world and its need for stimulation.

> *Je te salue de la Forêt Pétrifiée de la culture humaine*
> *Où plus rien n'est debout*

Mais où rodent de grandes lueurs tournoyantes
Qui appellent la délivrance du feuillage et de l'oiseau
De tes doigts part la sève des arbres en fleurs

Although he expressed discouragement at such moments, the tone that generally permeates his postwar writing is not one of pessimism. Although he was not less repulsed by the situation of man during World War II than after the first war, in which he had participated, this time it was in a much quieter mood that Breton searched for indices for upgrading the human condition. In the depths of political upheaval, of humiliating defeat for his country, and self-willed exile for himself, Breton was able to celebrate the triumph of resurrection. The site of his "hymn to the sole glory of nature and love" was the most remote tip of the Gaspé peninsula. *Arcane 17* is a piece written in the fall of the year when nature is permeated with the appearances of death, just as death was rampant in those darkest hours of the war-torn world of 1944. Yet in the death of human hopes as in the dying of nature's butterflies and roses Breton found the imprint of regeneration: "The rose tells that the aptitude for regeneration is without limit."[1] The renewal of nature, self-contained in its dying, makes Breton think of the human phenomena of which the life force is preserved: "What a consoling mystery there is in the rise of successive generations, what new blood incessantly circulates and in order that the species may not have to suffer from the usury of the individual, what selectivity occurs just in time, succeeds in imposing its law in spite of everything. Man sees this wing tremble, which in all languages is the first great letter of the word Resurrection."[2]

The primary reason that Breton could find hope in disaster is that he was able to call on the forces of love, which for the surrealists had always been the essential mechanism of exaltation.

[1] Breton, *Arcane 17* (Pauvert, 1965), p. 89.
[2] *Ibid.*, p. 90.

Among the abject portraits that twentieth-century literature pro-
vides of woman, surrealist representation of the feminine ideal is
a striking exception. She is considered more flexible, more recep-
tive to material realities, therefore more "voyante" and as such is
a medium, not for the purpose of perpetrating any mystification,
but as a guide toward clarification of confusions. In *Arcane 17*
the fay, Mélusine, replaces the Greek Ariadne in directing man
lost in the labyrinth. Perhaps, suggests Breton, it is time to put
more powers in her hands since man has abused his prerogatives
and given tumultuous evidence of his defeat. Indeed the love
theme is one of the most beautiful and touching in surrealist
literature from the earliest hermetic poems to the more clearly
understandable works of the war years, those which Aragon dedi-
cated to Elsa, and Eluard to Nusch, as Breton to Elisa. Love is a
deepening sense of self in the material as well as spiritual sense of
the word, since the distinction is a verbal one rather than a real
one to the surrealists.

In *L'Amour Fou* when love had the face of Jacqueline, Breton
had said of love: "I say that it must win and for that must have
risen to such a poetic consciousness of itself that all that happens
to be necessarily hostile in its path must melt at the hearth of its
own glory." As if by prophecy, all the anguish of having lost
that love turned to triumph when he found Elisa by that magical
power of chance in which he believed from his earliest experi-
ences in aleatory activity in Paris, and which had not abandoned
him in his exile in America. In the recuperation of love, which he
celebrated in *Arcane 17*, he saw the communion between man and
woman as a correspondence of the fusion of soul and flesh:

> If all fallacies regarding redemption are put aside, it is precisely
> through love and love alone that there can occur the highest degree
> of fusion between existence and essence, it is love that can suc-
> ceed in harmony and without ambiguity to conciliate those two no-
> tions, while without love they remain a source of hostility and
> anxiety. I mean of course the kind of love that is all inclusive, that

encompasses the whole duration of life, that recognizes as its object only a single being.[3]

Love also marks the communion between man and nature:

> Love, reciprocal and total, which nothing can spoil, which makes flesh turn into sun and a splendid imprint on flesh that is an ever singing source, inalterable and always alive, and whose water runs its path between the sunflower and the thyme.[4]

Finally, Breton finds that in being deprived of the things he holds most dear he is subject to a power of reversibility that makes him more deeply aware of the need to give of oneself:

> One has to have gone to the bottom of human grief, to have discovered its strange capacities, in order to salute with the same limitless gift of self what is worth living for.[5]

This obstinate championship of man's power to recapture a golden age in spite of the many reversals he had witnessed in his lifetime was a permanent mark of Breton's character. His attitude was of course in sharp contrast to the prevailing stoicism of the postwar existentialist philosophy that dominated the literary scene when he returned to Paris.

In *Entretiens* (1952) when he was asked by the interviewer if he agreed with Camus that the modern Sisyphus must roll his stone and try to enjoy life within the limits of his inescapable chore, Breton's answer was characteristic of the vigorous optimism that consistently accompanied him through both his sublime and catastrophic moments. Why accept as a final and irrevocable punishment what can be annulled! Why put greater confidence in the durability of the rock than in man's potential power to destroy it and thereby overcome the absurdity of the task?

[3] *Ibid.*, p. 288.
[4] *Ibid.*, p. 298.
[5] *Ibid.*, p. 107.

"One day or another it will break, abolishing as if by enchantment the mountain and its punishment."[6]

Nowhere in Breton's writings is the vitality of surrealism or the stature of its author better revealed. Breton's reaction to the myth of Sisyphus is in a sense a protest against the tendency of the humanistic philosophies of the West since the time of Pascal to rationalize the miseries of the human condition by vesting it with an illusion of dignity.

Few have had in our time as close and as constant an awareness of the tragic reality of human existence as Breton, who identified the essential tragedy of man not with his social or moral condition but with "the flagrant disproportion between the breadth of man's aspirations and the individual limits of his life."[7] Yet this incongruity between the span of life and the scope of human desire never discouraged Breton. Was he naïve, then? On the contrary it was his extreme sophistication that raised him above dejection and gave him not a grim but a gallant optimism. For the optimism is based on the assumption that existence is not final, or static, or limited, but subject to change, to fortuitous but predictable modification. Therefore, whatever is tragic is transitory, relative, and not an obstacle in man's progress toward the absolute.

When asked if he had any regrets about his life or work, Breton answered that his life had been lived exactly according to his dream of life. Although Breton didn't obtain widespread popular recognition in his lifetime, and lived to see lesser writers than himself win greater public acclaim, he showed no regrets. In maintaining an uncompromising attitude toward the principles of surrealism, he was willing to accept the sometimes unhappy consequences: the quarrels, and the solitudes, and the disconcerting reality of not being able to earn a living like his more pliable colleagues. He exemplified not the pure but the *total* poet, clarifying to a greater degree than anyone in his time, what the position of

[6] Breton, *Entretiens*, p. 248.
[7] *Ibid.*, p. 266.

a poet can be in society: not to seek to please and be admired, but to know and to communicate knowledge. His attitude could be summed up in *Prolegomena to a Third Surrealist Manifesto* where he said: "Considering the historical process . . . I am at least on the side of that minority endlessly renewable, that acts like a lever: my greatest ambition would be to leave its theoretical meaning indefinitely transmissible after me."[8]

As for Benjamin Péret, he passed the period of World War II in Mexico. He had previously fought for the loyalist cause in the Spanish Civil War. When World War II began his attitude against it had been more rebellious than that of any of his surrealist colleagues because as he said "he had been asked twice in his life to defend a society with which he had nothing in common."[9] After the fall of France he had spent some time in a Nazi prison in Rennes, then fled to Marseilles to join other surrealists such as Breton, Tanguy, Brauner, etc., who like him were undesirables no matter what regime ruled France during the war.

[8] Breton, *Les Manifestes du Surréalism* (Pauvert), p. 346. After writing free verse for more than thirty years Breton arrived, in his last poetic work, *Constellations* (1956), at the prose stanza, reminiscent of Rimbaud's *Illuminations* in its compactness and concrete ellipsis. The immediate inspiration for *Constellations* was the series of gouaches of Miro which date from the 1940s. Breton's word images are a cosmic venture in which man joins nature through the phenomenon of metamorphosis reflected in human nature in the functioning of love. As one reads these compact poems, meaning appears *contained* rather than conveyed, in the manner of the ancient rebus of the Cabala and of latter-day alchemists from whom Breton derived his model, the one in the other object—*l'un dans l'autre*, contained and containing—which Breton in the final development of the surrealist vision of the universe found primordial in nature as well as in humans within it. In *Constellation* words not only make love but Breton makes love with them. He penetrates language, and through language establishes a deep and intimate relationship with the physical world. Far from being automatic, poetry thus becomes a very studied and learned activity in which the poet seizes on the propitious, aleatory associations of his mind, tests them against nature's laws, directs them, and constructs around them his twenty-two tapestries revealing beyond the literary destiny of his poetry the significance of the new ontological posture it proposed to illustrate his efforts toward a redefinition of human destiny. For the development of Breton's poetic process see my "From *Poisson Soluble* to *Constellations:* Breton's Trajectory for Surrealism," *Twentieth Century Literature* 21, no. 1 (February 1975).

[9] Cf. *La Parole Est à Péret*, 1942.

From there he had managed to get to the Western Hemisphere. He adhered more closely than any other of the initial band of surrealists to the character of his early surrealist manner. His reactions to the war and to the hydrogen bomb are represented not in narrative or affective communication but by a fury of images of venom, of shame, of plague, and of polished bones. And in the midst of a distorted landscape of fire and bomb, man becomes a mushroom of the variety grown in cellars, and that field rats feed upon. The reference is no doubt connected to the air raid shelters of World War II that were the refuge of a frightened and constantly threatened humanity, bereft of its spirit of ad- venture.

While in Mexico and later back in France, Péret managed in his prose writings to reassert with renewed vigor and in a more explicit way than any other surrealist of the first era the broad lines of the surrealist faith in liberty, poetry, and love. In *Le Déshonneur des Poètes* he redefined, in the more precarious atmosphere of war, what the group, and particularly André Breton, had claimed to be the position of the poet in modern society: a revolutionary in terms of the basic strictures of that society but a nonpartisan form of the revolutionary. The formula, "the poet fights against all oppressions" includes oppressions that in their earlier days some surrealists had discovered to be intoler- able when they had temporarily joined the French Communist Party. The revolutionary spirit described by Péret is one of noncommitment, because as Péret thought, parties fight particu- lar situations and paradoxically in fighting these they create oppressive dogmas within their own ranks. It is up to the poet, says Péret, "to pronounce words that are always sacrilegious and permanently blasphemous."

Political rebellion that subjugates the total sense of revolt in the poet is for Péret a self-defeating mechanism: "He fights so that man may attain an ever perfectible knowledge of self and of the universe. It does not follow that he desires to put poetry at the service of a political action, even if it be a revolutionary one. But his quality of poet makes him a revolutionary who must fight in

all fields, that of poetry by means that are pertinent to it and in the social field, without ever confusing the two fields of action for fear of reestablishing the confusion that must be dissipated and, consequently, ceasing to be a poet, i.e., a revolutionary."

In *Le Noyau de la Comète* (1955) he reaffirms his faith in love, which he equates, like Breton, with the basic state of a poet. For Péret no one incapable of "sublime love" can be a poet. Péret, like so many of his fellow surrealists, had also known total involvement in love. Like Aragon, Breton, Eluard, Desnos, he was extremely devoted to the "one and only" love. What Jacqueline had been for Breton in *L'Amour Fou,* and later Elisa in *Arcane 17,* what Elsa had meant to Aragon, Nusch to Eluard, Youki to Desnos, in the case of Péret it was Elsie Houston, a Brazilian folk singer whom he had married in 1927. She is the focus of his love images until her death in 1943. After that he married the surrealist artist Remedios Varo. It is on the basis of his own happiness in reciprocal love that Péret wrote: "I don't think that the temptation of sublime love can be erased for a man once he has been able to surrender totally to it." The power to love, which he names in contrast to all the Don Juanesque sexual ubiquities and excesses, is for him intimately inherent in the condition of poet. Poetry is "the geometric locus of love and rebellion." But the notion of poet is not limited for Péret to that of a literary artisan. It is everyman "who is capable of evoking spontaneously the footpaths of a green forest as he looks at kindling wood and of seeing in daily life a negligible tool unless it is put to the service of an existence aimed at the elevation of man. He is not a stranger to poetry, the man who, even if placed on ground level, discovers in everything its celestial aspect, in contrast to a man who sees in woman only her sex and in kindling wood only its going price."

Love for Péret as for so many of the surrealists replaced the notion of the sacred associated with religious ecstasy, or, shall we say that he found in the love mechanism, triggered by sexual attraction, but quickly transcending it, the antecedent of divine love: "divine love being only a detouring of human love to impoverishing ends."

As in the case of Breton, so in Péret's wartime exile in the Americas, contact with the new world revealed the antiquity of that world, which had been new only to European colonizers. Péret like Breton found great contingencies between primitive concepts and the surrealist cult; he recognized a mystique which owed to the naturally permissive conditions of ancient tribal societies what in evolved ones could be won only through rebellion against prohibitive prejudices and mores. Out of this climate came an *Anthologie des Mythes, Légendes et Contes Populaires,* published posthumously in 1960 (Albin Michel).*

Among those who passed through the surrealist experience, two poets have won recognition in the postwar years both in France and abroad: René Char and Antonin Artaud, one for the positive values of his poetry which has crystallized many of the surrealist concepts, the other for the surrealist life which he has allegedly lived and for the negative character of his behavior which struck a sympathetic note in the postwar generation.

René Char, half a generation younger than André Breton, has carried on the tradition of surrealism better than anyone else, although he has supposedly gone through and beyond surrealism. Like Breton, simply and completely a poet, he has faced up to "this rebellious and solitary world of contradictions" as he terms it in *Le Poème Pulvérisé,* and has decided that it is impossible to live without having the image of the unknown ever before one's eyes. His universe, built as Breton's, upon a structure of metaphysical metaphors, is a place of discovery, where even "the harvest of the abyss" is a possibility. The poet's task in this life, whose limits he calls "immense" is to "extract from things the illusion they produce to preserve themselves from us" and, on the other hand, to let them keep that part which they would willingly yield to us. "The pulverized poem" represents this effort to

* Of all the surrealists, Benjamin Péret has least caught the attention of critics and scholars, partly because his works have been least accessible. As they are systematically re-edited, they will offer more and more opportunity for the scholar, poet, and critic to come in contact with one of the most spontaneous and representative poets of surrealism in whom gaiety and sublimity made a more total fusion than in any other.

remove the trappings of reality and to uncover what nature be-
grudges man.

"Il y aura toujours une goutte d'eau pour durer plus que le
soleil sans que l'ascendant du soleil soit ébranlé." His concept of
poetry, like Breton's is one of salutary foresight, intended to
enhance human qualities.

Writing with a brilliance and a freshness unmarred by any
allegiance or engagement to anything but the dictates of his
destiny as poet, Char has gained a quiet but well-anchored fame.

Antonin Artaud has been the other side of the coin, personify-
ing not the art but the legend of the surrealist. He is the one, says
Breton, who went right through the mirror. Unbalanced, later
totally deranged, he was committed for a number of years to a
mental hospital. Eventually he managed to get out only to end his
tormented existence in suicide.

This dark angel of surrealism, representing the initial pessi-
mism and revolt of the group, rather than its later manifestation
of constructive poetic vision, had a special appeal for the "angry"
or "beat" avant-garde. In his notorious letter from Rodez (the
hospital) he demonstrated the rebellious, impudent disgust of the
young generation of 1920:

"People are stupid. Literature empty. There is nothing more
and nobody left, the soul is insane, there is no more love, nor
even any hatred left, all the bodies satiated, consciences resigned.
There is not even any anxiety left, which has vanished into the
emptiness of bones."[10]

While most of the members of the surrealist group abandoned
this obvious sort of criticism of the state of contemporary society,
Artaud never grew out of it, never went beyond the feeling of
contempt for the absurdity of the world. The cult of the absurd in
mid-century, reminiscent of the Dada atmosphere of the first post-
war period, has found a symbol in the tormented Artaud. Artaud's
treatise on the theatre of cruelty has been, of course, seminal to
the avant-garde theatre of the fifties and sixties. This and other

[10] Antonin Artaud, "Lettre de Rodez," *L'Evidence Surréaliste*, in *Les Quatre
Vents*, no. 4, p. 185.

essays of Artaud collected in *The Theatre and Its Double* have been so widely translated and disseminated that they have been identified in the public's mind with the premises of surrealism. Unfortunately the more authentically surrealist writings became accessible too little and too late to demonstrate the fact that Artaud's surrealism had always been uncontrolled and apocryphal. Artaud's personal life-style, determined to a great extent by his inherent mental aberration, has been confused with the surrealist adventure.

The surrealist élan seemed out of place in a literary atmosphere permeated on the one hand by the anguish of sober-faced existentialists,* and on the other by the dark, sordid humor of a group of dazzling non-French writers who are living in Paris, writing in French and seeming to revive the spirit of the Dada era. For a time surrealism became merely an undercurrent, instead of flowing full-stream into the literary consciousness. Literary graftings such as Beckett's and Ionesco's produce in general late blossoms —which may explain the flowering of a new dadaism thirty years late. But the last flower, though often more brilliant than the early one, proves also more ephemeral. This latter-day dadaism translates only the apparent despair of our epoch. For, although the ills of the human condition and the man-willed ones of war are still glaringly with us, there is an inner dynamism in these times that makes pseudo-dadaism seem myopic, and the surrealist outlook more truly representative of the spirit of our age with its unrelenting, ever accelerating drive for enterprise and exploration. Belief in the inner resources of man, which might, if cultivated, transform the world, is a continuation of the prescience of Guillaume Apollinaire, who in the midst of the catastrophe of World War I foresaw for humanity much vaster domains in which to exercise his liberty. It is an optimism comparable with "voyance," it is the point beyond nihilism, which is perhaps the realization of the futility of nihilism. And "tremors" greater than those that crossed Lautréamont's intellectual horizon indicate today that the dream carries reality in its tracks.

* Obviously the existentialist domination of literature in the late 1950s has subsequently been abated. But my prediction of a return to the up-beat quality of life has not been fulfilled as we approach the end of the century. Dark philosophers of deconstruction prevail over the will to reconstruct.

11
the
world
transformed

Surrealism does not need to prove the authenticity of its position, for science, challenging man's utmost imaginative resources, has followed a parallel path of inquiry and is itself proving the poet's hypothesis with more tangible evidence.

Early in the twentieth century Einstein unraveled the imprecisions of time and space; the progress of nuclear physics in the ensuing years has shaken the concept of chronology. Science has also proved that the principles of causality, which for centuries had made determinism an essential axiom of materialism, are no longer tenable; for the caprices of the physical world have been found to be governed by the unpredictable rate and timing of atomic movements. Rather, it is chance—the "divine hazard" of the surrealists—and theories of probability that are needed to

gauge the dynamism of matter. Statistical calculation rather than rational theorems serves to approximate—not measure exactly—time, space, chronology, and the infinite variations of an ever incomplete and therefore limitless universe. It is Mallarmé's "coup de dés" which is emblematic of our effort to govern our existence and in the field of objective choice our knowledge of it. In rejecting the principle of causality the scientist with all his tools of reasoning confirms the surrealists' intuition that there can be a nondeterminist understanding of reality.

In a significant article, "The Image of Nature According to Contemporary Physics,"[1] the renowned German scientist, Werner Heisenberg, suggested that developments in modern atomic physics must have repercussions in the field of philosophy. His description of the relation between objective reality and man's intervention in it seems to have been taken directly from the pages of surrealist aesthetics.

First, according to Heisenberg, there was nature marked by God. Then man learned to envisage nature objectively, giving a somewhat simplified image of the universe. But the intervention of man's technical faculties in the observation of nature has resulted in abolishing the concept of an independent, static image. Man with his new methods and tools of observation has actually transformed "on a large scale" the world that serves as his environment, and he has marked it with the human seal. As a result the line between the subject and the object is vanishing.

"The knowledge of atoms and their movements 'on their own,' i.e., independently of our experimental observation is no longer the purpose of research: we find ourselves from the start in the midst of a dialogue between nature and man, in which science plays only a partial role, so that the division between subject and object, of inner and outer world, in body and soul can no longer be applied and raises difficulties."

The scientist can no longer contemplate and investigate nature

[1] Werner Heisenberg, "La Nature Selon la Physique Contemporaine," *La Nouvelle Revue Française* (January–February, 1959).

objectively but submits it to human questioning and ever links it to the destiny of man. Thus by his method he transforms the object and can no longer separate himself from the purpose of his quest.

These are not the verbalizations of a poet but the affirmations of a scientist, revealing inadvertently but dramatically the actuality of surrealism, of Breton's vision of the crisis of the object, and of Max Ernst's prophecy of the more general crisis of conscience that might rise out of it. Indeed, will the joint utilization of the new techniques of the artist and of the scientist eventually establish a new relationship between man and the universe?

The philosophy of science is the area for the consideration of the impact of man's knowledge of the material world upon his notions of humanism and destiny. Gaston Bachelard had like Heisenberg ventured an interrogation in respect to this relationship. A physicist and chemist, he proceeded to the field of philosophy, crossing bridges that he devised for himself. When he wonders whether a simple rationalism is capable of coping with the immense implications of the secrets of the universe unraveled each day more extensively, he gropes for the same type of modified rationalism as the surrealists and calls it a "superrationalism." What is more significant in his appropriation of the powers of imagination is his conviction that poetry is no longer a luxury but a necessity if we are to cope with the notion of an ever expanding reality. Literature must no longer simply fill an hour's vacancy in fugitive time, he says in *Psychology of Fire*. And in *L'Air et les Songes* he studies the generating power of language as used by the artist, which is for him one of the many manifestations of the dynamic movements in the universe. "The poem is essentially an aspiration toward new images,"[2] and new images inherent in the poetic use of language spell out, according to Bachelard, the modifications of reality like a gauge of its evolution. He opted for a "polysemantic" function of language, which

2 Gaston Bachelard, *L'Air et les Songes* (Corte, 1943), p. 8.

might enlarge the field of significations and the capacity to provoke the dream. He, as a man of science, seemed to concur with the objectives of surrealism. "Language is always a little ahead of our thought, has a little higher boiling point than our love."[3] He exhorts both artist and scientist when he finds that they have basically a common objective, to discover the metaphysical sense of the philosopher's stone: to turn the mud of reality into the gold of man's fulfillment here on earth. He who realizes this will know "the secret of health and of youth, the secret of life."[4] He exhorts the artist and the scientist as he says: "let us surrender, body and soul, to a material imagination." The position seems highly analogous to that of Pierre Reverdy's with his feet in the soil and his hair in the stars. In this inevitable conciliation between the aspirations of the artist and the scientist, surrealism has been the first to break the dichotomy and to communicate the desire to appropriate the data of the modern scientist in order to bring about the necessary revisions of our notions of reality and to produce a drastic transformation of the function of the artist in a scientifically advanced society.

Artists have always been first to present their visions, and the scientists have then provided substance for these conjectures of the imagination. The surrealists on their road to the absolute were in search of new myths to symbolize the new visions. The myth of Sisyphus is obsolete, even with modern variations, for it is the artistic symbol of a social reality that has been long extinct. It is no longer in the nature of man to roll stones, but to cut them, not to struggle up mountains but to blast passages through them, as centuries of his history can attest. It is one thing to appreciate Greek symbols for their beauty, for the authenticity of their meaning in their time, but to appropriate them and to try to adapt them to the needs of an entirely different age, seems to show a lack of imagination as well as a lack of a sense of historical truth. The myth of Sisyphus (as well as that of Icarus) is incompatible

3 *Ibid.,* p. 288.
4 *Ibid.,* p. 298.

with the astronauts' mission of conquest. The premises for the transformation of man's social condition have already been laid, and if physical slavery has not yet been totally banished from the world, release from it has been proved possible; therefore it can no longer be considered an inevitable part of the human condition. Philosophies and literatures, then, which use the physical bondage of man as a point of departure are laboring with an old-time model. Man has already found a greater diversity and flexibility in the employment of his time on earth. He has freedom of movement in an ever widening orbit. His actions are self-willed even if he often appears to act by rote. In many parts of the world he has earned—often paying for it dearly—a certain freedom of thought. But it is a limited thing, this freedom to think, the freedom to dream, unless the mind strives forever to widen its comprehension, to multiply the possibilities of its perception! Perhaps the aspiration to immortality, heretofore manifested in the effort to increase the life span, would find more satisfaction in intensifying the mind's speculative forces. For reality will be as narrow or as vast as man's power to envisage it. It is this spiritual progress of man, "a greater emancipation of the mind," as Breton called it, which is the chief concern of the future, and it is for the artist to provide new myths to dramatize man's ascending power to control his universe.

Lautréamont's appeal today is due to the fact that his anguish over the biological condition of man took the larger proportions of a spiritual combat. Likewise, Apollinaire's notion of human progress was based on the desire for man to attain spiritual heights by becoming "more pure, more live, and more learned." So too, the timeliness of surrealism lies in its emphasis on the need to enlarge the orbit of the human intellect.

The endeavors of the scientist and the artist in this field seem to be closely linked. With the unraveling of cosmic mysteries, the keys of nature may, as Breton hoped, be at last within man's reach. In such an atmosphere of expectancy, literature needs more than ever before the vitality of those whose objective it is to

enhance the forces of imagination. Instead, current fiction supplies us with an ever lengthening gallery of nonheroic characters, asphyxiating in their limited worlds from which they seek no exit. If the novel-genre persists in developing along lines so incongruous to these times, surrealism's dynamic adventure is, by contrast, a signal to the poet to maintain the heroic role in literature.

epilogue

Poetry has proved to be the frailest of the Muses, yet like the delicate weed of the fable it bends but does not break in the powerful currents of changing literary genres. The vitality that surrealism has injected into the ailing but long-lived invalid, is being recognized more and more by French poets and critics, by those who themselves did not share in the literary revolution that surrealism unleashed in the 1920's. Many writers in other parts of the world, trying to adapt other languages to new perspectives, are appreciating and emulating the changes in the use of language that the French surrealists achieved, and which transformed the most regulated, grammatically precise language, into the most liberated, winged accomplice of literary imagination. Consciously or unconsciously the style of many a formal French Academician has been affected by the work of these linguistic pioneers. The clichés of analogy which still clutter so much of the poetry of other languages seem to have been radically removed

from the French literary language. It is an example that the literatures of other countries, some quickly, others belatedly, have been following. The study of the increasing influence of surrealism on non-French literatures will deserve to be the object of many a future investigation by literary historians.

Novelists such as Alain Robbe-Grillet and Michel Butor seized with new eyes the world of objects that surround contemplative man, and like their predecessors the poets of the previous generation, they tried to establish new relationships between the concrete world and the writer's introspections through the cultivation of the "regard" or unprejudiced eyes and uninterpreted designation of the vision. The great difference that Hegel signalized between romanticism and the modern spirit is being demonstrated in the "nouveau roman" by those who cease to absorb within their subconscious world the objective reality which they encountered, but instead attempted to project the human web into the orbit of nonsubjective existence.

It remains to be seen if these technical feats are to be endowed with the exaltation which marked the surrealist credo. For it was this faith in the potential powers of the human mind over both the subjective world and the world of concrete reality which made of surrealism a worthy successor to the classical ideal.

index

253